# Impressions of Arabia

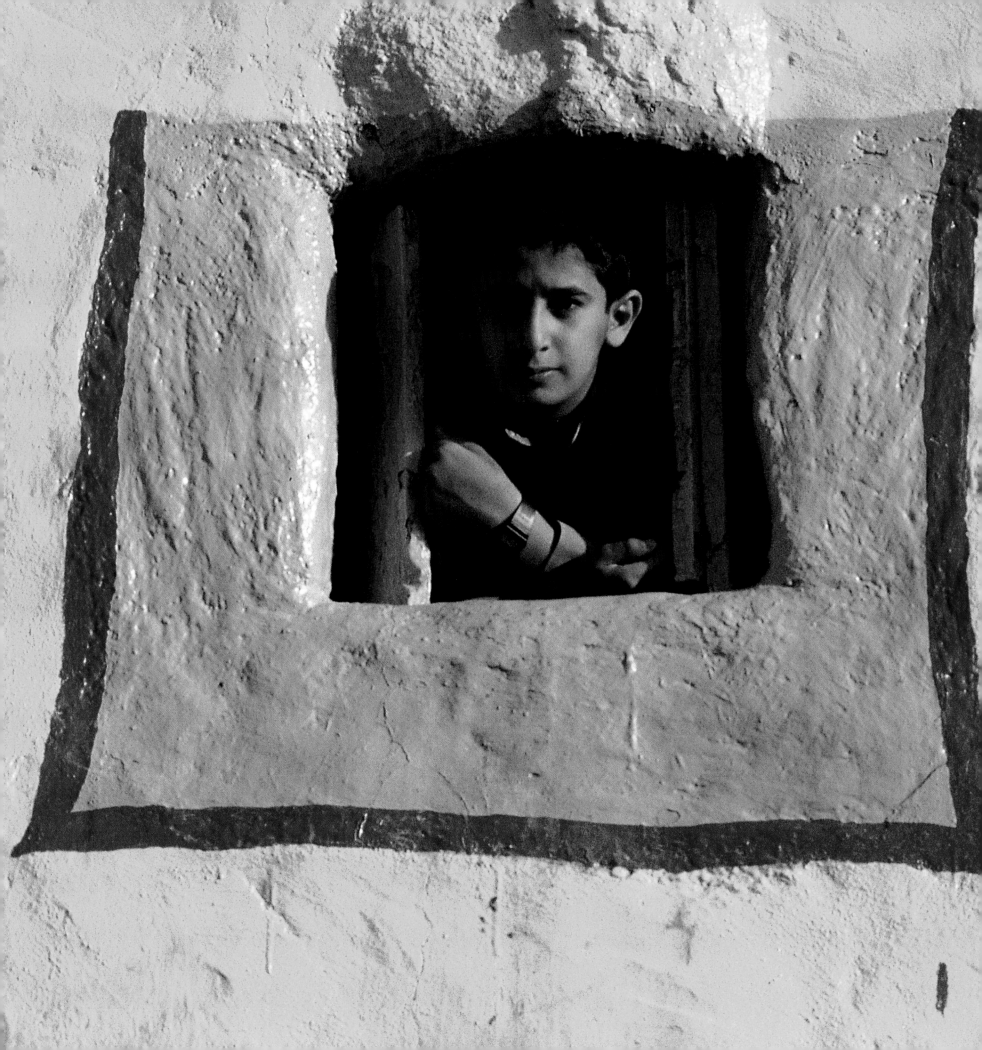

# Thierry Mauger

# Impressions of Arabia

*Architecture and Frescoes of the Asir Region*

Flammarion

Paris-New York

*The old house, for those who know how to listen,*
*is a sort of geometry of echoes.*

Gaston Bachelard, *The Poetics of Space*

## ACKNOWLEDGMENTS

I would like to thank His Royal Highness Prince Khalid Al-Faisal for his invitation to spend time in the province of Asir, and for the trust that he placed in me.

I am also grateful to Abdul Rahman bin A. M. Al-Qahtan, director general of rural affairs and his assistant Ahmed M. Hakami for their enlightened advice; Ibrahim A. Al-Sayed, former director of the King Fahd Cultural Center; Muhammed Hasan Garib Al-Alma whose hospitality and enthusiasm for his culture have never waned; Faya Muhammad Al-Mashny and Fatma Muhammad Al-Ahdaly who kindly agreed to act as our interpreters; Jarulah Abdul Rahman Muhammad who welcomed us unreservedly into his home; Fatma Ali Al-Zahir and the family of Zeid Abdul Kaled who disclosed to us the secrets of their art.

I also benefited from the friendly and expert advice of François Pouillon.

Translated from the French by Nissim Marshall (text)
Kathleen Guillaume (captions)

Designed by DA Graphisme/Daniel Arnault

Cartography by Picto-Carte/Claire Levasseur

Library of Congress Catalog Card Number: 96-86000

Flammarion
26 rue Racine
75006 Paris

French edition: *Tableaux d'Arabie* © Les Éditions Arthaud, Paris, 1996

ISBN: 2-0801-3624-0
Printed in Spain

# A FEW FACTS
# ABOUT SAUDI ARABIA

The Kingdom of Saudi Arabia which covers 865,000 square miles occupies the majority of the Arabian peninsula. Officially proclaimed in 1932 by Abdul Aziz Al-Saud, the Kingdom is a monarchy founded on the principles of Wahhabism, a reform movement that drew its inspiration from most strict of Sunni orthodoxy.

Of all the Kingdom's provinces, the Najd has by far the strongest national identity. This province has always been better protected from outside influences than the peripheral regions, Hejaz and Asir in the west, and Hasa in the east, which were places of passage. The capital, Riyadh, lies in the central region, while the two holy cities, Mecca and Medina, occupy the Hejaz.

In this land, dominated by deserts and steppes, the average annual rainfall is barely six inches. The great southern desert of the Rub al-Khali receives virtually no rain. Asir is an exception, with an annual precipitation of up to 20 inches.

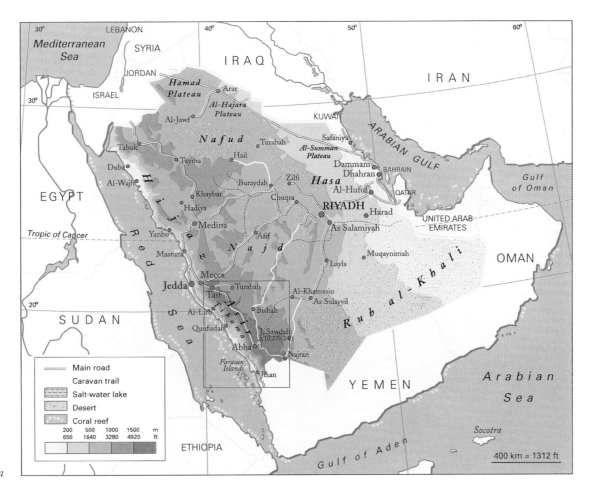

*The Arabian Peninsula*

5

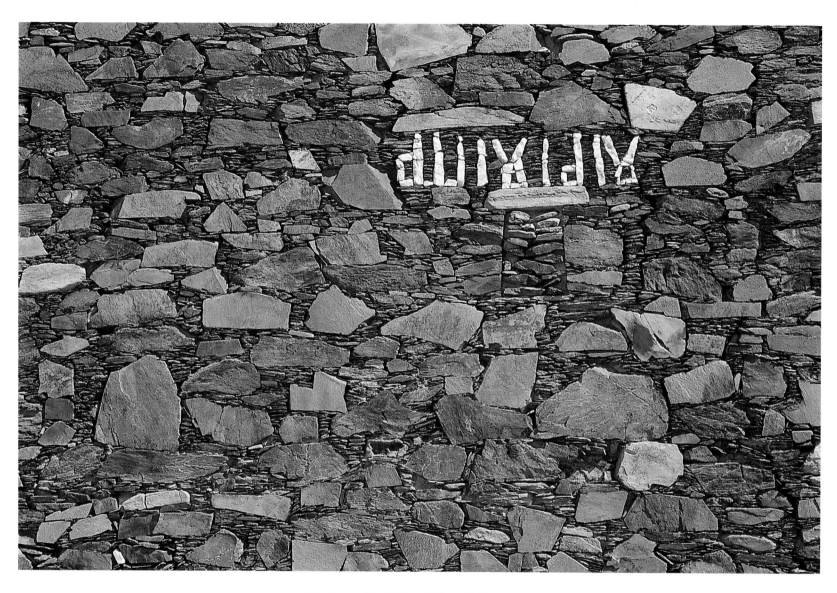

*The first article of the profession of faith*
*(La ilaha illa Allah, "there is no god but*
*Allah") is written in quartz letters on a wall*
*still miraculously standing in a field of ruins*
*(Bal Ahmar).*

# CONTENTS

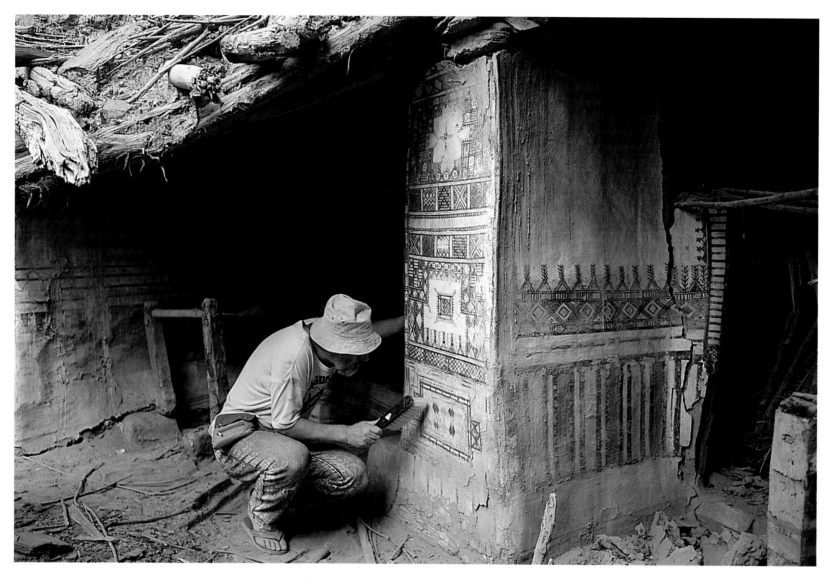

*This outstanding and extremely rare pillar
(*batrah*)*, decorated with natural pigments,
was exhumed by the author, from in between
a ceiling and a floor that were about to collapse
(Rijal Alma, Rijal).*

# INTRODUCTION

## *The Context*

I discovered the Asir region after traveling across Saudi Arabia in search of a diminishing Bedouin culture. In doing so I encountered a very disparate environment: sedentary alongside nomadic lifestyles; tall, polychromed dwellings alongside oblong black tents. I was struck at once by the image of itself that this society wishes to project and how it asserts this control. Architecture, whether built or woven, lives above all in the ideas which generate it and it is thus in these ideas that architecture's dialectic with space is played out.

This book is the result of two surveys conducted in very different conditions with a four-year hiatus. In the first trip, beginning in 1979 and continuing over ten years, I tried to use photography to record a threatened heritage. I did this as a dilettante, with the distance and freedom that characterize the amateur. As such I felt exonerated from the moral imperative which allowed me to photograph Saudi women, a highly taboo subject, and the old houses which had fallen into disfavor through their dilapidation.

My long stay in the area had familiarized me with the local way of life and its values. In front of each house, the shoes at the door and the presence of a car attest to the number and gender of the occupants (since men only are permitted to drive). It is difficult to enter a house uninvited, or without a valid reason. Throughout my stay, I had knocked on doors with a boldness that amazes me in retrospect. My status as a foreigner helped to legitimize my conduct, but I sometimes noticed a glimmer of distrust, as if my desire to visit the house was a pretext to look at the women. The topology of the premises and the host's behavior were equally revealing. The courtyard is the transitional space from outside to inside, and one that increases the distance between the two.

The host made me wait to allow the women time to move to another part of the house. Movement through the household space took place in a process of filtering (moving through the courtyard) and then chanelling (according to sex and degree of intimacy). I often had difficulty in visiting the terrace since it is the private domain of the women, which enables them to pass unseen from shadow to sunlight. It also provides a means by which women communicate with each other across the rooftops throughout the neighborhood.

On my return to France, François Pouillon encouraged me to put my experience to work at the École des Hautes Études en Sciences Sociales in Paris. In joining the academic community, I temporarily left an area that was dear to me, to allow my impressions of the Asir architecture to be consolidated into a fuller, deeper analysis than my first, limited, impressionistic experience had allowed. I had seen enough in Asir to arouse my interest, but too little to satisfy my curiosity. I needed to return. The concern to learn more was accompanied by a desire to track the process of architectural change and development in a region subjected to a host of cultural and political influences.

On my second visit in 1994, at the invitation of the Governor of Asir, Prince Khalid Al-Faisal, I went straight to Riyadh, where I learned that the prince was on vacation at the time. Since I imagined him to be entirely inaccessible, I did not think I might have an audience with him. We finally met through the intervention of a Saudi friend, and the encounter was decisive for my project, as I felt that he understood my intentions. His letter of recommendation granted me rights but also implied a certain code of conduct.

I felt morally bound to the prince. Although he tactfully refrained from asking me directly, I had decided that I would not photograph any women and that my interest lay only in the local architecture. Despite the neutrality—to western eyes—of my project I was questioned numerous times during my work. When I chose a ruined house rather than an opulent residence, this suggested to certain Saudis an intention to denigrate the kingdom. This reticence was just a demonstration that their confidence had often been abused. Nevertheless, in photographing the buildings I sometimes made mistakes in all innocence. For example, I once photographed a curious corbelled structure which was leaning against a wall. The owner protested until finally its function occurred to me: it was an outlet for the latrines.

However the presentation of the letter from the prince usually brought about a change in attitude: if the prince was authorizing me to take pictures, the act in itself must be laudable. My interlocutors felt that I must be lavishly paid for such an idle pursuit, and they often pressed me to continue, perhaps hoping for some gain themselves.

## *A photographic testimony*

Throughout history collectors have plundered whole regions to bring home relics of the past which did not belong to them. As part of the cultural furniture, the houses of Asir and their wall paintings are not in danger of being removed, but they are at risk of falling into ruin for numerous reasons: compromises between conflicting impulses whether physical erosion or a lack of conservational energy. It was therefore important to document them before this happened.

Better than words, photographs bear witness to the wealth and the irrepressible personality of a decorative art. According to André Leroi-Gourhan, "Of all the branches of philosophy, esthetics is the one that is the most difficult to express in words." Photography is an effective recording tool beyond the power of verbal description, depicting a process in action. It introduces a diachronic dimension, revealing the evolution of tastes through transmission, borrowing, and changes of environment. The image thus transcends the theoretical bastions of discourse by physically showing an object rather than describing it.

If there is ever a theme that demands the use of color, it is the theme of this book. The riotous colors of Asir come as a surprise in a country that is dominated by the tones of the desert. No Westerner had ever been able to explore the picture gallery that is the territory of the Sinhan, and I decided to use this opportunity to pioneer a documentary method that would both convey and conserve the authenticity of this Arab culture. I did this, always keeping in mind that photography has the power to capture the essence of a culture, and simultaneously to betray it.

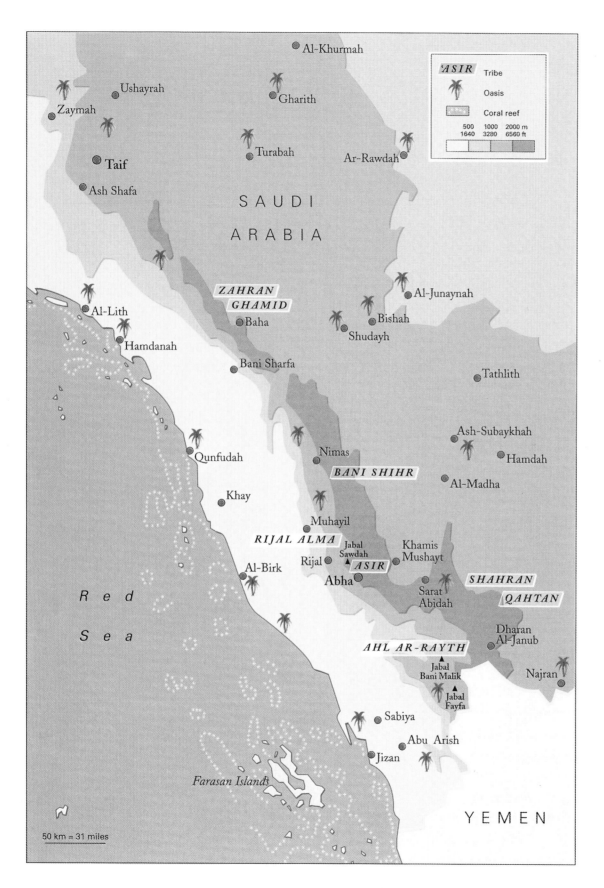

Al-Khurmah

Ushayrah

Zaymah

Gharith

Taif

Turabah

Ar-Rawdah

Ash Shafa

SAUDI

ARABIA

*ASIR* Tribe

Oasis

Coral reef

| 500 | 1000 | 2000 m |
| 1640 | 3280 | 6560 ft |

Al-Junaynah

*ZAHRAN*
*GHAMID*

Al-Lith

Baha

Bishah

Hamdanah

Shudayh

Bani Sharfa

Tathlith

Ash-Subaykhah

Qunfudah

Nimas

Hamdah

*BANI SHIHR*

Khay

Al-Madha

Muhayil

*RIJAL ALMA*

Jabal
Sawdah

Khamis
Mushayt

Rijal

▲ *ASIR*

Al-Birk

Abha

*SHAHRAN*

Sarat
Abidah

*QAHTAN*

*Red*

Dharan
Al-Janub

*Sea*

*AHL AR-RAYTH*

▲
Jabal
Bani Malik

Najran

▲ Jabal
Fayfa

Sabiya

Abu Arish

Jizan

*Farasan Islands*

YEMEN

50 km = 31 miles

*Southwest Saudi Arabia*

# ARCHITECTURAL BACKGROUND

## *An atypical region*

The name Asir is part of a complex reality that includes geographical areas differing in size and content dependent upon different periods in history and prevailing ideologies. It describes the heartland of this area and the seat of a confederation of highland tribes centered on the town of Abha, as well as the entire southwestern area of the country and one of the fourteen provinces of the kingdom established by King Faisal.

With its awe-inspiring landmarks, its dense woodlands and the delicate coolness of its mountain peaks, Asir differs dramatically from the typical Saudi landscape. The diversity of the climate and altitudes allows for the cultivation of a wide variety of crops, from tropical and sub-tropical produce to the fruit and vegetables of temperate regions. "This could have been the site of the Garden of Eden," wrote St. John Philby, who in the 1930s was commissioned by King Abdul Aziz to draw up a map of the southern reaches of Asir.

The entire Southwest differs from the rest of Saudi Arabia in that it has a highly structured relief, which can be divided roughly into three ecological zones. Facing westward,

*Section of Asir landscape showing relief and architectural features*

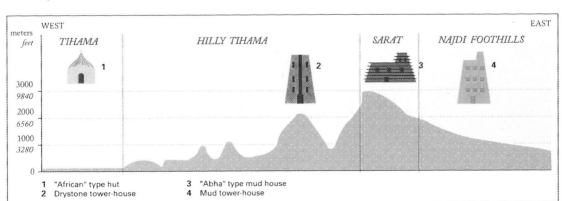

| | |
|---|---|
| **1** "African" type hut | **3** "Abha" type mud house |
| **2** Drystone tower-house | **4** Mud tower-house |

along the Red Sea, is the coastal plain of Tihama,[1] hot, humid and swept by salt-laden breezes. The area closest to and most influenced by Africa, it is occupied by a black population who subsist by farming and fishing. This coastal plain abuts a mountainous barrier called Sarawat, where the highlands (Sarat)[2] peak at an altitude of over 10,000 ft at Jabal Sawdah. These mountains retain the rainfall brought by the northwest winds in winter and by the southwest monsoon rains in summer. Farmers cultivate the land on the terraced slopes. Facing eastward, the Sarat highlands drop gradually to the Najdi foothills. On one side are the sedentary farmers of Sarat, and opposite them on the fringes of the Rub al-Khali are the nomadic Bedouins.

These sharp contrasts between lowland and highland, between populations without a tribal tradition and highly structured tribes, between a region of high rainfall and an arid zone, between sedentary farmers and nomadic Bedouins do not offer the whole picture. Toward the sea, the Tihama landscape is a sequence of ridges. At twilight these appear as a graduated series of transparent blues, a delicate monochrome in which the distance is denoted by differing shades in the landscape. One can make out these barriers, rising from the hilly Tihama, which is inhabited by nomadic goatherds, while hard-working farmers live in the isolated mountain areas.

## The tribal distribution of space

Although a farming community, the rural population of Asir has preserved the tribal structures of the desert. The tribes are organized in related hierarchical units. There is a close correlation between the division of the tribal territory (*dirah*) and genealogical fragmentation.

The tribal groups are organized on three levels: *qabila*, *batan* and *fakhdh*. Metaphorical correspondences between these levels and the human body underlies the semantic value of the whole and its parts. No specific term exists for a confederation, which is exclusively designated by its eponym, for example, the Rijal al-Hijr. The tribes, such as the Zahran, or the tribes gathered in confederations, such as the Bani Shihr for the Rijal al-Hijr confederation, bear the name of *qabila*-s. They are made up of factions called *batan*-s, for example the Bani Bishr of the Qahtan tribe, and the former can be considered as a major lineage, represented by the metaphor of the abdomen, which supports the upper portion of the body. Each faction is divided into sub-factions called *fakhdh*-s, for example the Al-Suman, which is a sub-faction of the Bani Bishr, who are themselves a faction of the Qahtan tribe. The *fakhdh* is a minor lineage, represented by the metaphor of the thigh, a segment of the lower portion of the body. The *fassila* is the smallest lineage, represented by the metaphor of the legs and feet, the lowest portion of the body on which

the entire tribe is supported. This comprises an extended family, consisting of nuclear families or *usrah*-s.

Major tribal confederations cover Asir from north to south. Looking at a tribal map of Saudi Arabia, one is struck by the fragmentation of the tribal territories of Asir, as opposed to the vast and continuous territories of the nomadic tribes of the Najd: the apparently structureless space of the latter contrasts with the highly structured space of the former, in which the mountainous scarps have added to the complexity and the fragmentation of the tribal system.

The large tribes scattered over Sarat have been geographically fixed since the tenth century A.D. In his description of Arabia, Hamdani gives their distribution, but without mentioning their territorial limits. Today these tribes are still in the places they formerly occupied. The centrifugal dynamic can be identified by one principle: the largest tribes occupy Sarat, spread across one or both of the foothills, and they feature both sedentary and nomadic segments.

The expansion of the population in the heart of the highlands forced the people on the periphery to move from agriculture to herding, and they eventually became desert nomads. The westward thrust probably occurred for similar reasons. Tribes have occupied the western Sarat foothills from the earliest times. These early settlers were expelled, or absorbed, by stronger tribes who occupied Sarat, and who were eager to take advantage of their complementary agricultural and pastoral resources made possible by these two ecological zones. This is illustrated by the annual migration between the foothills, which are too hot in summer, and Sarat, which is too cold in winter, through mountain passes locally called *aqaba*-s. It is no accident that the most powerful tribes are spread over several ecological zones, such as the Zahran, the Bani Shihr, the Asir and the Qahtan. The expansion of their territories into the foothills was accompanied by the fragmentation of the hilly Tihama into separate territories: Tihamat Zahran, Tihamat Bani Shihr, Tihamat Asir and the Tihamat Qahtan.

Markets are often located at the border between two ecological zones to take advantage of economic exchange. Beyond this activity, the Sarat tribes have obviously tried to control the main access routes to the sea in order to maintain their supply of products from Africa. Abha was linked to the port of Jizan by Wadi[3] Dhilah. The historical importance of Rijal, in Rijal Alma, is due to a privileged situation which enabled it to control the route between the port of Qunfudah and the Asir highlands.

Hilltop watchtowers, the ones that control the approaches to the different ecological zones, defensive midfield towers and fortified granaries[4] reflect factional conflicts. Thus Asir's villages without exception were originally installed in a genuine defensive situation. Many locals felt that this military style of architecture reflected the tribal anarchy, synonymous with endemic violence, disorder and insecurity—experiences which are still fresh in their memories.

Following page:
*Despite its tall houses, now in ruins, set up the side of the slope like an amphitheater, Rijal is still attractive.*

Pages 18–19:
*All inhabited areas have been constructed: the houses, of course, but also the farming areas, with terraces built both to suit needs and to be more efficient (Jabal Bani Malik).*

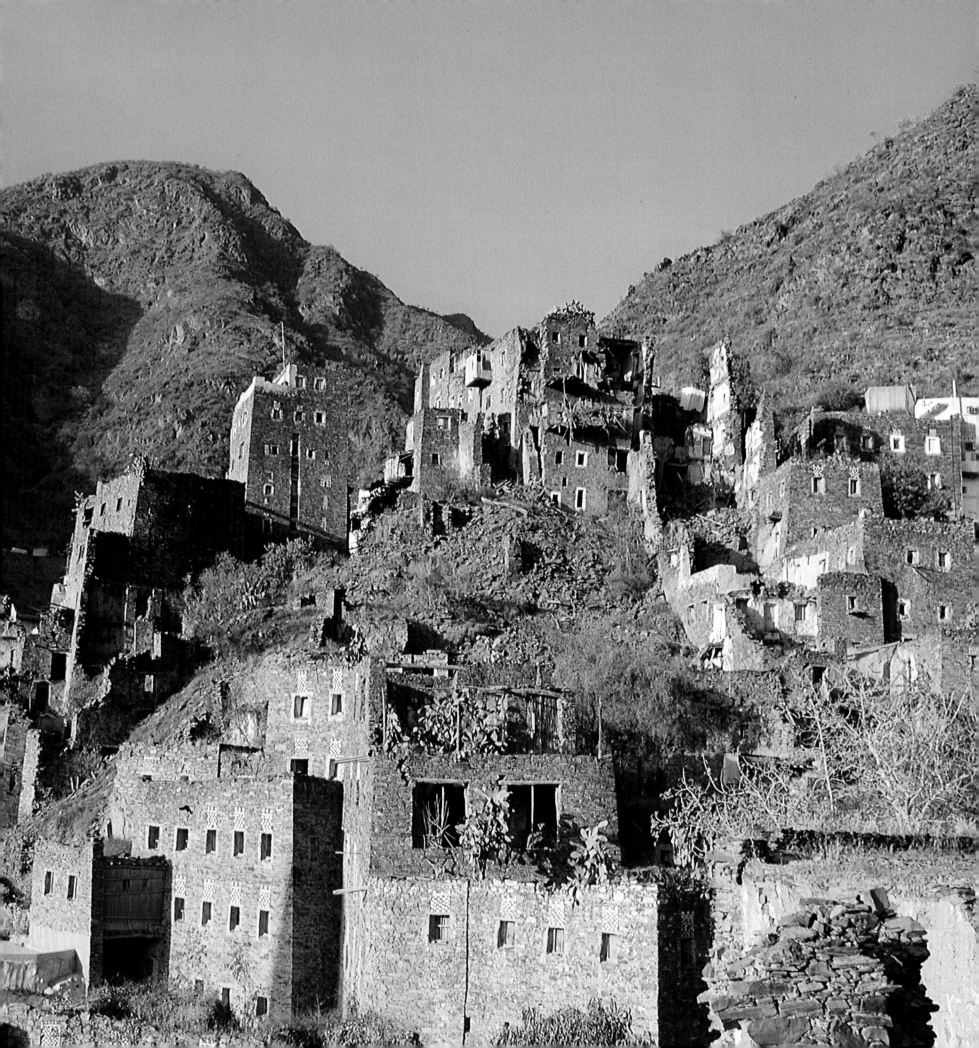

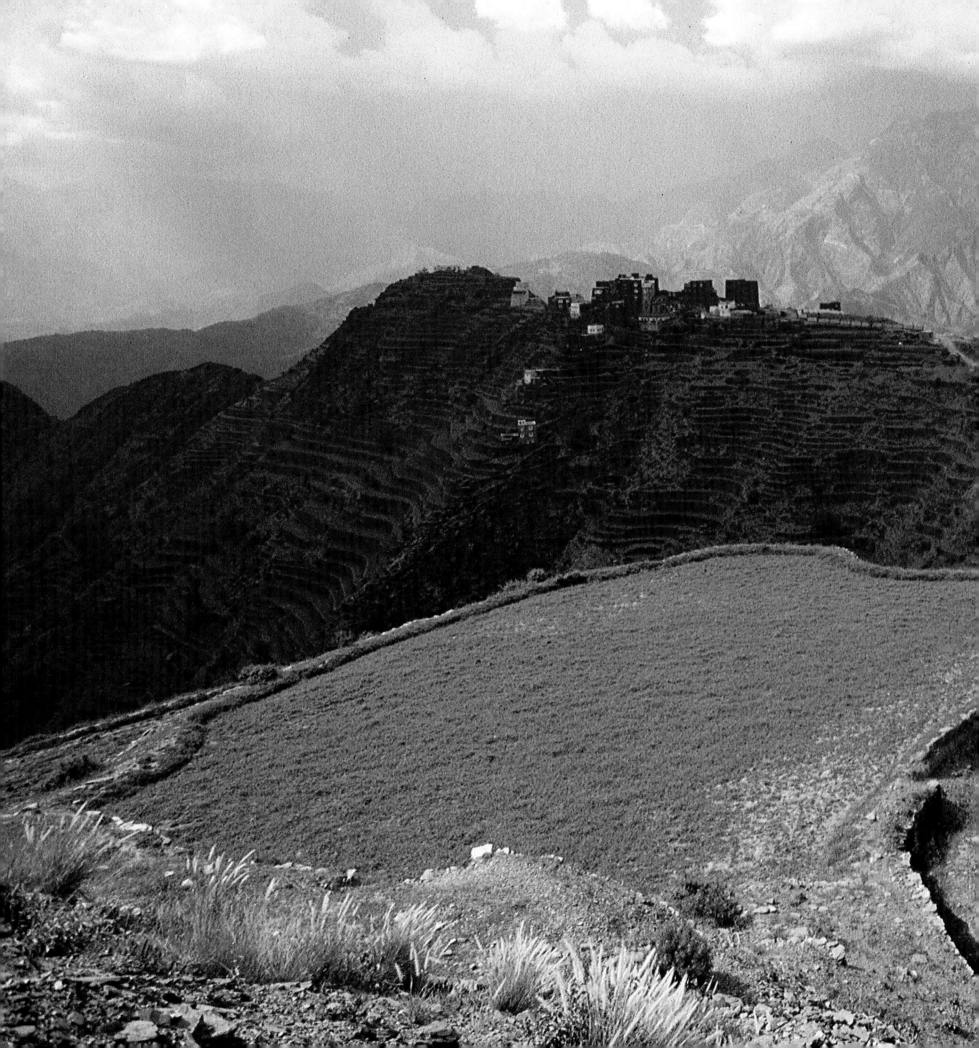

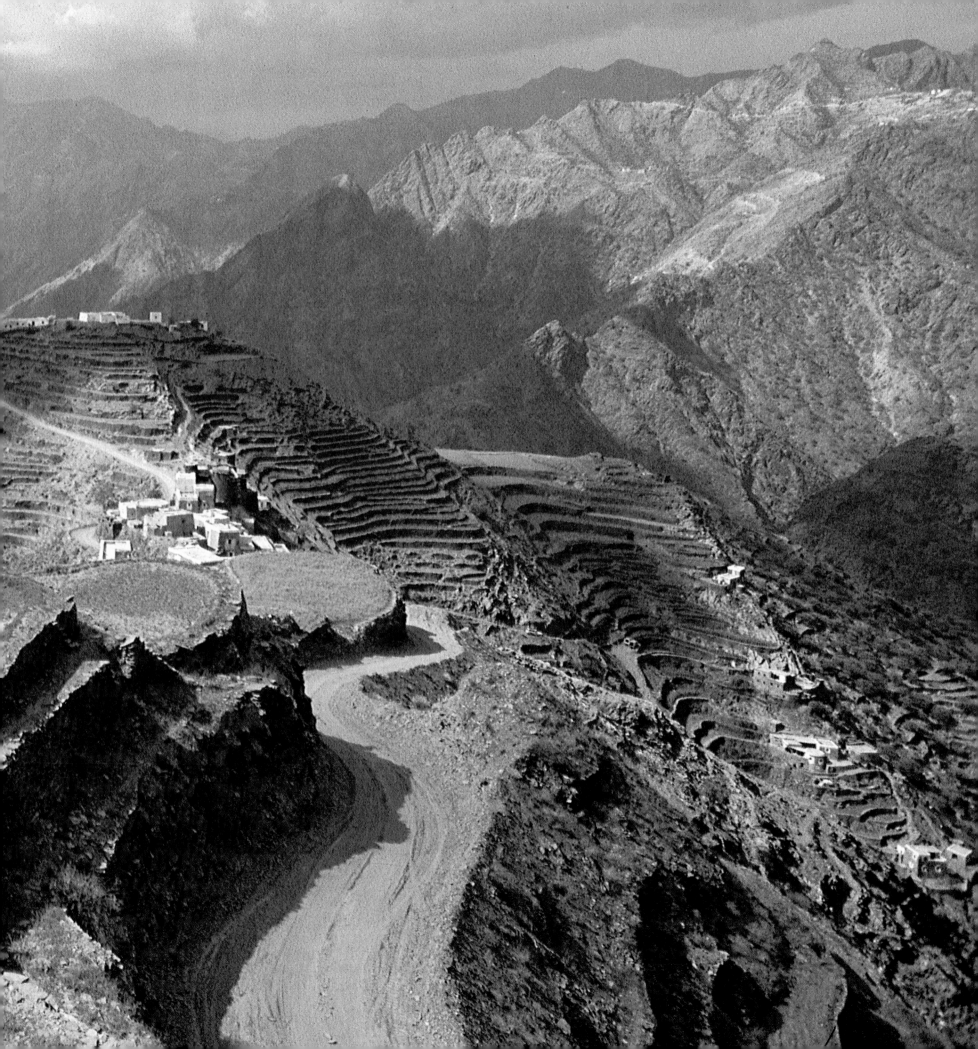

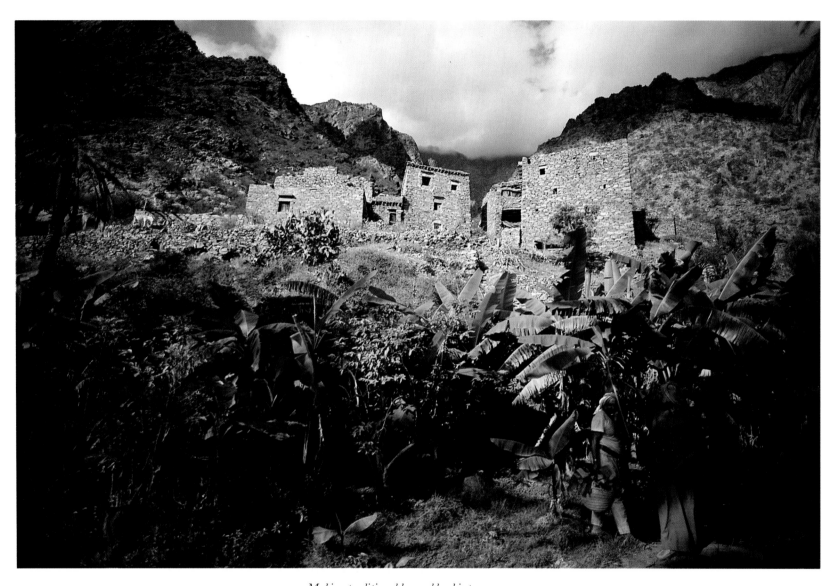

*Making traditional houses blend into
the natural environment can be explained
by naturalistic arguments: doesn't this hamlet
behind a curtain of banana trees look like
something coming out of the mountain?
(Tihamat Zahran).*

# AN EXEMPLARY ARCHITECTURE

## *Architectural variability*

If architecture is an important means of identifying a cultural area, the architecture of Asir is especially significant. It has achieved a form of expression that is so distinctive that even a cursory glance can identify its harmonizing characteristics. The region's architectural styles are organized in a pattern that demands further enquiry.

This region with dramatic variations in topography allows the definition of architectural areas within which individual differences are maintained while limited by a common style. Beyond the typological record, we cannot escape the question of the meaning and the function of these inventive forms. They appear to proliferate, as if gratuitously self-generated. Building a house requires an encounter with a material whose properties demand the recognition of architectonic laws, and an esthetic tradition that dictates its style. Hence there are various solutions to the problem posed by technical limitations. Each style fits into an inventory of possible forms originating from a tradition rooted in history, the product of several interacting cultural influences.

Taking the building material as a major criterion highlights the variations caused by climatic constraints. The drystone tower-houses (*husn*-s), built on a square plan, characterize the scarp land which receives heavy rain from the mountains on the western slopes of Sarat up to Abha, and the hilly Tihama. The walls taper towards the top of the buildings, and the windows are often reduced to vertical slits. Jabal Bani Malik and Jabal Fayfa, on the border with Yemen, display fine examples of terraced landscapes, built on slopes that are normally too steep for cultivation. They use more stone than would ever be needed to build houses. Anchored on the rock foundation, the retaining walls are raised using stone blocks extracted from the slopes or from the substratum. Stairways connect one terrace to the next, and are pared down to a few ledges projecting from the walls. Not many regions give such a strong impression of agriculture practised as architecture. The tall slate houses of Jabal Bani Malik are grouped together in fortified hamlets in a labyrinth of tangled tracks. The tower-houses of Jabal Fayfa are drystone structures on a circular plan with external ledges embedded in the walls serving as stairways from one story to another.

The mud houses[5] of the "Abha" type (*husn*-s) are found mainly in the capital of Asir. They extend to Bilad Shahran[6] around Khamis Mushayt and Bilad Qahtan around Sarat Abidah, which are the areas of highest rainfall.[7] The main weakness of mud architecture is of course its vulnerability to water, and particularly at the base of the walls where erosion ultimately causes the house to collapse. The preservation of mud houses is based on the principle of "good boots and a good hat," that is, a drystone foundation that raises the mud and protects it from soil erosion, and consecutive rows of shale (*rakaf*) embedded in the walls at regular intervals. These individual slates overlap slightly, encircling the masonry and descending to the top of the base to keep dripping rainwater away from the walls. The projecting slates give their structures a forbidding appearance, and a strong sense of individuality. The houses are seldom more than three stories high, and their windows are small and square. The walls are uniform in appearance without ornamentation, though a window is occasionally embellished with a colored border.

A drive along the expressway between Abha and Khamis Mushayt, which are about twelve miles apart, reveals the change in architecture. As well as the difference in altitude between the two towns—7200 ft and 6500 ft respectively—there is the fact that Khamis Mushayt is offset from the escarpment. Beyond the ridge, which acts as a barrier to humid air, the climate becomes arid: this is an area of mud tower-houses (*husn*-s), which are widely distributed throughout the Najdi foothills because of the unchanging climate and the need for defensive construction.[8]

On the oldest mud houses, fragments of quartz are used in between each layer, thus demonstrating the technical link between structural and decorative elements. This suggests the existence of a direct lineage from the "Abha" type houses, where projecting slates are used in place of decorative quartz to afford protection from the rain.

The mud house probably extended from the south, until it came into contact with the stone houses north of Abha.[9] A differentiation took place in the form of a technical addition—projecting slates—due to the climate as a modifying factor. It is, in fact, not uncommon to find a mixture of stone and mud in the same structure, stone predominating north of Abha and mud in the south. If the walls have been limewashed,[10] it is difficult to identify the materials. However, the presence—or absence—of projecting slates is the best clue as to whether the house is built of mud or of stones.

Huts of the "African" type (*ushsha*-s) are scattered on the Red Sea coastal area and the banks of the east–west flowing wadis, which swell with the rain falling on Sarat. A conical or ovoid roof, made of sorghum straw set in a rope lattice, tops a cylindrical structure of branches filled with cob. The shape of the roof is determined more by the material than by the climate: the vegetal nature of the the roofing material expresses links with an economy based on cereal crops and the steep slope of the conical roofs prevents deterioration of the straw from damp.

## Architectural dualism

Cultural as well as natural influences have resulted in clearly differentiated architectural forms. Two major types of traditional dwelling can be found in the Southwest: the Bilad Ghamid house and the Yemeni house. These two architectural poles circumscribe the heartland of Asir. Bilad Ghamid is part of the southern Hejaz between Asir and the rest of Saudi Arabia. This separation is not artificial: all along Sarat, the region of Nimas (Bilad Rijal al-Hijr) forms a pass between the highest parts of the Abha region to the south and of the region of Baha which includes the area of Ghamid (Bilad Ghamid) and of Zahran (Bilad Zahran) in the north. A striking contrast to the Arab house[11] can be seen: the windows open outward, and four families can live in adjacent dwellings, the latter arranged around a central axis and interconnected, each having its own private space. This architectural distinction precisely matches the geographical difference between the Hejaz and Asir.

The Yemeni house is found from Bilad Rijal al-Hijr to Najran. Its most salient feature is its vertical structure: the animals on the ground floor, the men on the first floor, and above them, the women. Each group of living beings is thus kept separate from the others. This distribution of space by story can be explained by obvious functional reasons: the ground floor is readily accessible to the animals, and the top of the house must include the kitchen to facilitate the removal of smoke and smells. The women who inhabit this story can also take advantage of using the terrace without being seen.

## The southarabian[12] influence

Beyond the undeniable architectural continuity between Asir and Yemen we can juxtapose Asir with the former North Yemen to highlight the distribution of the different types of architecture, and here we find a certain diversity within unity, comparable to what is found separately in each country. The tall mud houses of Saada have a clear link with those of the eastern foothills of Asir. Tihama reveals a corresponding architecture: the coastal plain, whether on the Yemeni side (Tihamat al-Yaman) or Saudi side (Tihamat Asir), has given rise to the same type of hut.

The southern Arabs can be distinguished from the northern Arabs by their sedentary way of life, based on lucrative farming. Their tall solid architecture is found from Asir to Hadhramaut, where it reaches its most ostentatious expression at Shibam, which Westerners have called the "Manhattan of the desert."

In view of the state of anarchy and insecurity that prevailed in Asir until the Wahhabi conquest, the verticality of the houses has been attributed to a military origin and function. According to Kamal Abdulfattah, verticality is a response to the need for defense. The tower-house also incorporates elements designed to reinforce its defensive capacity: a single entrance doorway and a first level that is windowless or perforated only with small openings. While verticality is extremely important in this region for protection, different solutions exist elsewhere. In the Najd the house, or group of houses, is protected by fortifications. In the southern Hejaz, the houses themselves are joined to each other to form a wall; the villages are situated on the hilltops and are dominated by watchtowers. When they occupy a slope, the houses are built in order of ascending height to form a kind of defensive cluster.

When this defense was rendered unnecessary after the *pax saudiana* (after King Abdul Aziz Ibn Saud unified the tribes and brought peace to Arabia in the 1930s), the tendency was to build houses closer to the fields and to allow access to cars, and linked to this was the loosening of the architectural fabric in general. Motor vehicles too have altered the spatial relationships between the buildings, resulting in less densely packed clusters of housing.

Symbolism too continues to be an important bearer of ancient values, even when the symbols no longer correspond to any reality. For example, verticality continues to characterize the buildings, despite the demise of its defensive function. It may seem a flight of fancy to link architectural verticality with the defensive requirements of the same context if one did not recognize one surprising continuity. There is no symbolic break between the defensive verticality of the tower-house and the need to arm oneself. The photograph of a warrior farmer armed with a rifle and the photo of a tower-house produce one and the same image, as if the man could measure his uprightness by comparison with the house. In a society that exalts honor, it behoves the tribesman to project the most flattering image of himself: the hieratic and rigid pose, as if standing to attention, proclaims this intention.[13] Experience shows that the warrior is always reluctant to crouch, as this would diminish him both physically and figuratively. This structural homology between regions (Sarat/Tihama), architectural types (vertical/horizontal) and postures (standing/crouching) reveals a constant relationship between different areas of expression. It appears obvious that the high/low opposition underlies a hierarchical principle based on verticality.

Some houses possess features indicating the owner's membership of a precise social order, the rank of chieftain being at the top of this order. Some architectural forms are deliberately ostentatious: other houses are taller, and have a periphery wall flanked at the corners with towers and a monumental entrance, though the whole village may be fortified.

Certain decorative motifs have a significance which draws on their relation to the use function of their media. House decorations, like body marking, enables the group, or

each of its members, to express a collective or individual identity. Among the tribes of Asir and Rijal Alma, the immutable whiteness of quartz makes it an ideal choice for the openings of the houses. Lanceolate motifs framing the windows are a recurrent theme: the symbol of the spearhead (*ramh*) expresses the inviolability[14] of the premises. This motif is repeated on loincloths, and on some of the monoliths of the temple of Athar, which stood near Qarnaw, the ancient Minaean capital. In Yemen, plaster washes on the façades also use this motif. All this points to a remarkable continuity. The dagger, more difficult to depict than the spearhead, appears in the uppermost part of a watchtower that surveys Wadi Us in Rijal Alma. Some new houses have adopted this motif in the ironwork decoration on their façades and doors.

The idea of defense as an explanation of the verticality of these houses that distinguish themselves throughout the Kingdom from the generally low level of housing, is however far from sufficient. The vertical architecture may also be seen as expressing the civilization of a region of builders, a brilliant demonstration of their skill in mastering construction in the third dimension.

This architectural tradition is probably quite ancient, possibly preIslamic. When Hamilton described his difficulties in interpreting the building that he excavated at Shabwa in 1938, Sir Leonard Wooley suggested that the wall bases were the foundations for much higher buildings, similar to the traditional tower houses of Hadhramaut. This type of house, which appears to have emerged in the early southarabian period in the Sabaean region, was still current in the fourth and fifth centuries A.D.

For archaeologists, it is paradoxical that the tower-houses had been maintained inside a town as solidly fortified as Shabwa. The creation of the large defensive enclosures should have made individual systems of protection unnecessary. It is conceivable that the fortifications were unreliable or that the houses represented the continuation of a type of traditional dwelling that predated the building of the fortified towns, dwellings made superfluous by the arrival of collective means of defense. Jacques Seigne suggests that the tower houses symbolized a social status, and this appears to be confirmed by the few building dedications that have been deciphered: they show that these houses were designed for family use, generally built with royal approval. Hence it seems unrealistic to promote one reason as the cause of this verticality. The defensive value of the tall houses, the weight of architectural tradition and the prestige that they conferred could explain their dissemination throughout the regions of Yemen on the fringe of the Ramla as-Sabatayn Desert.

The tall mud houses of Shibam have an evocative power that challenges our rationality. This verticality is sometimes traced back to the Babylonians,[15] a hypothesis that would be implicitly substantiated by the use of unfired, sun-dried brick (the adobe[16] technique), already familiar in Mesopotamia. But, without necessarily endorsing the idea that this Babylonian skill inspired by the myth of the Tower of Babel, this connection remains unavoidable if not provable.[17]

Archaeologists are often faced with the problem of having to reconstruct hypothetical structures from these vestiges: but such structures must remain notional and do not constitute hard evidence. Other material factors raise further questions about the relationship between Babylonians and South Arabians. For example, the swing-plough, which is still used today throughout southwestern Arabia to accomplish simultaneously tilling and sowing, is one of the earliest farming instruments. Many authors have analyzed the form and uses of this tool without drawing any firm conclusions. Nevertheless one might suggest further links between the vertical thrust of the architecture of ancient Mesopotamia and present-day Southern Arabia. Although the search for analogies "at any price" has often led to misinterpretations, one cannot exclude the possibility that this search has a basis, insofar as it depends on cultural contexts which show a mutual continuity and which have actually been proven and are supported by archaeological findings.

Another consideration is the use of space. In urban environments, the quest for height often originates in areas where there is a shortage of land. The reasons for verticality in a rural environment are obviously not the same, as horizontal expansion can proceed usually without difficulty. Yet a number of cases invalidate this claim. In Shibam—an excellent example—the builders obviously tried to make the best use of the space circumscribed by natural constraints: the town is built on a mound in the middle of Wadi Hadhramaut, whose floods can be devastating. No extension of the town was possible,[18] and later it became necessary to build another town opposite. At Jabal Bani Malik and Jabal Fayfa, the concern to minimize the encroachment upon farming land—acquired with difficulty by building mountainside terraces—led to the construction of multistory houses. The problem of cereal storage also lends weight to the choice of verticality, since storage of the harvest requires a protected granary. Where this does not exist, the granary becomes an area of the house sheltered from light but with proper ventilation, generally on the first floor.

According to Ibn Khaldun, the sedentary population built taller houses as their living conditions improved. Until recently the Yemeni dwelling was closely linked to considerations of social status. The princely palace of Ghumdan, built according to Hamdani in 25 B.C. is an example of this ostentatious show of wealth; its 20 stories were an impressive sight for early Muslim travelers. Despite the absence of any spatial limitations, multistory buildings, clearly visible in Riyadh since 1973, are a mark of prestige and success. The two towers of the Saudi Arabian Monetary Agency and the Saudi Development Fund in particular glorify international financial power and were built to match the ambition of the Saudis. "It is highly significant," says Pierre Bonnenfant, "that the adobe houses [of Riyadh] are often called people's houses, *bayt shaabi,* an implicit reference to an élite mixed with an attitude of disparagement towards adobe." The same expression is used in the Rijal Alma to contrast the low house, *bayt shaabi,* with the tall house, palace or *qasr.* Both are deeply inscribed in a hierarchical relationship, but determined by the criterion of height.

Lucien Golvin rejects the Babylonian hypothesis and agrees in part with Ibn Khaldun, declaring that the proliferation of stories appears to correspond with increased income or the expansion of the patriarchal family. By comparing the increase in verticality with the horizontality of the houses of Bilad Ghamid, one can again see that other solutions exist.

While the horizontal lifestyle favors interaction and freedom of movement, a vertically oriented house reinforces hierarchy and competition. As he climbs the stairs, the master of the house symbolically expresses his role as the unifier of the family. In Yemen, and, more precisely, at Sanaa, where this architectural type was created, this metaphor is confirmed. The patrilineal relationship is associated with patrilocal residence. Contrasting values are assigned to the multistory principle: the high and the low, the pure and the impure. In this hierarchy along a vertical axis, each floor has a specific role: the ground and the first floor are reserved for the livestock, for animal feed and for storage. The second floor is devoted to the servants and the food stocks. The third, fourth and, (depending on the size of the house) fifth floors, are reserved for the women and children. On the top is the floor for men. Today these functions have been restructured—each domestic unit of an extended family is isolated to create a small family unit on the Western model—but the vertical principle remains crucial. The different floors, traditionally in a complementary distribution, have thus become self-contained dwelling units. At some stage in the future, one particular domestic unit can change its location of residence. This movement is a result of a break in the traditional living patterns, greater mobility dictated by employment, and the desire to relax communal obligations and gain greater independence.

These detailed considerations of the importance of verticality in architecture contribute to a complex, nuanced picture. Thus the quality and height of the buildings of Rijal, the capital of the Rijal Alma confederation,[19] reflect the importance of the area. Its inhabitants describe nostalgically the time when the town held power throughout Asir. While the town is situated in the middle of a valley that limits its expansion, it is also positioned at the heart of a fertile area framed by terraces with coffee plantations. Rijal exported clarified butter (*samn*), hides, and gum, and sold arms and ammunition throughout the area. Controlling the passage between the port of Qunfudah and Sarat, this trading center was also a transit point for foreign goods. This prosperity explains the scale of the houses that accommodated both storage areas and extended families, and whose expansion meant the addition of up to five stories. The defensive argument is thus challenged by the native inhabitants, and the houses of Rijal seem to substantiate all the other hypotheses for explaining their height, except the most common.

An attempt to identify the principles underlying the concept of verticality shows that its axiomatic value lies only in the sharing of functions and varies with context. Taking into account the information collected by the archaeological projects in Yemen and the actual facts, one can conclude that the tower-house is a permanent reference to the southarabian civilization.

The style and decoration of the house are closely linked. Nothing is more foreign to Islam than the traditional concept of a façade; unlike the prominence attributed to façades facing the street by Western architecture, the Arabian façade is usually closed to the exterior and turned inward. Thus an austere type of construction has developed in the Wahhabi Najd, where it would be almost impossible for visitors to come across a decorated wall. Only on the rare stucco ornamentation can one distinguish a subtle play of light and shade. Windows and doors are necessary concessions, but tend to be reduced to their simplest expression, and limited to the *majlis*, the men's reception room, and a few ventilation openings, placed high up in rooms such as the kitchen. By contrast, the entrance door, often very elaborate, of chiseled, sculpted or painted wood, depicts the "face" of the house,[20] revealing the wealth of the inhabitants. A parallel to this austerity of façade can be found in the feminine costume imposed by the Wahhabi Najd: the black *abaya* dilutes and blurs the shapes of the female body. Veiled, the women disappear into total anonymity. It is easy to see in this a generalized apprehension that hampers any tendency towards distinction, individuality and originality.

This is not the case in Asir, where the façades demonstrate a rupture of style with the austere tonalities of the Najd. Windowless façades and veiled women in the Najd contrast with open façades and unveiled women in Asir: stark austerity on the one hand, exuberant ornamentation on the other. By comparison with the practices of the Najd, this style seems scandalous.

It is usual to attribute the same values of identification and usefulness to all manner of markings, despite the diversity of techniques and media. The decorated façades relate not to a tribal but a regional code, and their formal details are determined by the materials available. In the southern Hejaz, a quartz frieze, consisting of juxtaposed triangles, decorates the buildings. In Tihamat Asir, the black and white checkerboard patterns of light and shadow dominate the doors and windows. It is tempting to see in these checkered patterns a representation of magic squares. In the Asir, the quartz fragments are arranged in geometric patterns on the stone façades, while they are placed randomly on the mud walls of the Qahtan to break the uniformity.

A strong link exists between the tattoos of the women and the façade motifs, both of which have lost any apotropaic function. The most effective illustration of this can be seen in the Sinhan division of the Qahtan tribe. Against the *grisailles* of Arabia Petraea, some houses set their painted façades, a paradoxical fertility of colors against a background of unrelenting harshness.

There is some similarity between these painted façades and the masks worn by the Bedouins of the Southwest: both display the same contradiction. Inevitably one associates the screen formed by the mask with the desire for concealment, and its ornamentation with the desire for display: it attracts while at the same time establishing a distance. To conform to the standard imposed by the Wahhabi Najd, the masks too are plain, without embellishment or regional distinctions.

The special care paid to the treatment of the openings suggests protection against the erosion caused by rainfall. The practice of painting façades also adds a textured dimension that is echoed in clothing. The openings are gaps that can be compared with the sleeves, shirt front and lower robe, and slits for the eyes in the case of the mask. The layout of embroidery obeys very specific rules: it recalls that the openings must be protected, because it is through them that evil spirits can enter the person. Similar treatment is applied to the doors and windows, and even the terrace of a house. The essential purpose is to thwart the attempt—the temptation—of the *djinns* to enter through one of these openings. Consequently the number of windows must be limited and their size reduced.[21] But this explanation is not enough—these small openings do not endanger the structure of the walls which are in themselves unstable because of their building materials. Other factors determining the size of the windows are involved, such as thermal insulation, protection against intrusion[22] and the concealment of the women. The latter dictates the fact that the shutters are indoors and folded on to the window openings.

Many façades display a hierarchy between openings of different sizes and positions: the openings are absent at lower levels, they appear as ventilation slits and light diffusers slightly higher, as modest windows on the upper floors, and as bay windows for the uppermost *majlis*. This progressive enlargement of the openings with height is associated with the function attributed to each floor and is compatible with architectonic requirements.

"The simple placement of the door and windows on the façade of the house is as varied, as unexpected, as captivating as the features on the face of a man," Le Corbusier observed. The builders of Asir are concerned with achieving organic balance rather than symmetry. The distribution of the façade elements is not uniform, but it avoids a predictable arrangement of the openings and gives the building a dynamic energy.

Najran is the southernmost bastion of the Wahhabi Kingdom. Some elements of the façades here show a particularly strong Yemeni influence: while stained-glass windows are commonly used in Najran, they do not appear in the rest of Asir. The use of alabaster window panes, or oculi, the antecedents of stained glass, is said to have been introduced into Yemen through trade with Palestine, particularly with Jewish craftsmen, nearly 600 years ago. The traditional alabaster has today been supplanted by glass, in a flamboyant spectrum of red, green, blue, yellow and white. The motifs include circles, rosettes, stars, plant motifs and the seal of Solomon.

Ibex horns—preIslamic signs and symbols[23] of prestige—ornament the corners of certain façades, and this practice is still common in Yemen.[24] On returning from the hunt, the men offer the horns of the animal to the village chieftain to be displayed at the corners of his house. The persistence of ibex horns, together with stained glass, are the distinguishing features of the Najran façades.

If all presentational efforts are focussed on the façade of the house, there is automatically an opposite value to be assigned to the space behind, where esthetic codes are

relaxed. Greasy papers, tin cans and animal scraps mark out the rear of the house and reveal the living standards of the owner. The opposition of front and back is thus linked to the contrast of clean and dirty.

# African influences

Theodore Prochazka remarks that the inhabitants of the hilly Tihama are more closely related to those of Sarat than to the coastal population, as confirmed by the architecture. It seems certain when one untangles the web of relationships between the different tribes. Non-tribal populations live along the coast. They resemble Arabs so little that their origin cannot be doubted: Africa has taken root in this region on several occasions. Historians generally recognize the occurrence of three Abyssinian invasions, the first two in the third century B.C. and the third in the sixth century A.D. The populations living in the African type huts have descended from the Abyssinians, or from the freed slaves of Sudanese origin, such as the Al-Sabiya of fictitious tribal origin. Lacking a tribal link, these populations established a solidarity based on a common origin.

Unsurprisingly African style huts are found between Qunfudah in Saudi Arabia and Zabid in Yemen. This geographic continuity partly explains the absence of cultural fragmentation and the spread of architectural practices from the same source. Alongside these huts are the houses in the style of the palatial complex of Al-Idris, partly embedded in the sand. Some of the latter exist at Sabiya and Jizan, and also in the Farasan Archipelago. Their façades, pierced with one door and two windows, are covered with *bas reliefs* made from stucco, carved with floral and geometric motifs. Importantly they are located in a region that was once controlled by the Al-Idris dynasty, which originated in Fez.

Less clear is the African connection with the domed huts[25] found in the hilly Tihama and still widespread in Qahtan and Ahl Ar-Rayth. Situated at the intersection of Sarat and Tihama, the former are genealogically associated with the Qahtan of the high plateaux, while the latter are exclusively from Tihama. Both are undoubtedly Arab, and share the same material culture. The domed houses are spread among the herding populations of the Horn of Africa, such as the Masai, Oromo, Afars, Danakil and Bedja. To make any connections, technical processes must be identical, while variations—that is the different ways of producing similar huts—are shown in the materials and working practices. Formal relationships on the one hand and differences in execution on the other show that similarity is not identity. If one rejects the African influence, the idea of choice signifies nothing more than the almost tautological proposition that an architectural type emerges and is adopted because it is compatible with a whole series of elements within a totality.

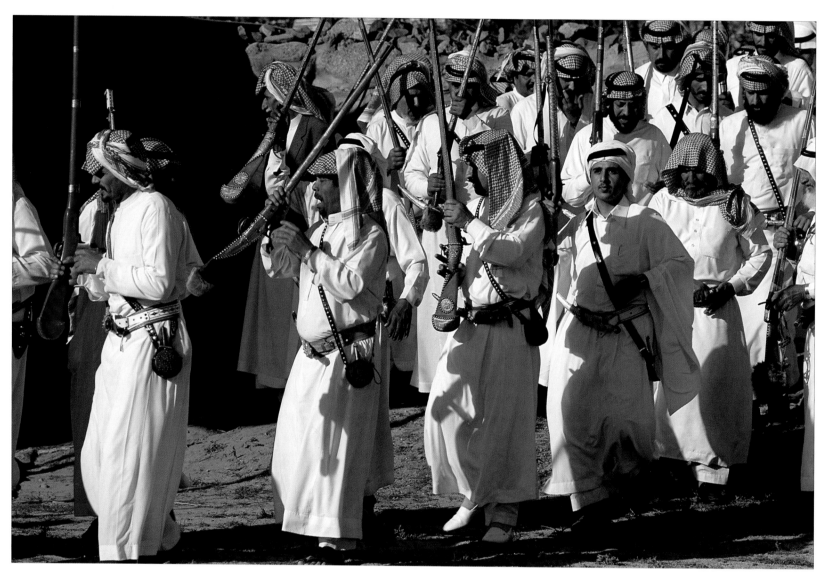

*There is no symbolic breach between*
*the defensive aspect of the watchtower*
*and this martial dance. The soaring height*
*of the construction and the straightness*
*of the rifles draw the same shape*
*(Bilad Qahtan, Bani Shihr).*

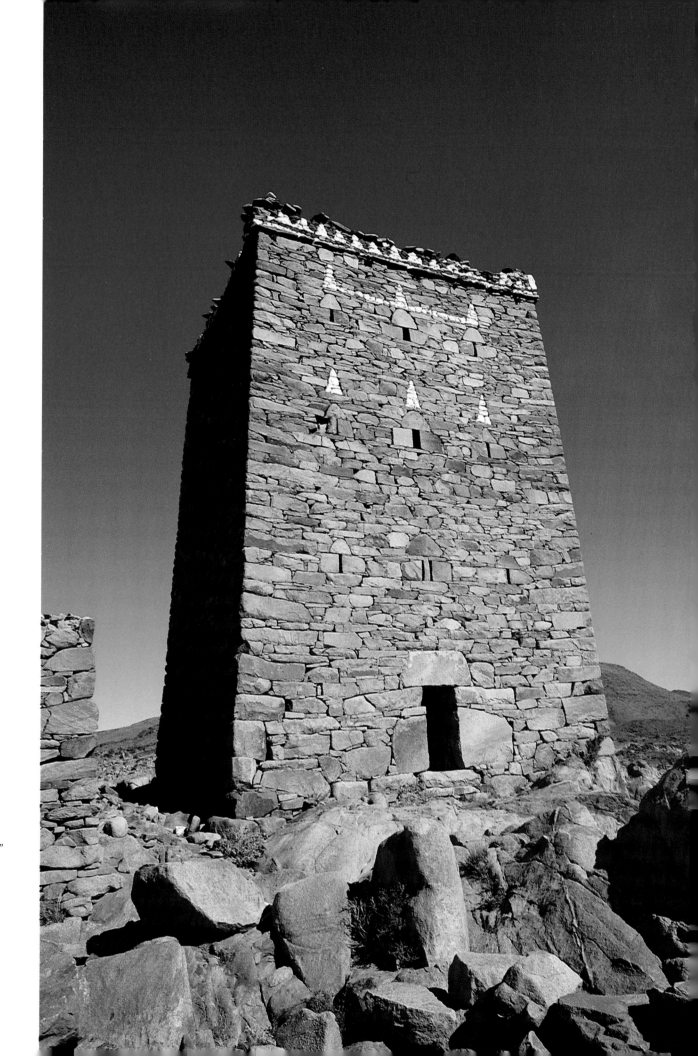

*Although reduced to the state of a useless
sentry, this drystone watchtower still stands
to attention. Its builders gave the walls "batter,"
which makes them thinner and thinner
the higher they reach. This architectonic idea
not only makes the watchtower very stable,
but makes it look like the trunk of a pyramid,
a singular form in the whole Southwest
(Hejaz, Bani Saad).*

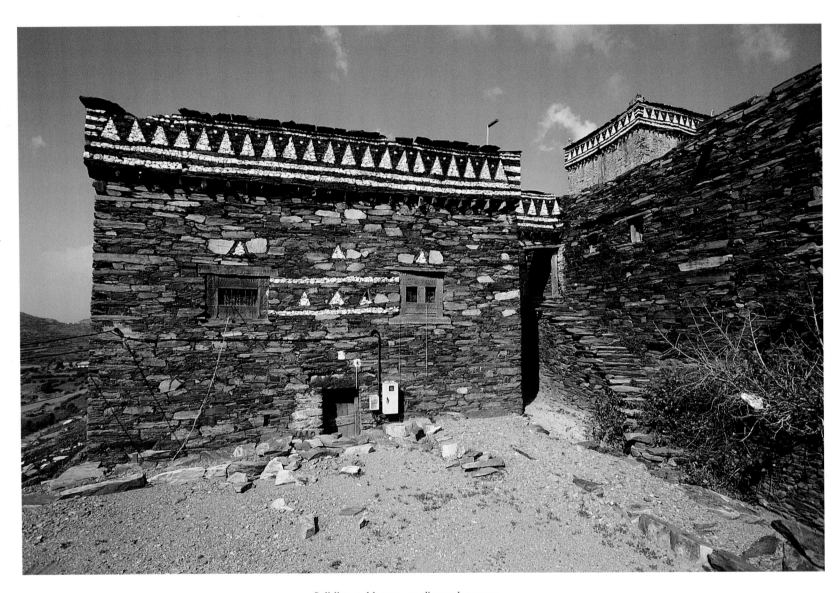

*Solidity and beauty, quality and economy
are the characteristics of drystone villages.
The houses line up rubbing shoulders to form
a fortress (Hejaz, Bani Malik).*

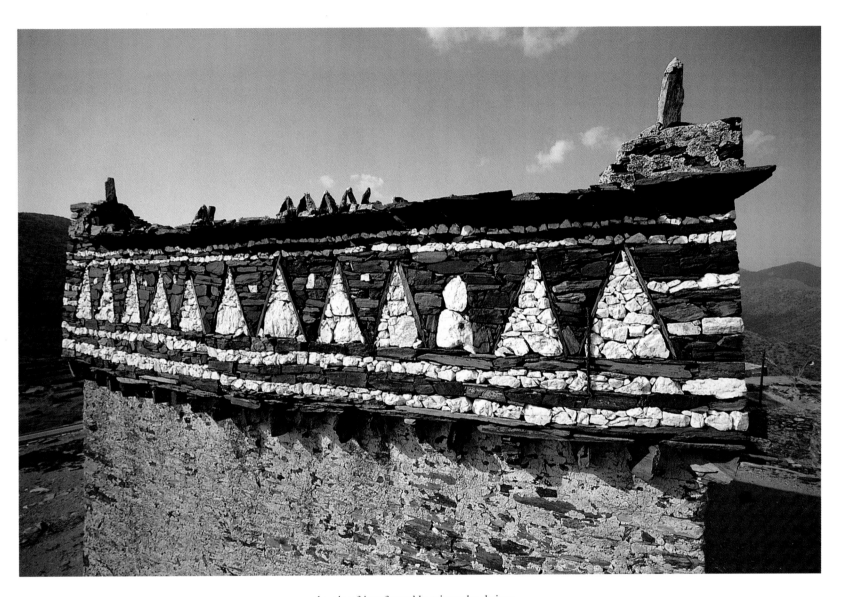

*A coping frieze formed by triangular designs
in quartz. The black–white pairing in
the decorations, expressed in the opposition
between schist and quartz, should be seen
as showing a taste for the brilliance of contrasts.
This is the style of the* hawar.

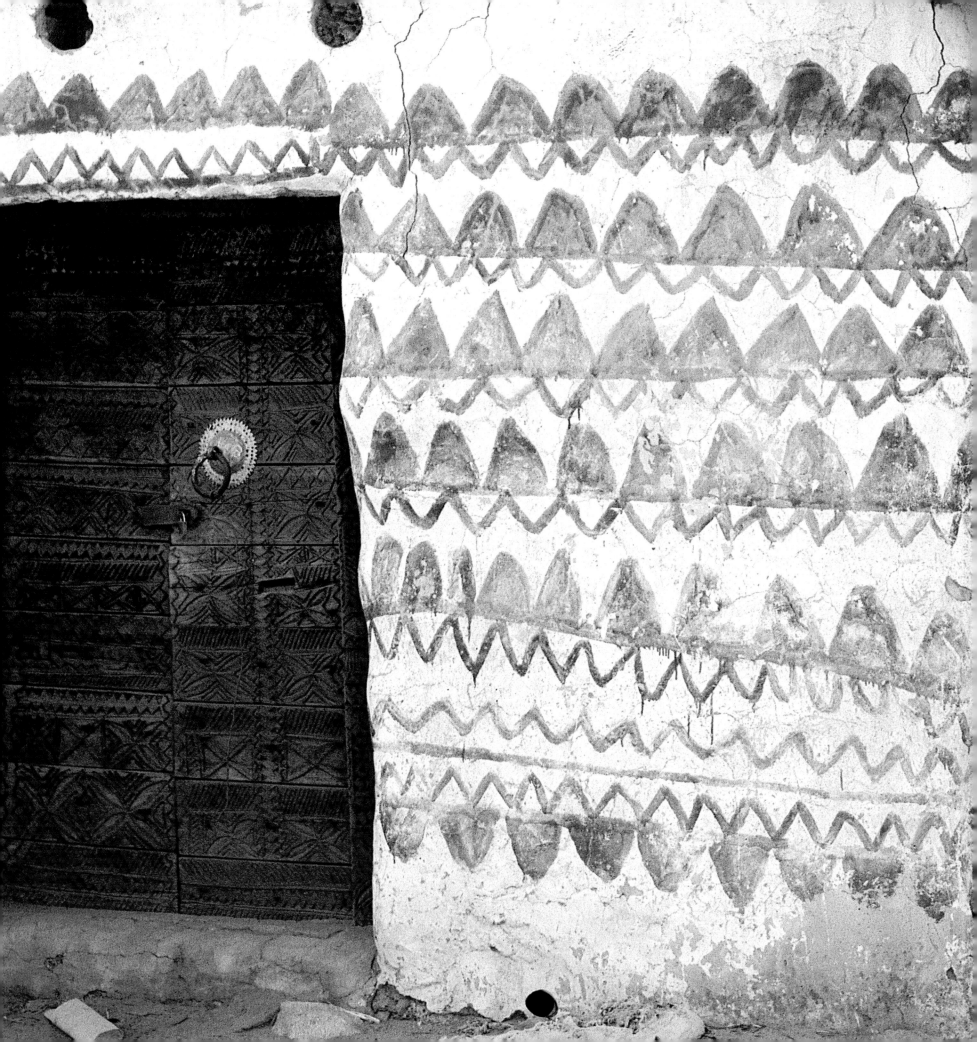

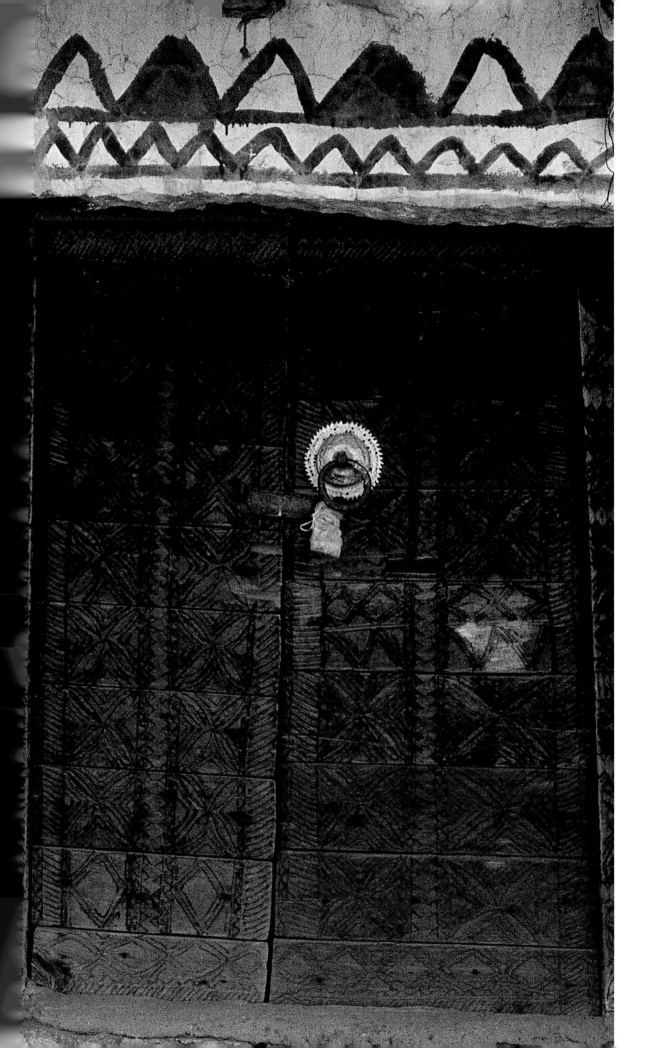

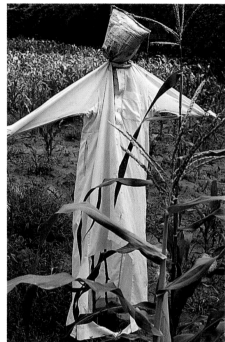

*This anthropomorphic scarecrow dressed
in the national costume, the* thobe, *is meant
to frighten away birds and baboons.
Expressing an iconoclasm that clings on,
the head has a form but no face (Rijal Alma).*

*This façade, with geometric doors and
simple paintings, carries the dual mark
of a particular cultural system and of
an original individual awareness.
The painter has carried over to this wall
a theme that is also found on the coping friezes
of the houses (Hejaz, Bani Malik).*

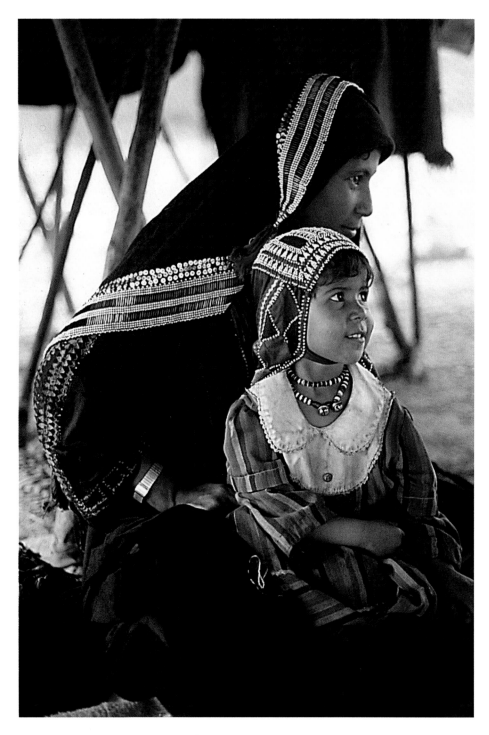

*Two generations together, and already
the traditional costume has been abandoned
in stages, the headdress being the last piece
to disappear (Tihamat Hejaz).*

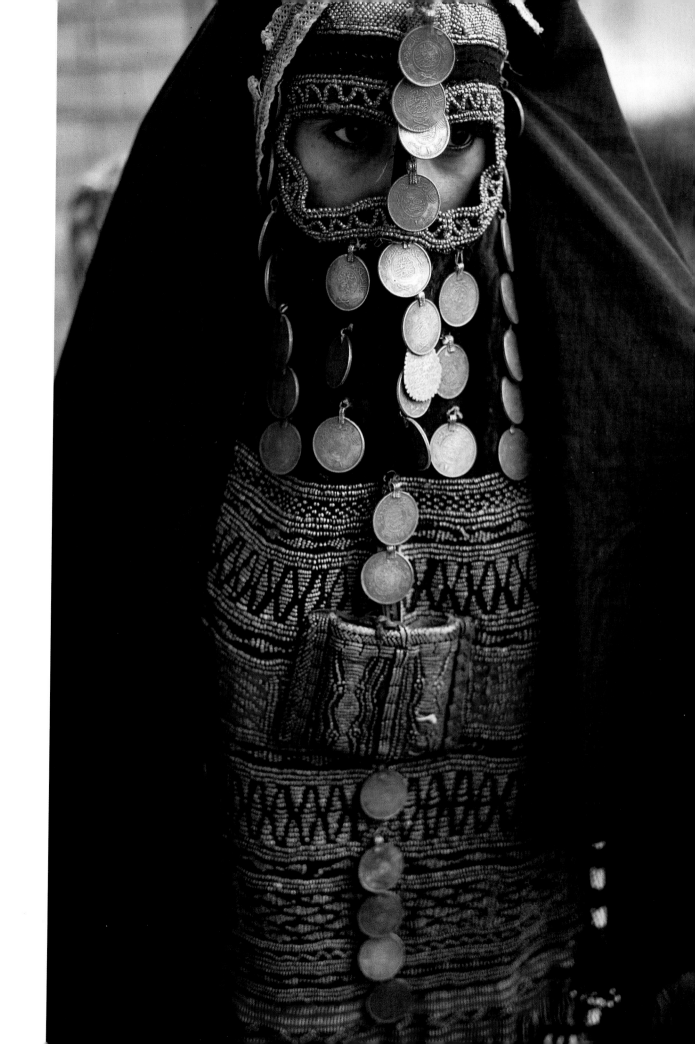

*As the artist Jean Helion might have said in this context: "There obviously I dreamt of trees, women's bodies, and not triangles, nor even rhythms." (Southern Hejaz).*

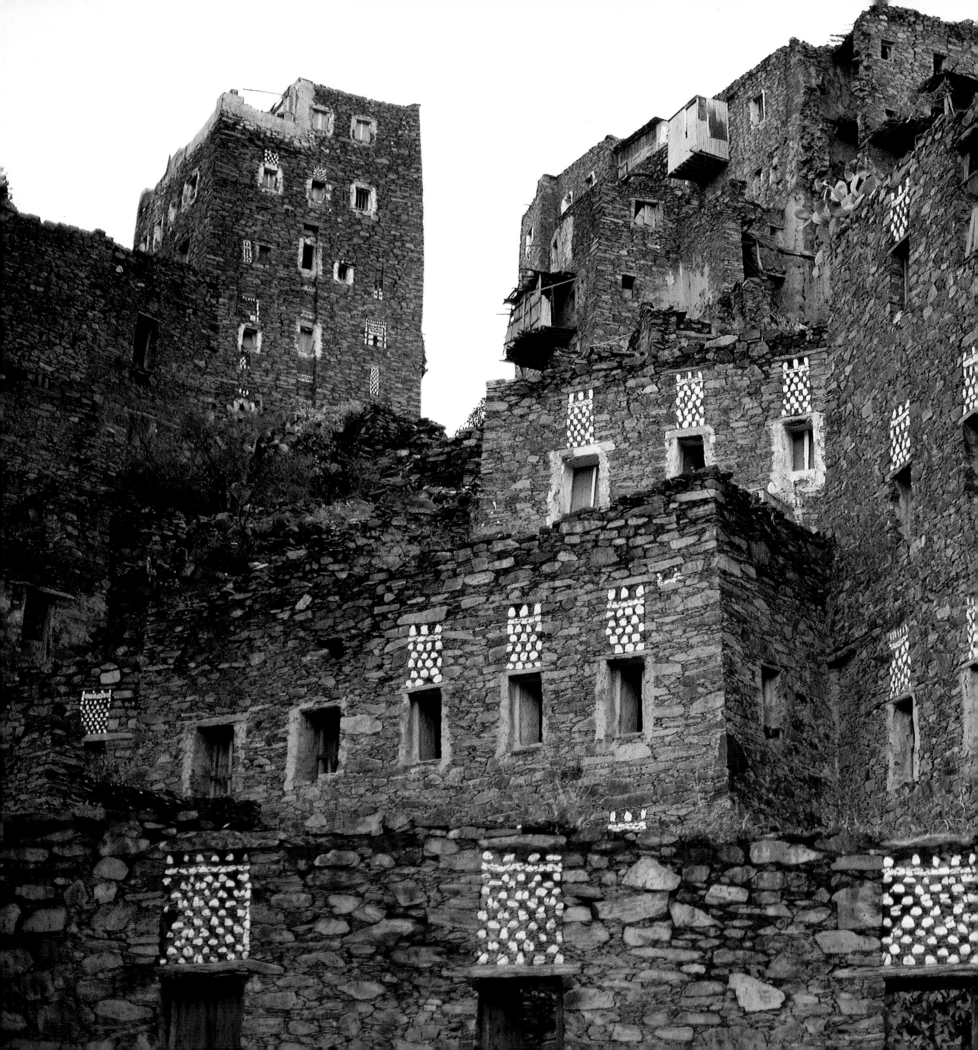

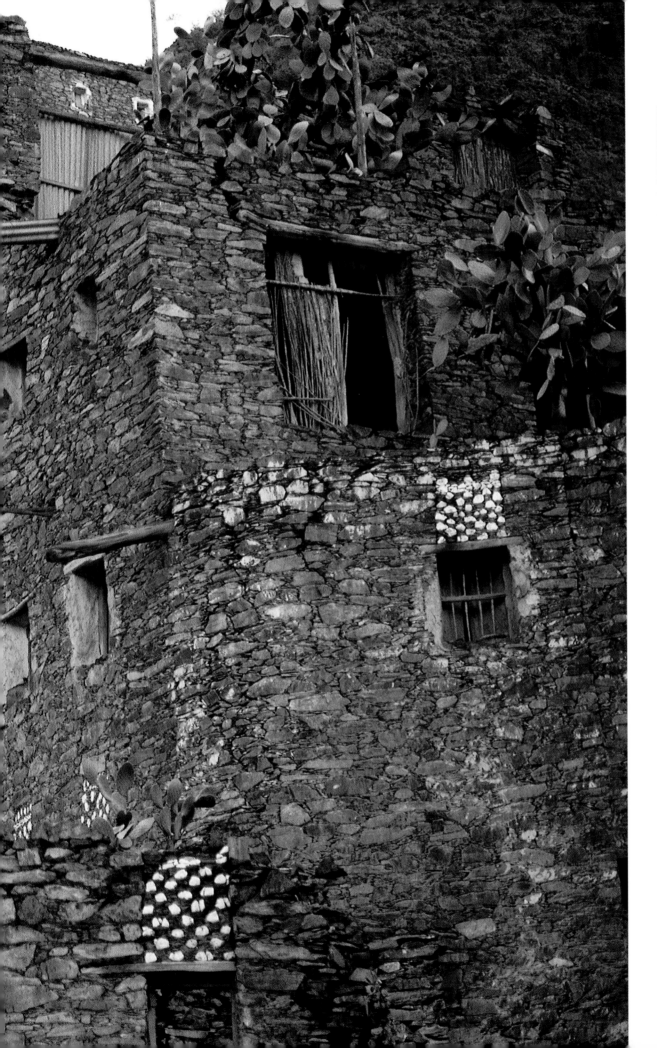

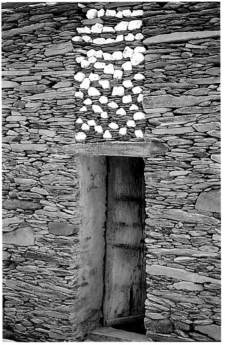

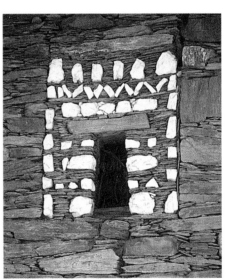

TOP: *The lintel above a door formed by pieces of quartz set out like a checkerboard.*
ABOVE: *This window surround with chevrons in quartz attracts the eye.*
LEFT: *The characteristics and the height of the edifices in Rijal clearly show the importance accorded to it. Controlling the route between the port of Qunfudah and the high plateaux, this trading center was a passage point for goods going from the Tihama to the Sarat. A sign of abandon, the prickly pear trees are taking over the buildings (Rijal Alma).*

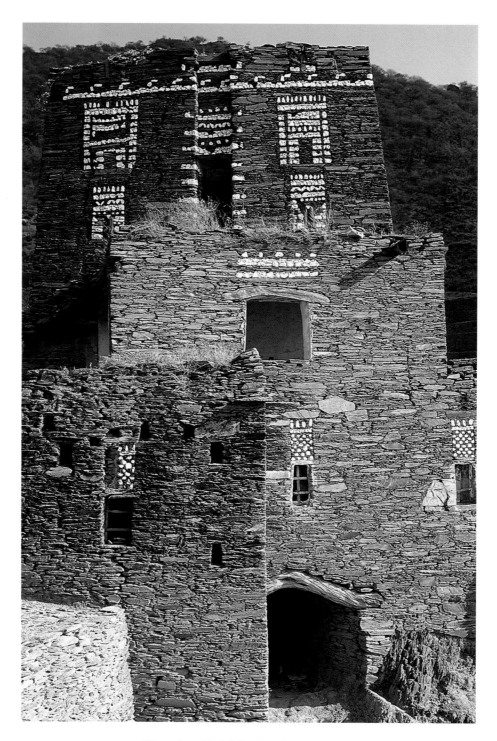

*The walls, with tightly adjusted stones
and carefully worked decorative patterns,
make this fort a typical example of its kind
(Rijal Alma).*

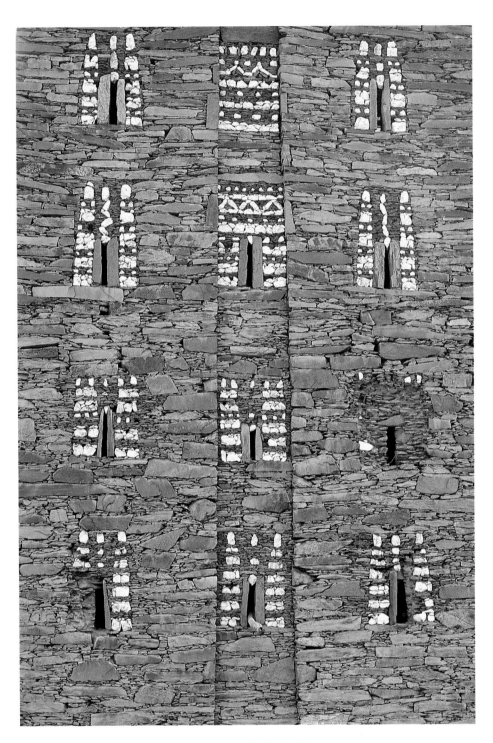

*The quartz patterns give individual character
to the façades of drystone houses. The quality
of the work and the sophistication of the pattern
reflect the owner's social status. Frames that no
longer have their decorations show that the quartz
chips are placed by recessing of the windows during
construction. Instead of giving rise to decorations
in relief, these look more like embroidery.*

43

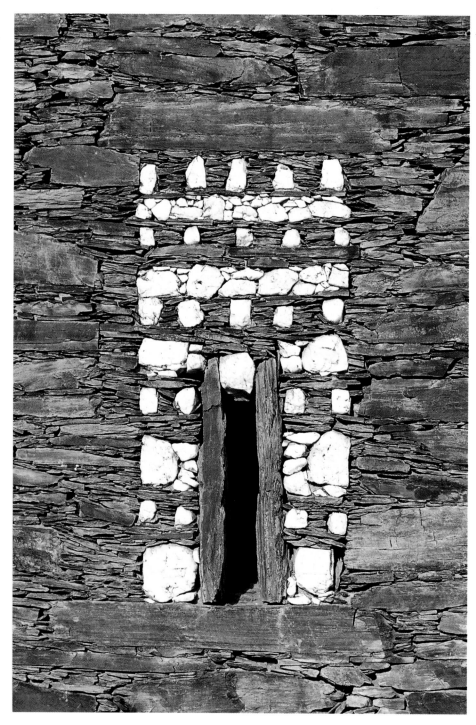

*The loophole window particular to tower-houses is made with two flat stones creating a narrow, vertical opening. The quartz frame stands out against the severity of the dry stones (Rijal Alma).*

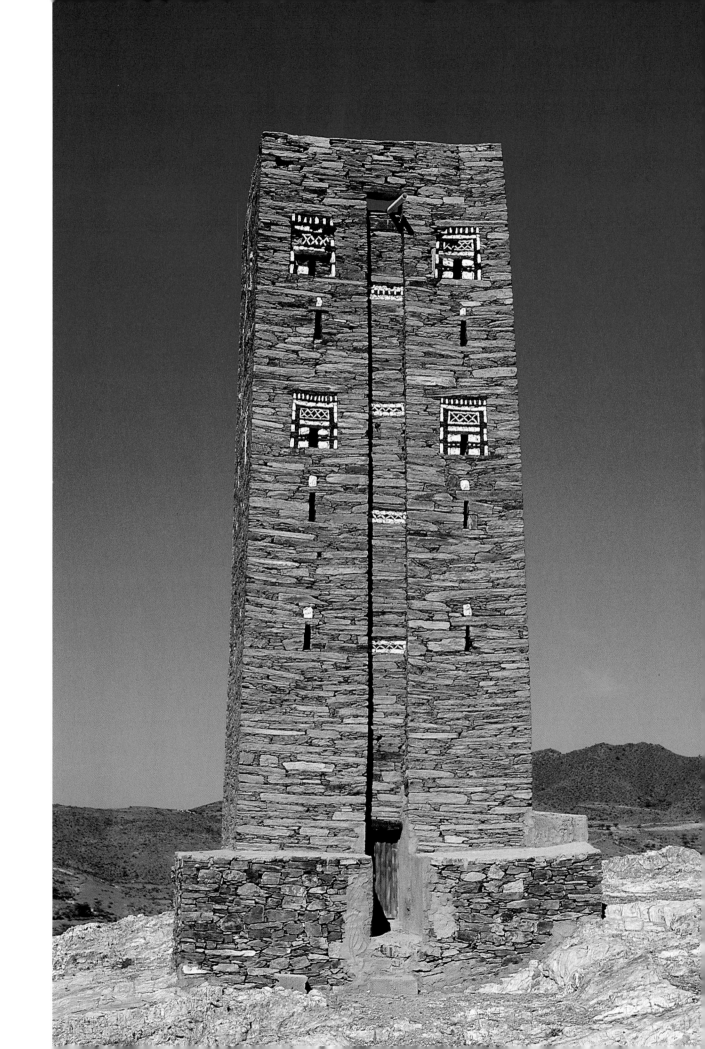

*Seen from the outside, this fort is first and foremost the perfection of soaring lines (Asir).*

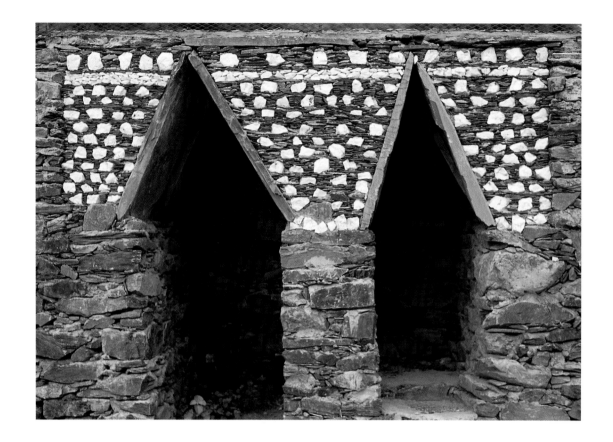

*This open-roof mosque (*mashad*) shows the mihrab and minbar. The walls in which they are set are speckled with quartz, a decorative style particular to the Tihamat Asir (Rijal Alma, Rijal).*

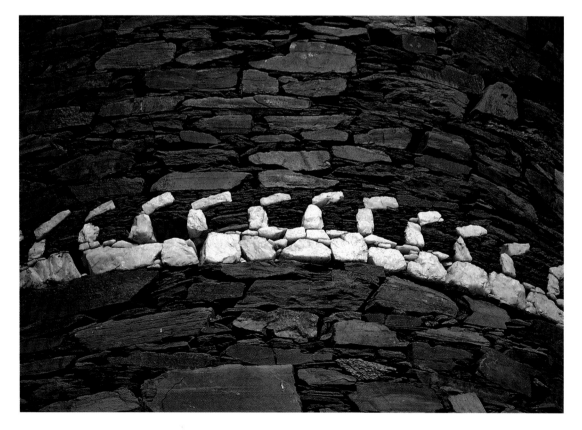

*Close-up of a belt of quartz marking out the layers in a watchtower (Asir).*

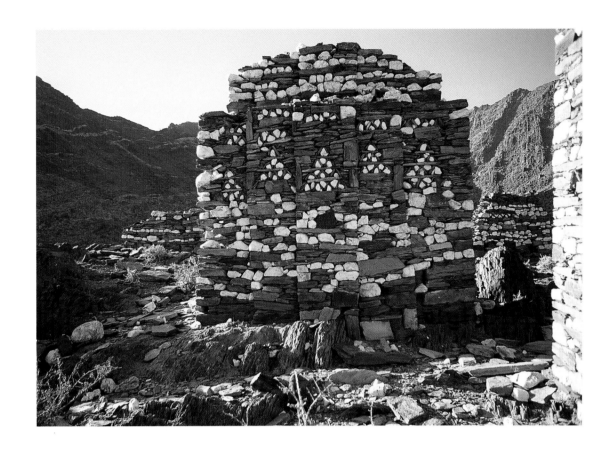

*A rare monument to the dead, this ancient drystone tomb is eleven feet six inches (3.5 meters) high. Each decorative pattern is structured by layering up chevrons, which make a triangle shape. Inside each chevron is a quartz shard (Bal Ahmar).*

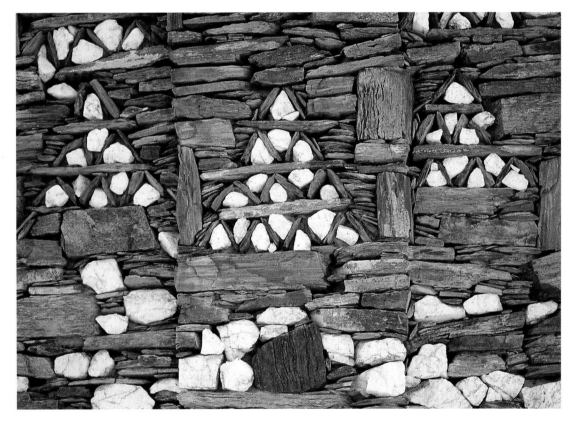

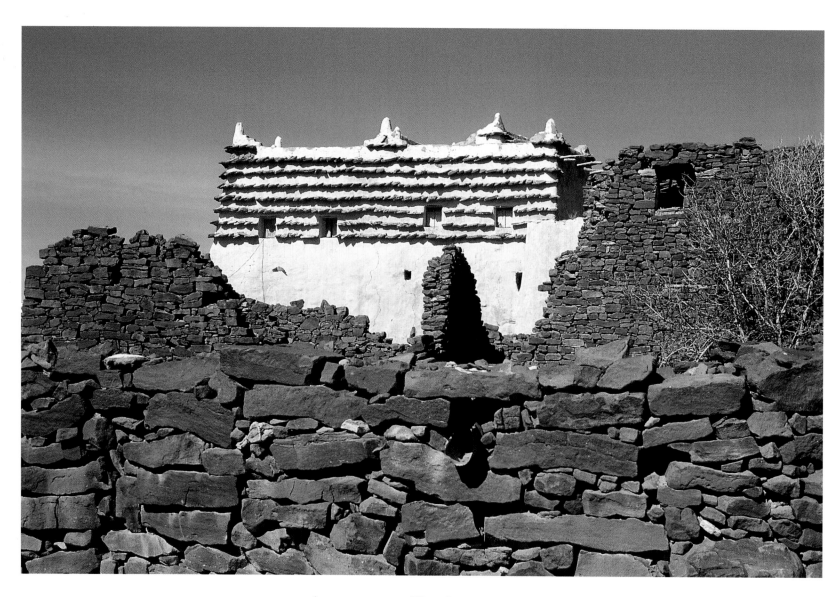

ABOVE AND RIGHT: *Where the two architectural areas meet, both drystone buildings and mud houses with shingling coexist, the former coming before the latter (Bilad Shahran and Asir).*

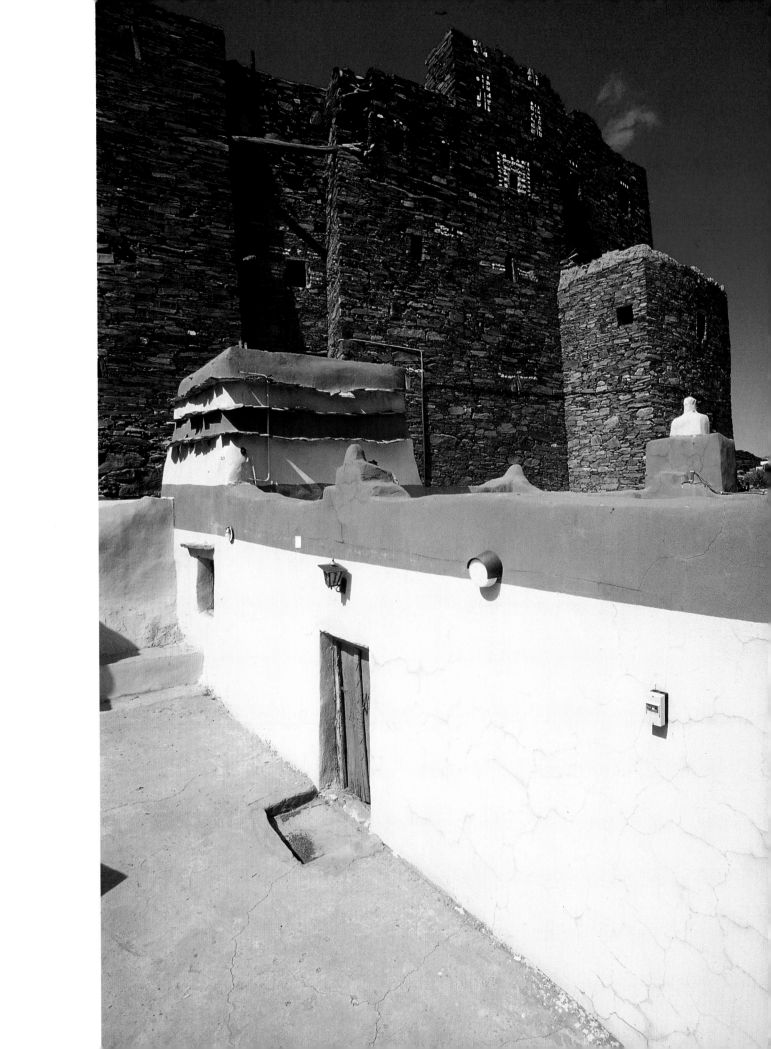

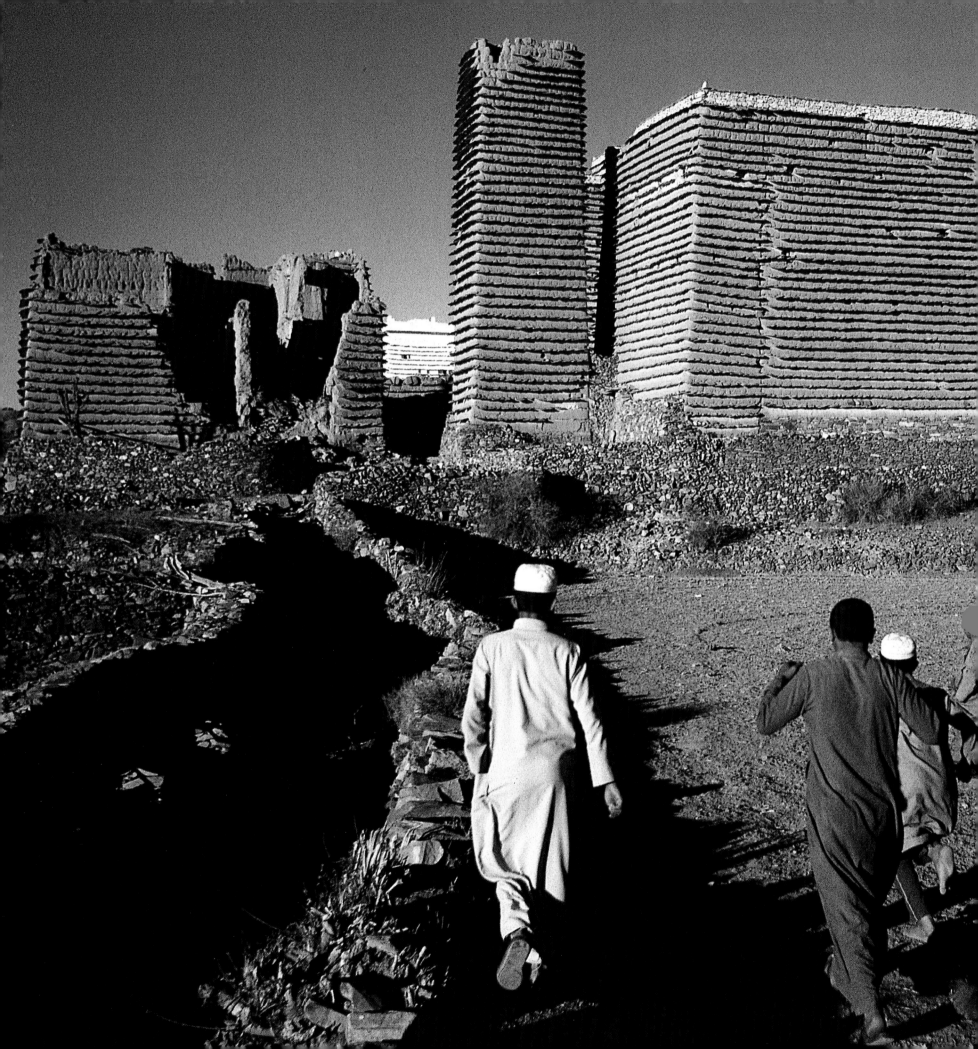

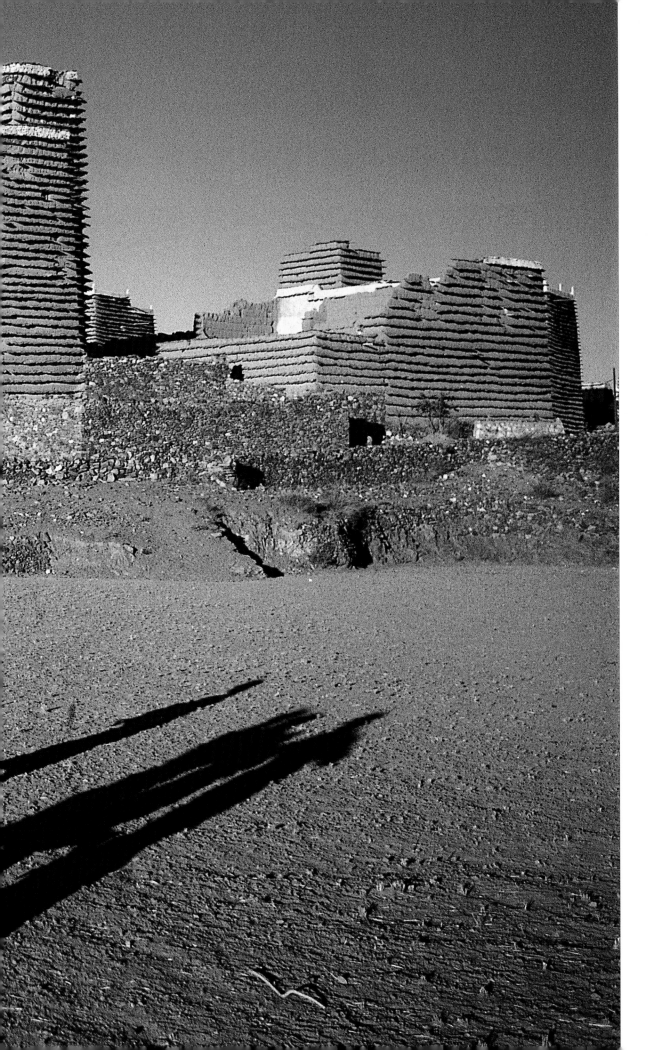

*This massive mud construction, with shingling in projecting slates and flanked by two fortified granaries, suggests defensive architecture: windowless walls in the lower part of the construction, narrow openings in the upper (Bilad Qahtan, Bani Bishr).*

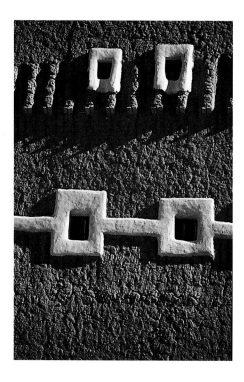

*The thick layer of gypsum hemstitching the windows is meant to ward off the evil eye, and protects from rain.*

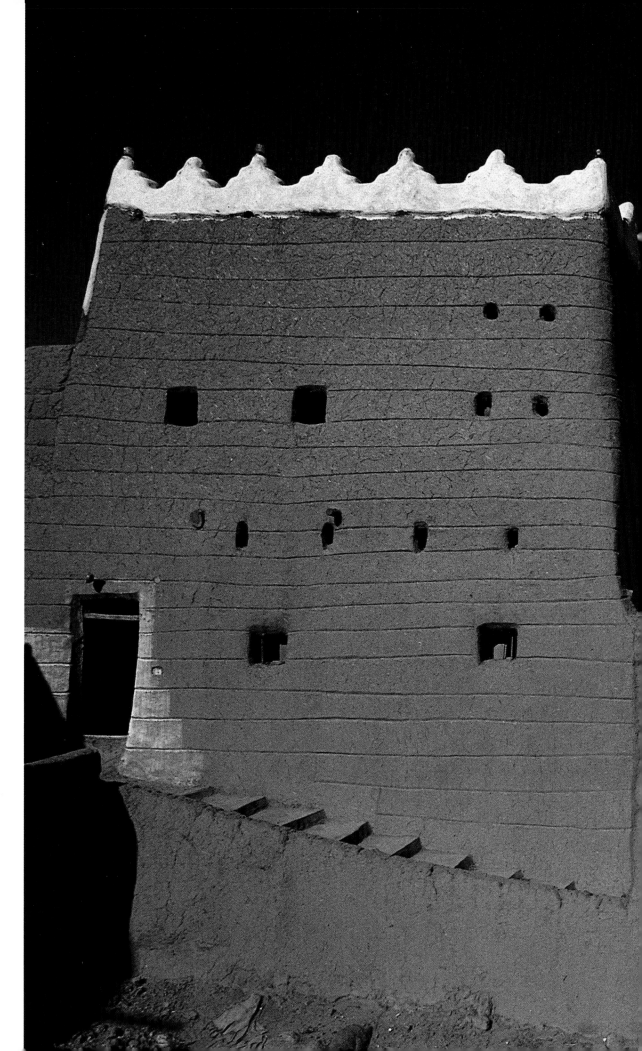

*The castle of Mushayt, in the town of Khamis Mushayt. The latter, set on the eastern bank of Wadi Bisha, derives its name from the clan of the Rushayd section of the Shahran. The day of the souk is Thursday—*khamis *in Arabic (Bilad Shahran).*

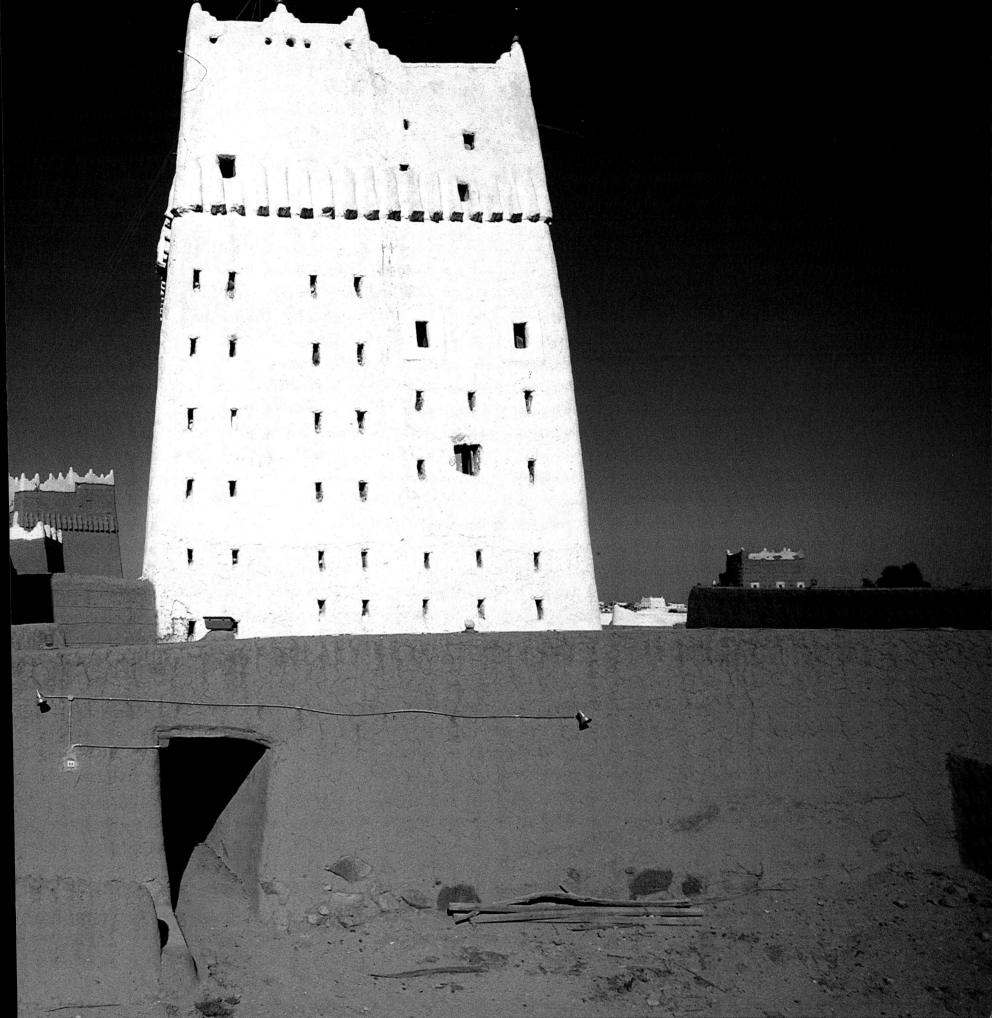

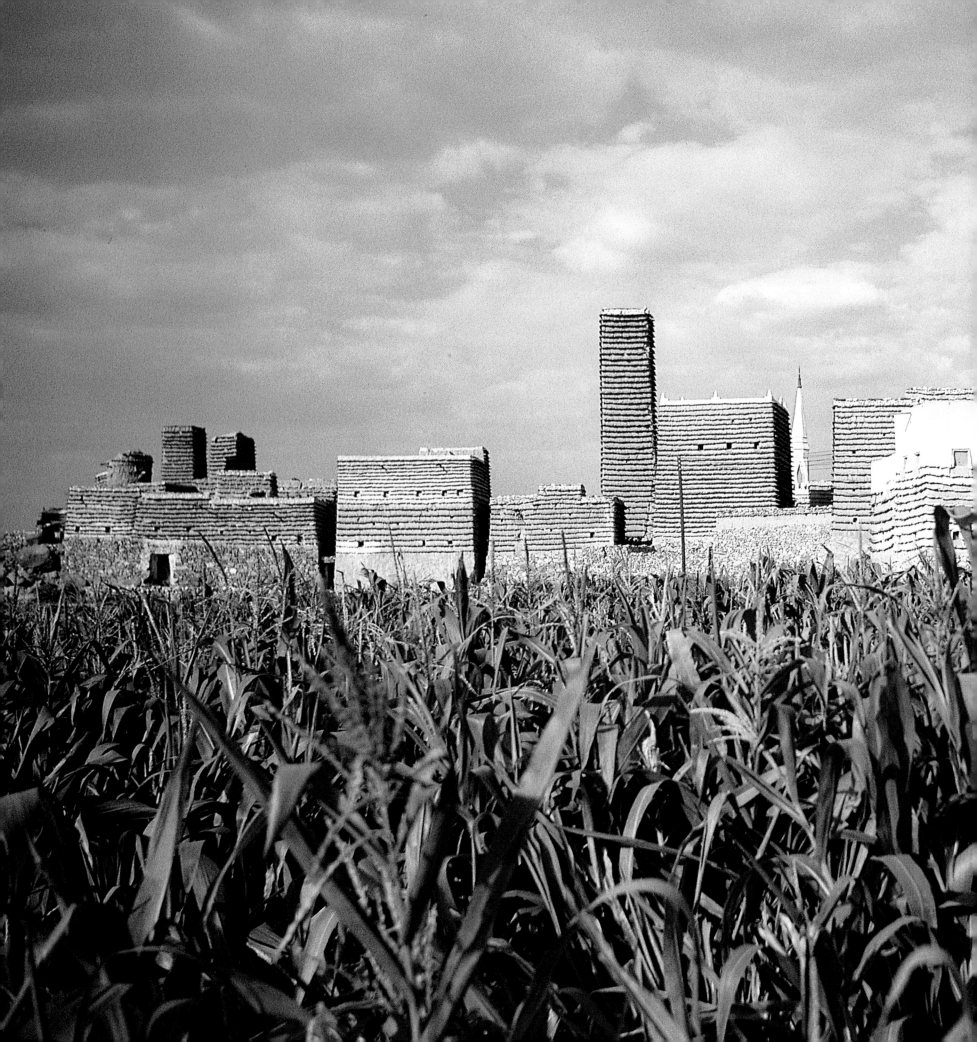

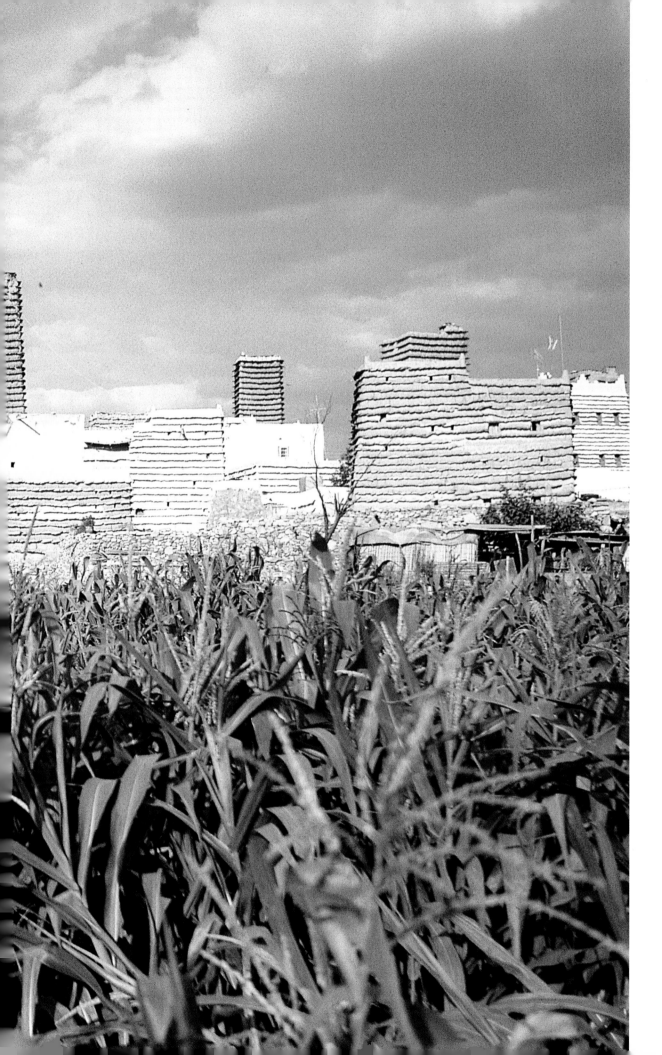

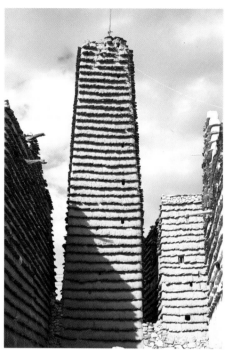

*Soaring up and taking possession of the sky, this fortified granary embodies the hamlet's riches.*

*Cereal splendor against a mud village background. The vertical lines of the mosque and granaries, the horizontals of the houses, with the projecting slates narrowly woven all the way up, the lines of dominant forces create an architectural rhythm special to the villages of Bilad Qahtan (Bani Bishr).*

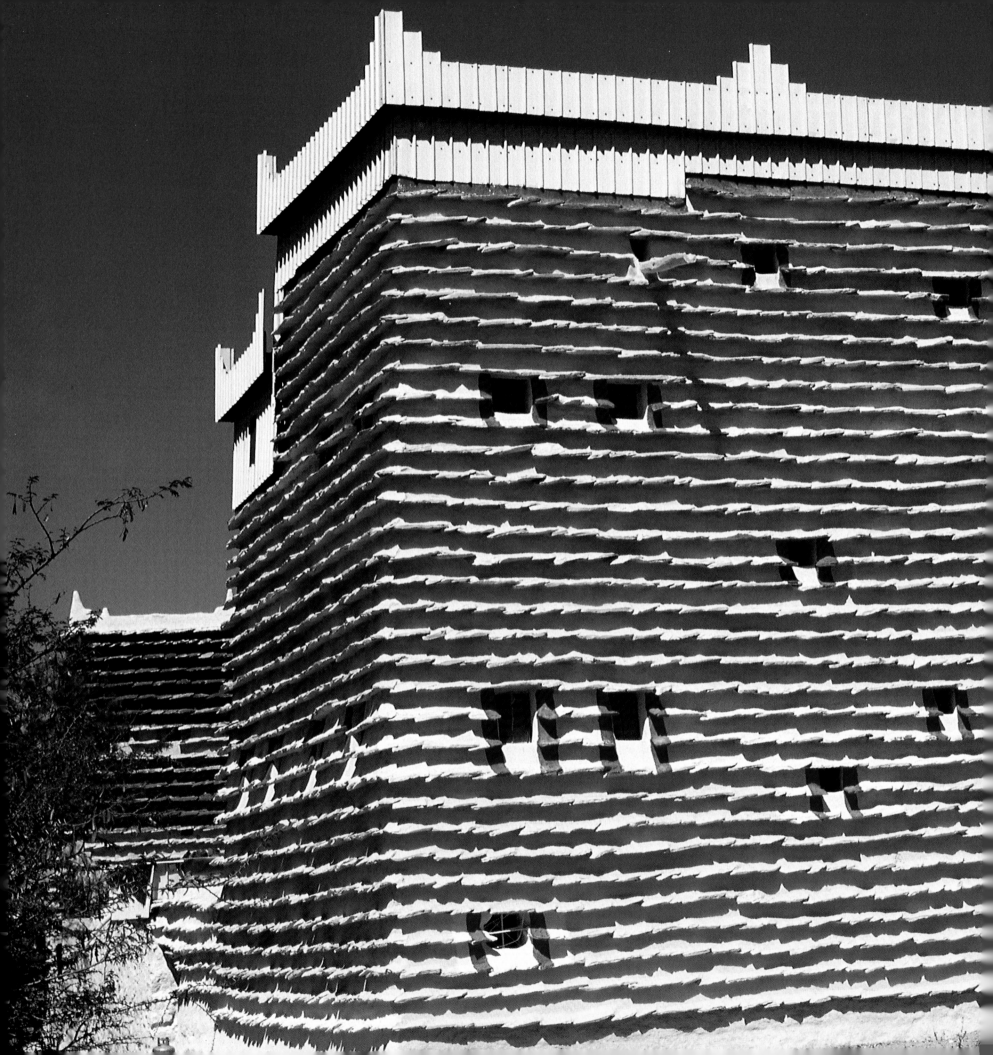

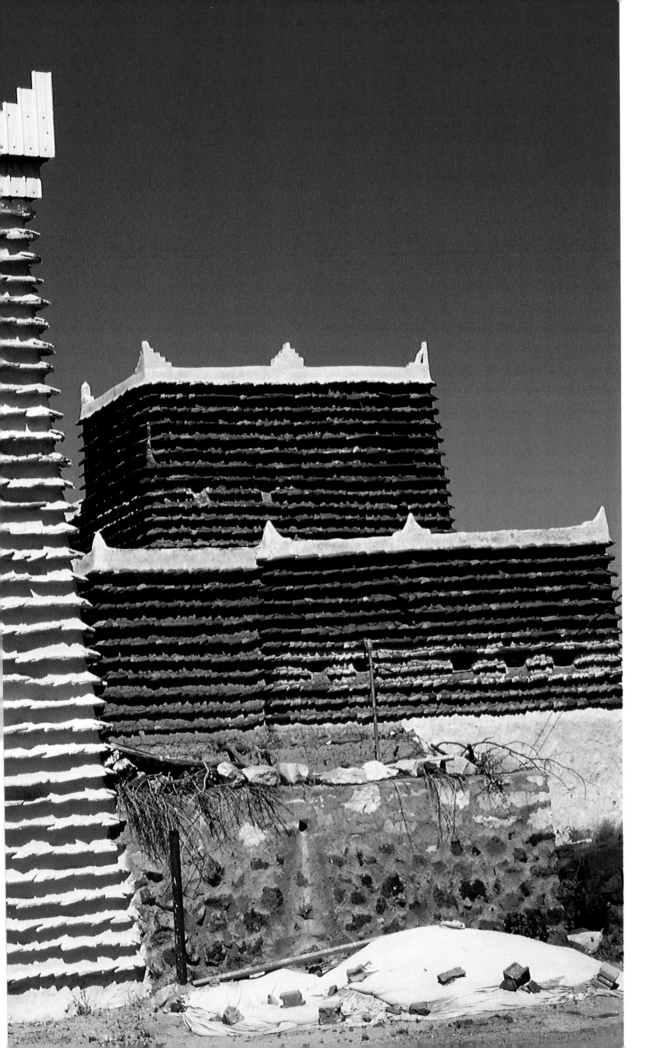

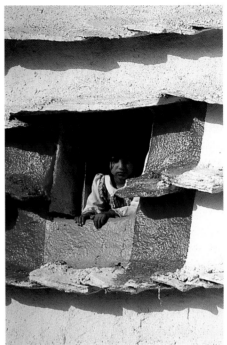

*Safe behind the wall with its carapace of projecting slates, from the cover of the window, a fearful, fascinated little girl eagerly awaits visitors.*

*Although traditional, this mud house covered with projecting slates lets slip a certain modernity that sets it apart from its neighbors: the walls are painted, the windows penciled round in red. Even if the terrace-roof can no longer be used, the recently installed, metal superstructure, holding up corrugated sheets, does make the roof completely watertight (Bilad Qahtan, Bani Bishr).*

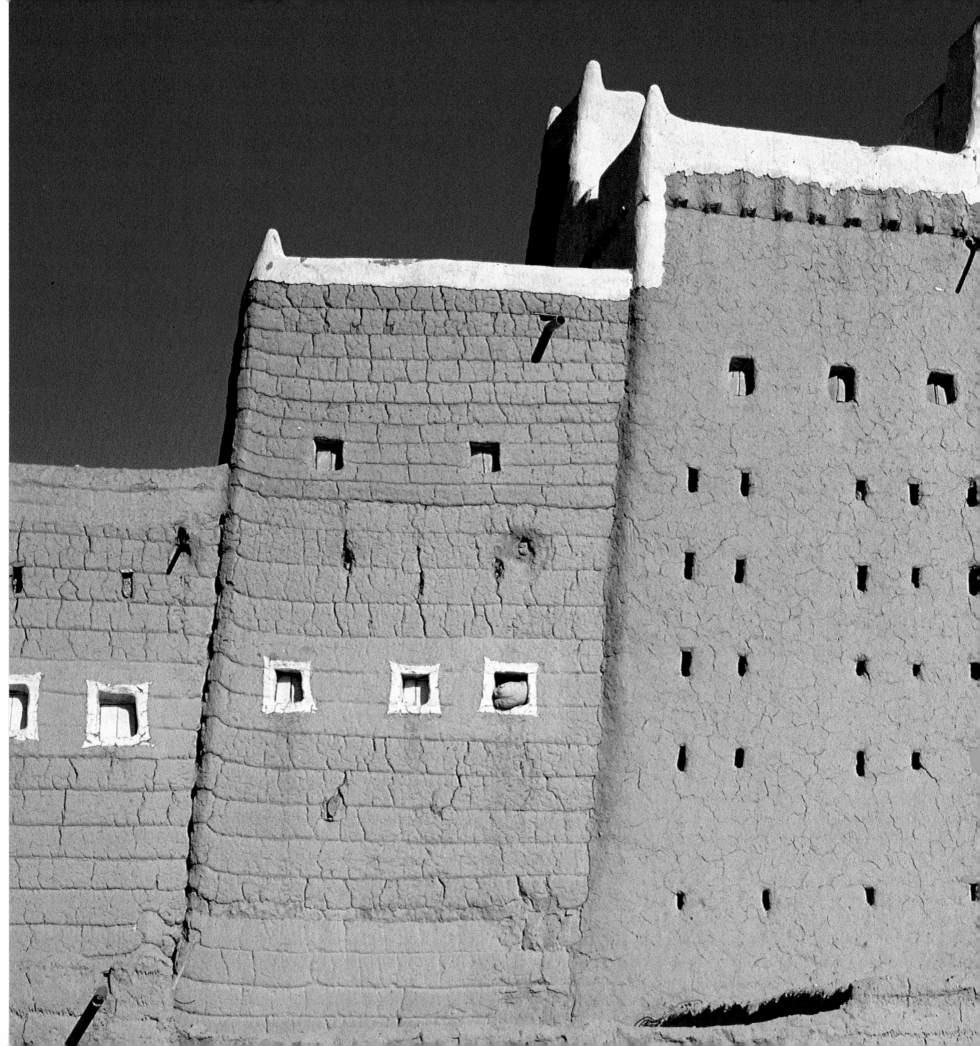

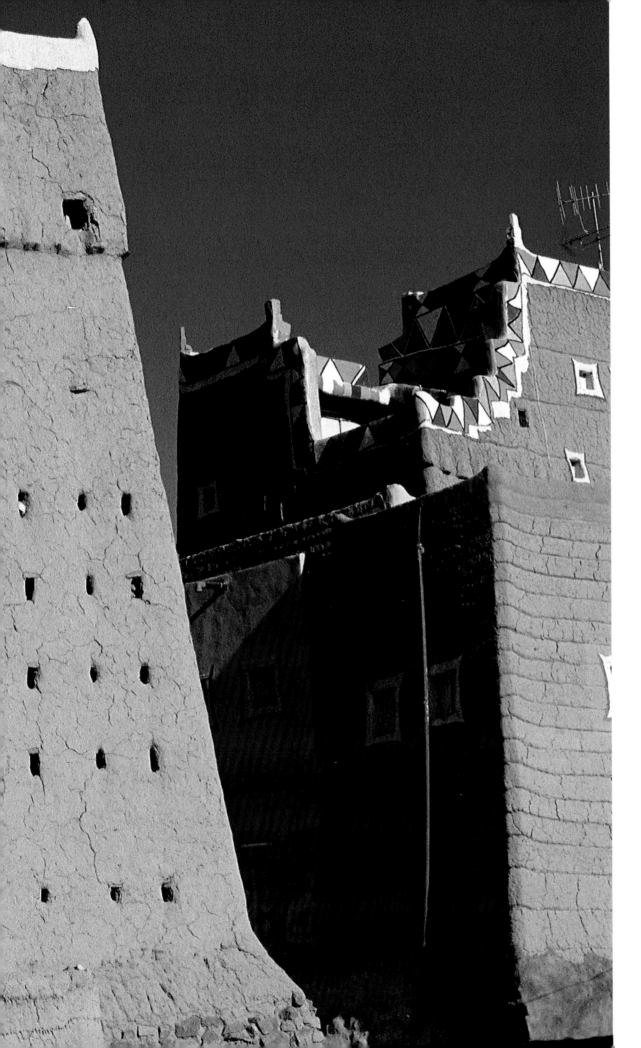

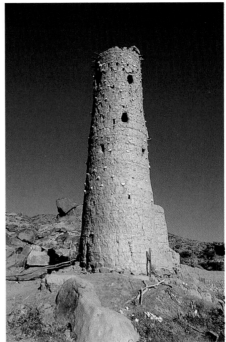

*The use of mud for building has caused quartz to fade out somewhat, though it still fulfils its decorative role. Yet it is no longer set out in beautiful arrangements, as can be seen in this watchtower: fragments emerge here and there like almonds in nougat.*

LEFT: *These houses show that imposing architecture can be born from the most modest materials (Bilad Qahtan, Sinhan).*

FOLLOWING DOUBLE PAGE: *In a landscape with chaotically piled up rocks, the cultivation areas bristle with tall, round towers like factory chimneys, which were both for storing grain and for defense (Bilad Qahtan, Sinhan).*

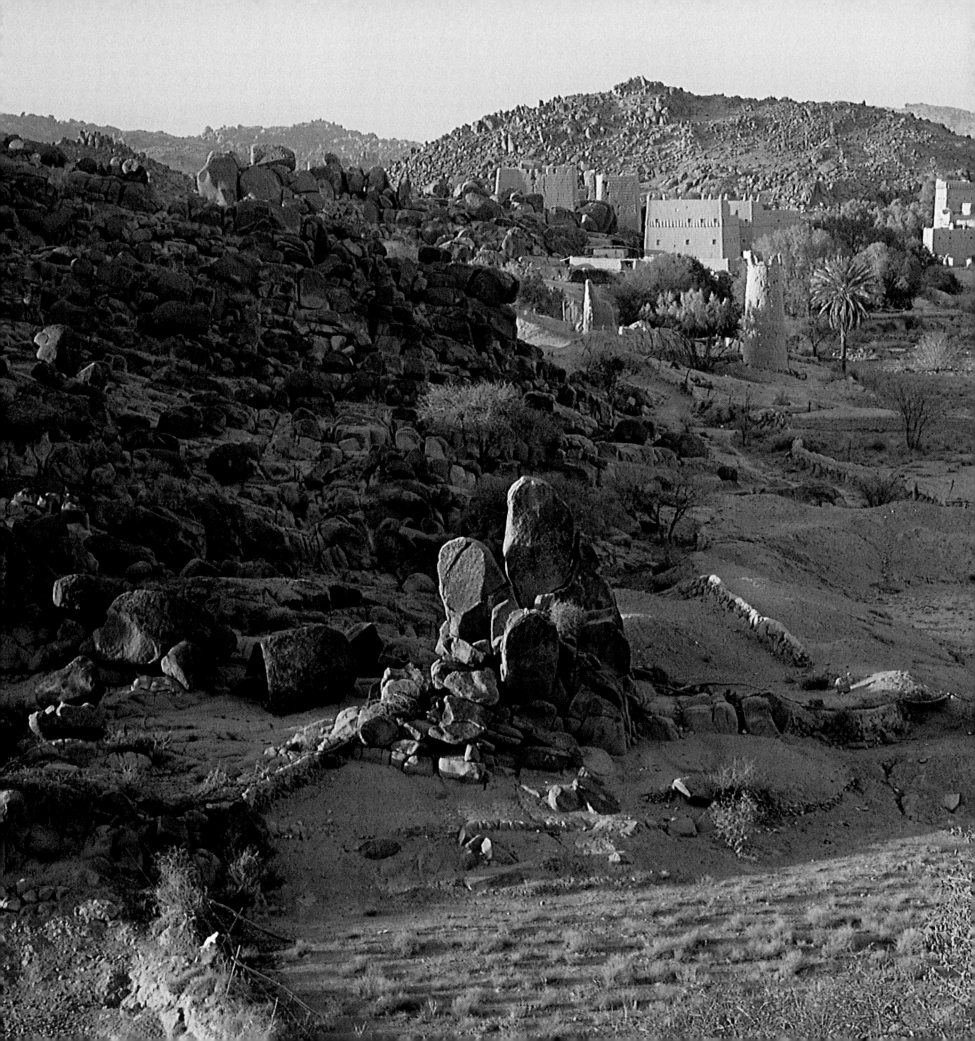

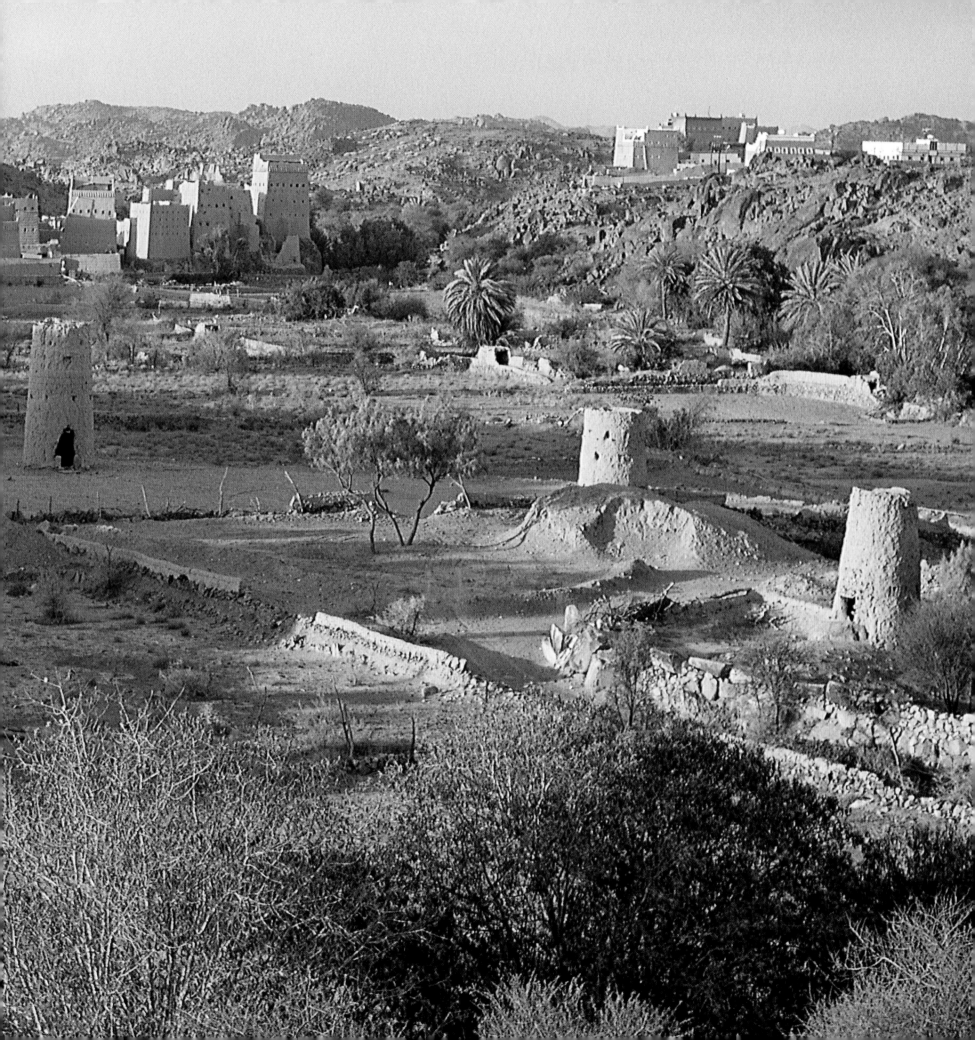

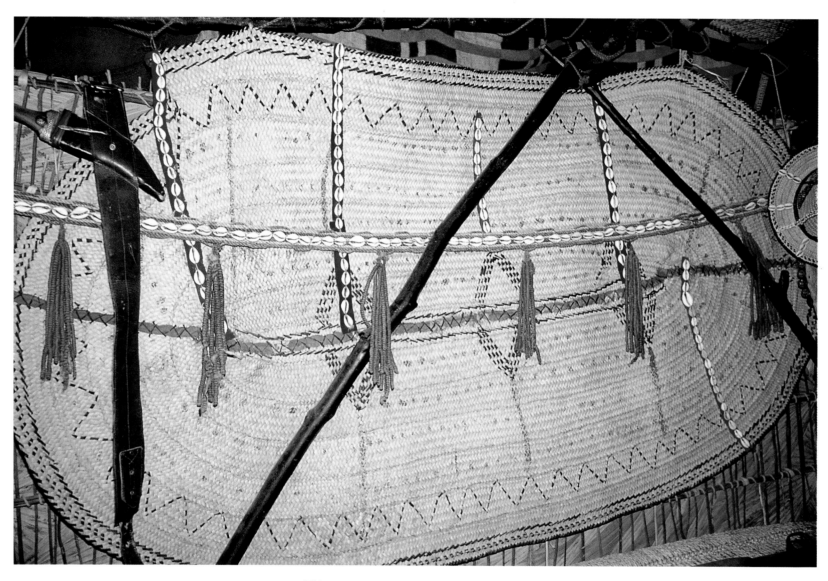

*This mat covered in cowry-shells and*
*geometric patterns decorates a tent wall*
*(Tihamat Asir, Rabiyah).*

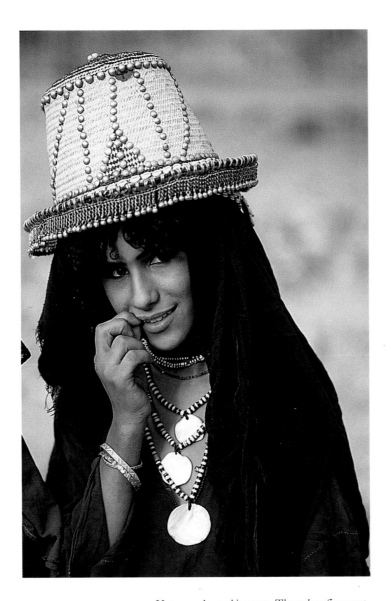

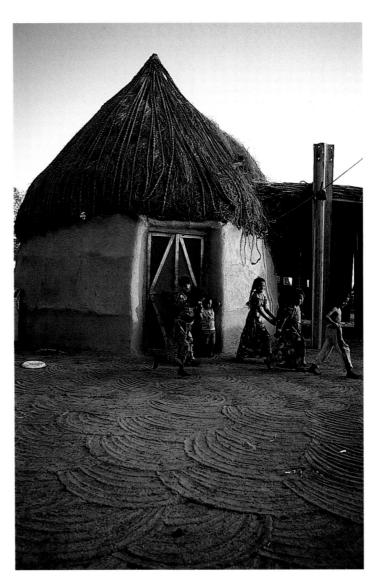

Hats are also architecture. The only refinement
in clothing that the women goatherds
of the Tihama have, makes them deservedly
proud. Very tightly woven, it is brightened
up by fine strips of leather in a triangle.
A curtain of fine chains with bells attached
glints and shakes around the edge.
Cowry-shells and brass nails liven up
the straw color (Tihamat Qahtan).

A piece of pottery with a straw hat is
what the "African" hut looks like here.
Branches swollen with cob form the circular
wall, which is topped with a conical roof
made of sorghum straw fixed down by a
network of ropes. A sign of acculturation is
the solid iron door that guards the entrance.
Here, the ground in front of the hut is decorated
with fish-scale patterns (Tihama).

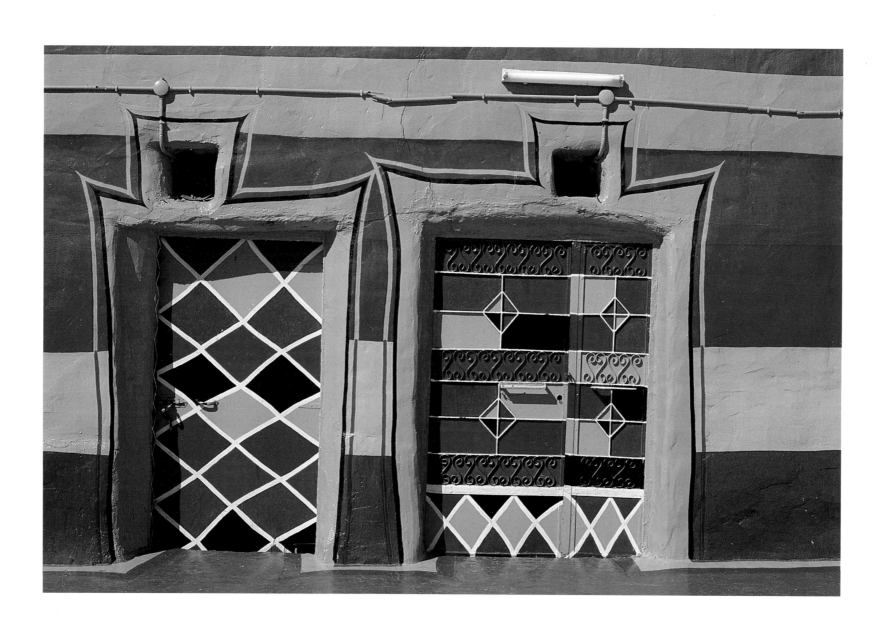

# POLYCHROME FRESCOES

## *The private world of women*

The division of labor is determined by competence and gender: men do the building and women are responsible for the decoration. This latter skill is transmitted from mother to daughter, and in painting the houses help is enlisted from the other women in the community. This collective work has a value beyond the immediate one, as the dissemination of shared knowledge and as an apprenticeship for the future.

According to Janine Sourdel-Thomine: "The taste for ornamentation is manifested in a predilection for filling in every surface in a manner at once linear, dynamic and colored, without any narrative or symbolic intention...." Fundamentally, this impulse towards decoration indicates the privileged, unique and intimate relationship between the woman and the house, and her response to being withdrawn from public life. It could be a way of displaying her talents as if the activity could be used to express implicitly the female domain which is inaccessible to men.

Women account for the paintings with matter-of-fact explanations. A typical comment was: "We have always done it. Our mothers did the same. It's beautiful." The decorative impulse is a commonplace of human nature and in this case competition to own a beautiful house plays a major role. The skills and personalities of the women are invested in this task. Previously reserved for the decoration of the *majlis*, the frescoes gradually spread throughout the house, inside and out, finally appearing on the façade. Of the interior frescoes that define various rooms, those decorating the *majlis* are painted with the greatest care. The frescoes are appreciated not as works of art but as a symbol and proof of the skill of the painter—the wife of the host—and it is the latter who accepts the honor.

Polychrome metal doors stand out against the framework made of cob-filled branches capped by the straw roofs. But the real surprise is indoors. The inhabitants group and align household objects: flower-enamelled plates, basketwork trays, coffee-pots and goblets are clustered together and hung from wooden hooks. These objects have become part of the decoration, and their quantity a reflection of the inhabitant's wealth.

Murals with a naive freshness, meticulously descriptive, cover the vaults of the hut. Representing scenes and objects from everyday life, they break the unspoken taboo about depicting living creatures. In one design, two men are shown face to face, like the human representations on the bas-reliefs of ancient Egyptian tombs, although the comparison might be attributed to the clumsiness of the painting. The same parallel can be made of the two-dimensional depiction of the leaves of a plant, or the representation of cars that appear in frescoes in the huts of Al-Zohra, a village situated on the other side of the border. Alongside these naturalistic scenes are childlike representations of plants, such as "sunflowers" with lanceolate leaves. Triangles, diabolos, lozenges and chevrons crowd the vaults in concentric patterns. The stark simplicity of the frescoes' geometric style evokes African art. We might therefore conclude that the frescoes of Tihama are derived from two opposing and exclusive esthetic systems: figurative on the African side and geometric on the Arab side.

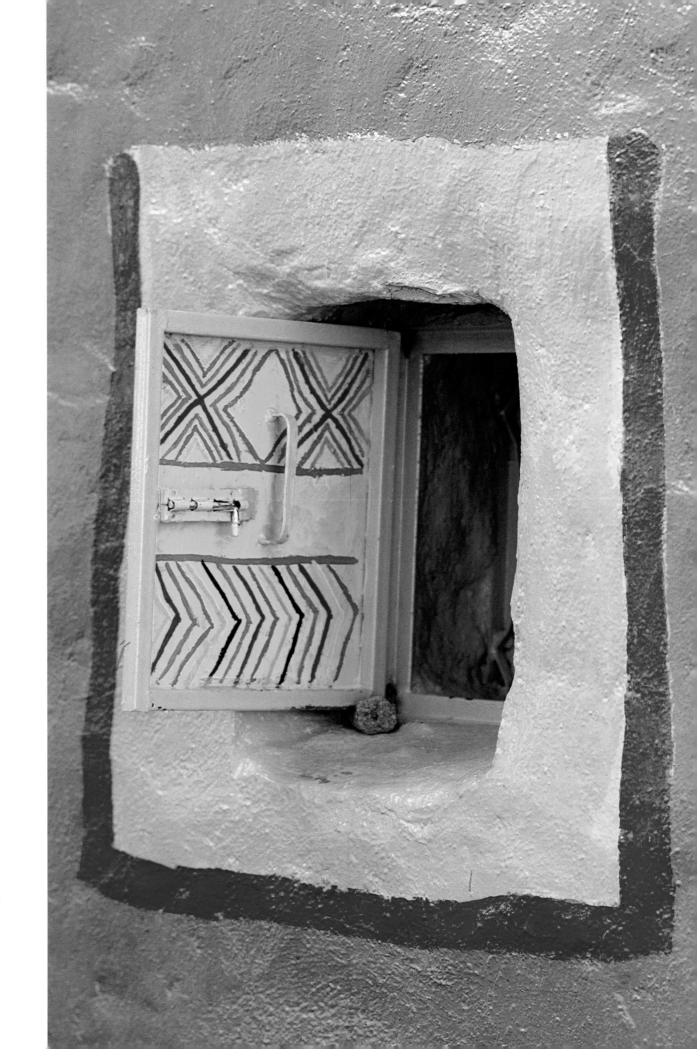

*The houses of the Sinhan have an inalterable marking: the windows are underlined in blue and edged round in red on three sides (Bilad Qahtan, Sinhan).*

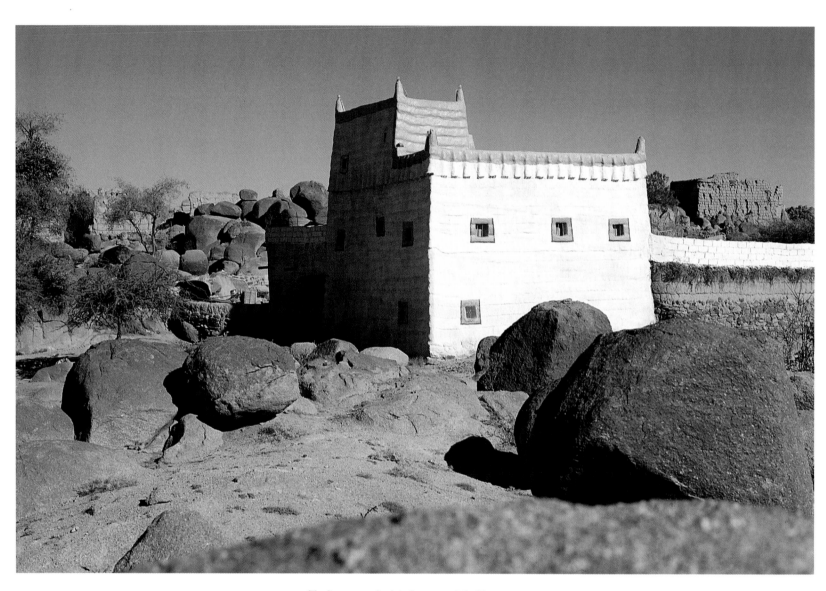

*To the eye sated with the grays of Arabia*
*Petraea, this house, amid a chaos of granite,*
*pleasantly surprises us with its limewashed*
*walls (Bilad Qahtan, Sinhan).*

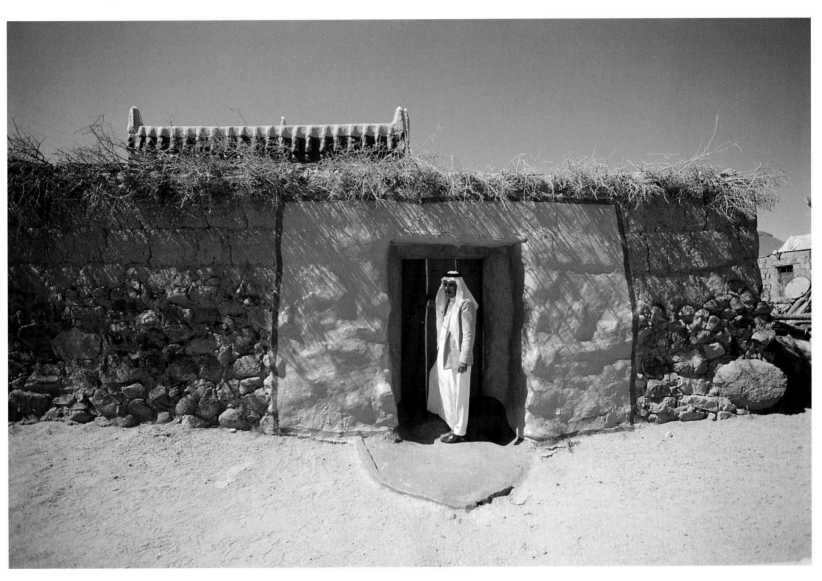

*Every house that possesses a courtyard*
*takes you in through a painted door.*

*Change and permanence: this mirror
symmetry celebrates the passing of five years
for the doorway of this house.*

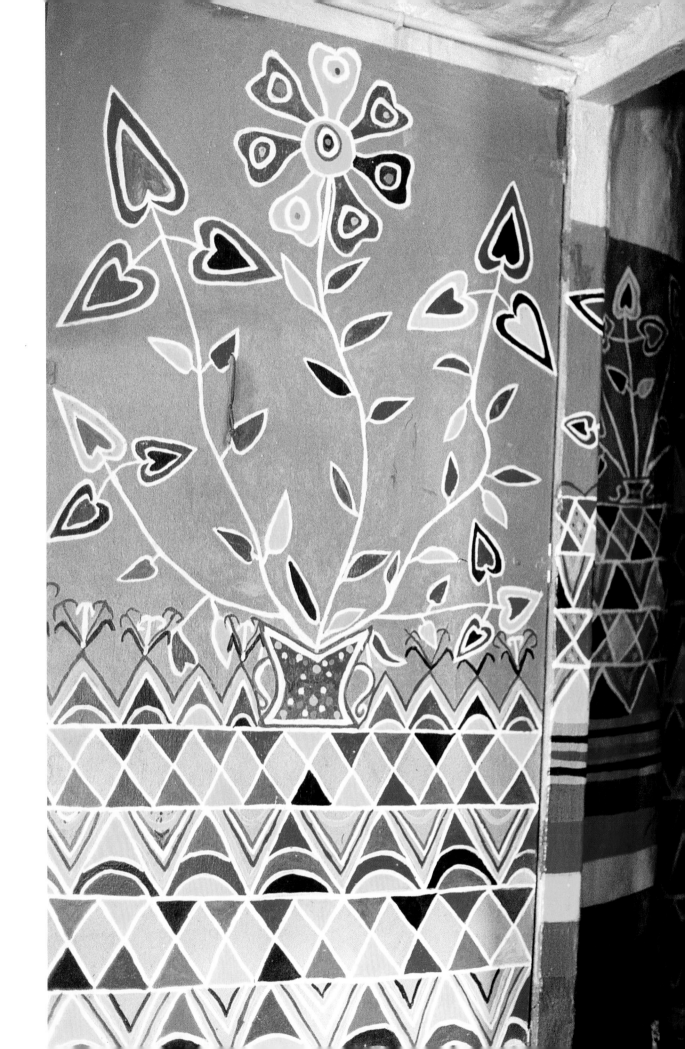

*The heart-shaped leaves have appeared recently, probably inspired by the metalwork seen on metal doors and rails on pick-ups.*

*Clothes chosen often reproduce the bright colors of the façades (Bilad Qahtan, Sinhan).*

*Although modest, this house is literally soaked in paint. In a primitive handling of the environment, the rock it leans against has also been painted, creating a symbiosis of natural and constructed elements.*

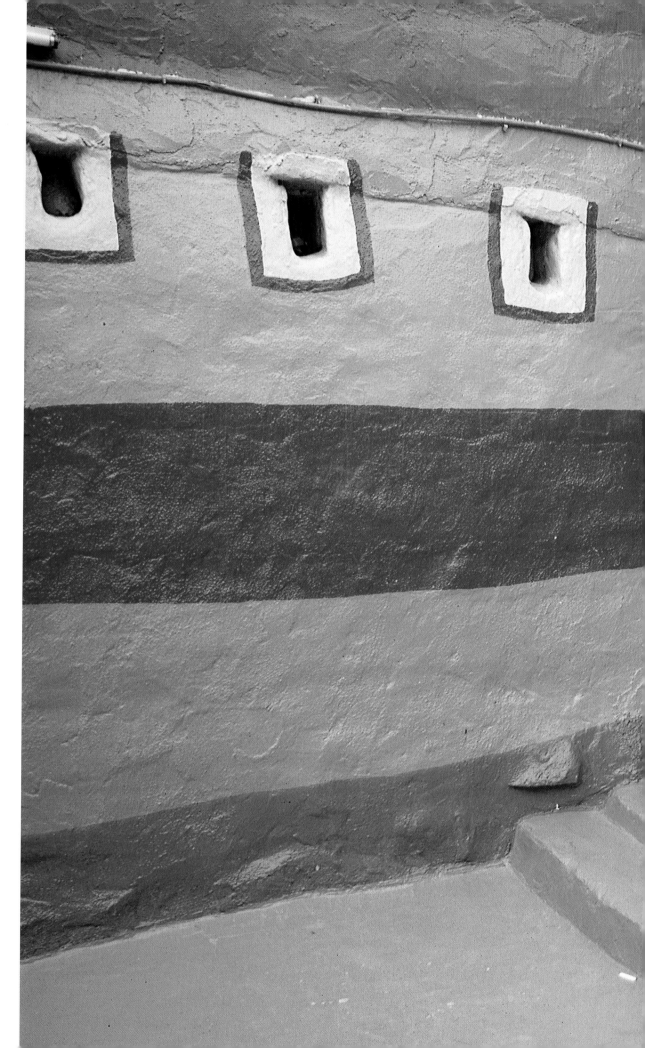

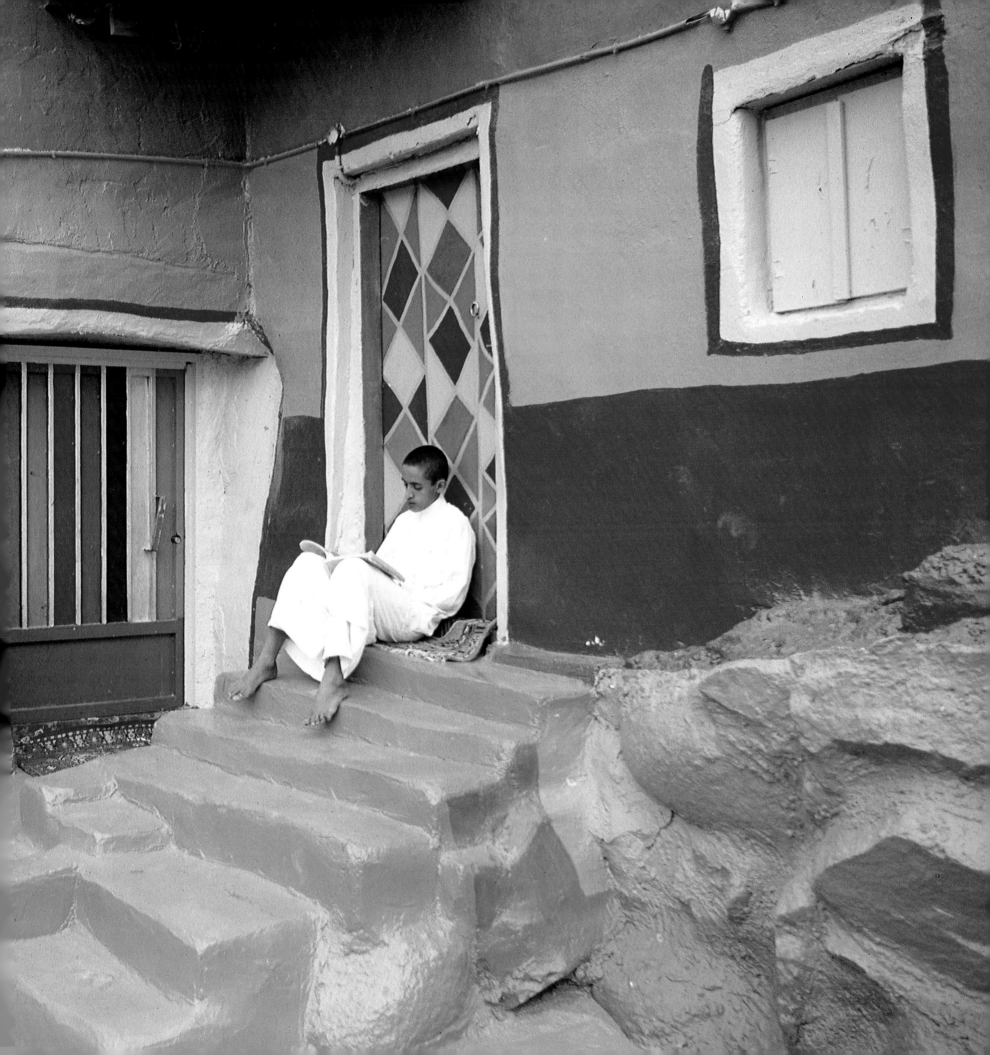

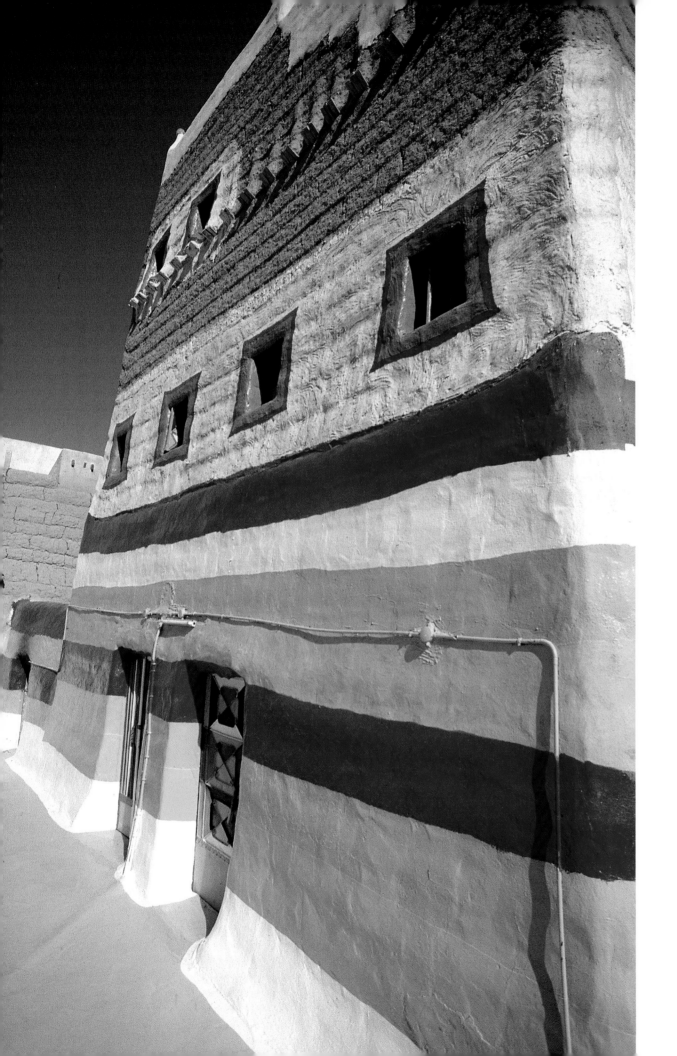

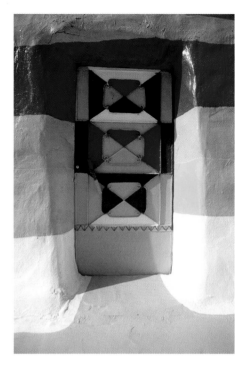

ABOVE AND FOLLOWING PAGE:
*These metal doors impose their metalwork designs on the colorist.*

*The different façades are personalized more through changes in color and arrangement, than differences in surface structure (Bilad Qahtar, Sinhan).*

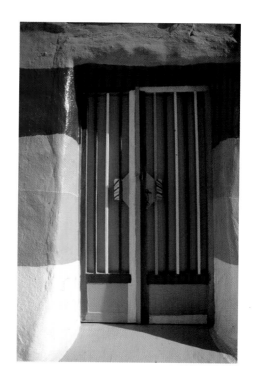

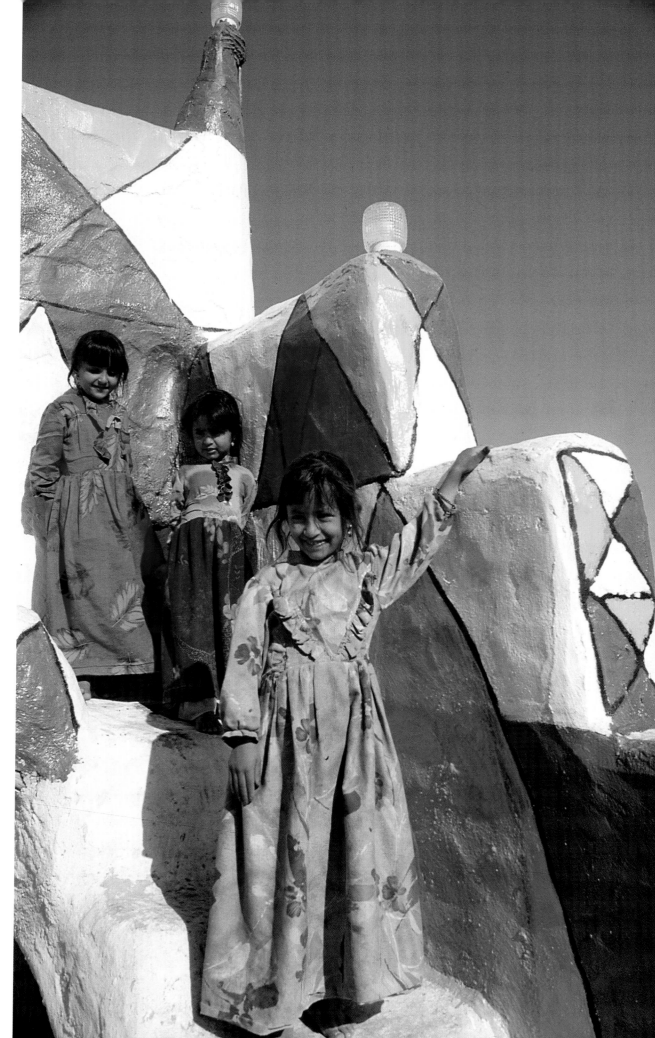

*A house shuts us in, so we need to feel free.*
*Through its ridged terrace, it opens up*
*to the sky and provides the women with*
*an area away from the eyes of men.*

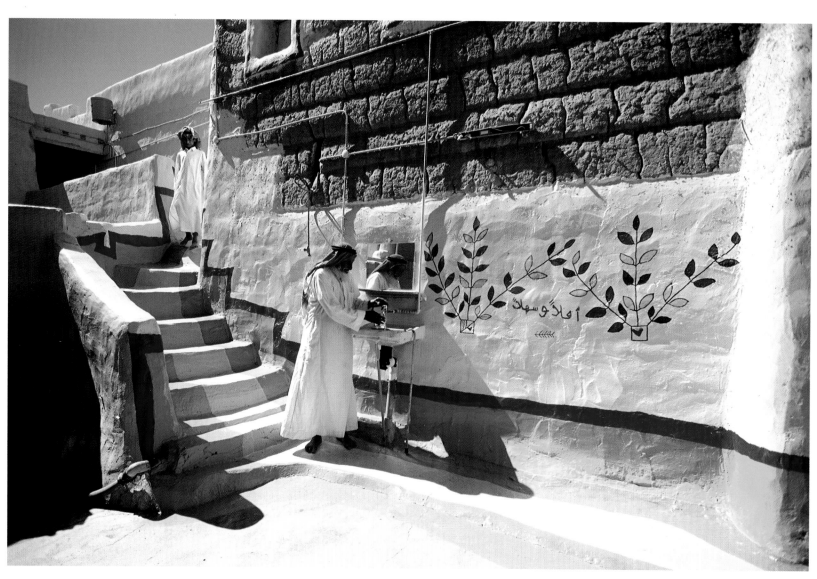

*The washstand on the way to the* majlis,
*expressing the exuberance of abundant water,*
*the glorification of the symbols of cleanliness,*
*ritual purity, purification and welcome*
*(Bilad Qahtan, Sinhan).*

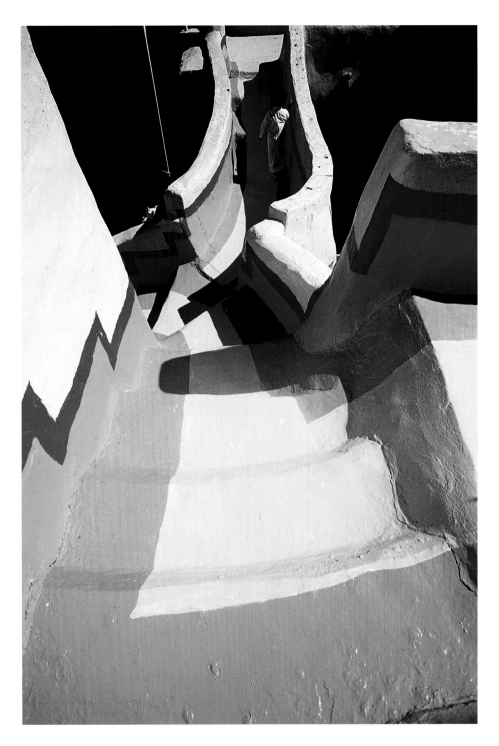

*An open-air staircase seen from above.*
*Its color scheme shows that there have been*
*changes in color sensitivity. Witness the pink,*
*a second category color, symbolically speaking.*

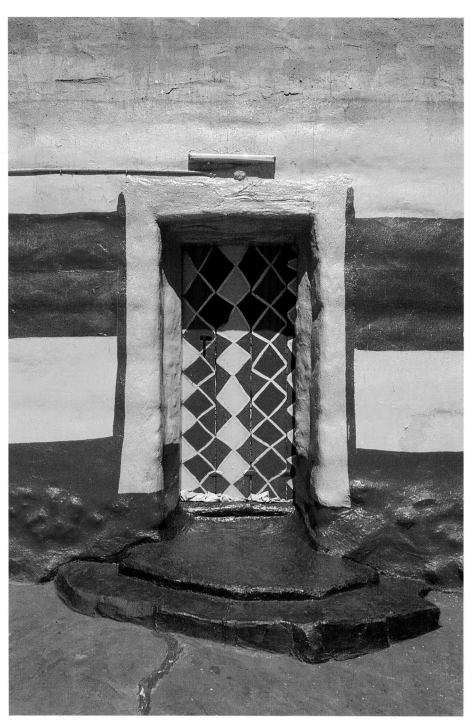

ABOVE: *The constant desire to decorate the door, and paint the steps, derives from the need to increase their symbolic value as thoroughfares. The key, set in a slot, allows the sliding-bolt lock to be operated (Bilad Qahtan, Sinhan).*

RIGHT: *Detail of a fresco composed of horizontals, in each of which an elementary design is multiplied over and over within that section. Rhythm is obtained by alternating the repetition of three colors.*

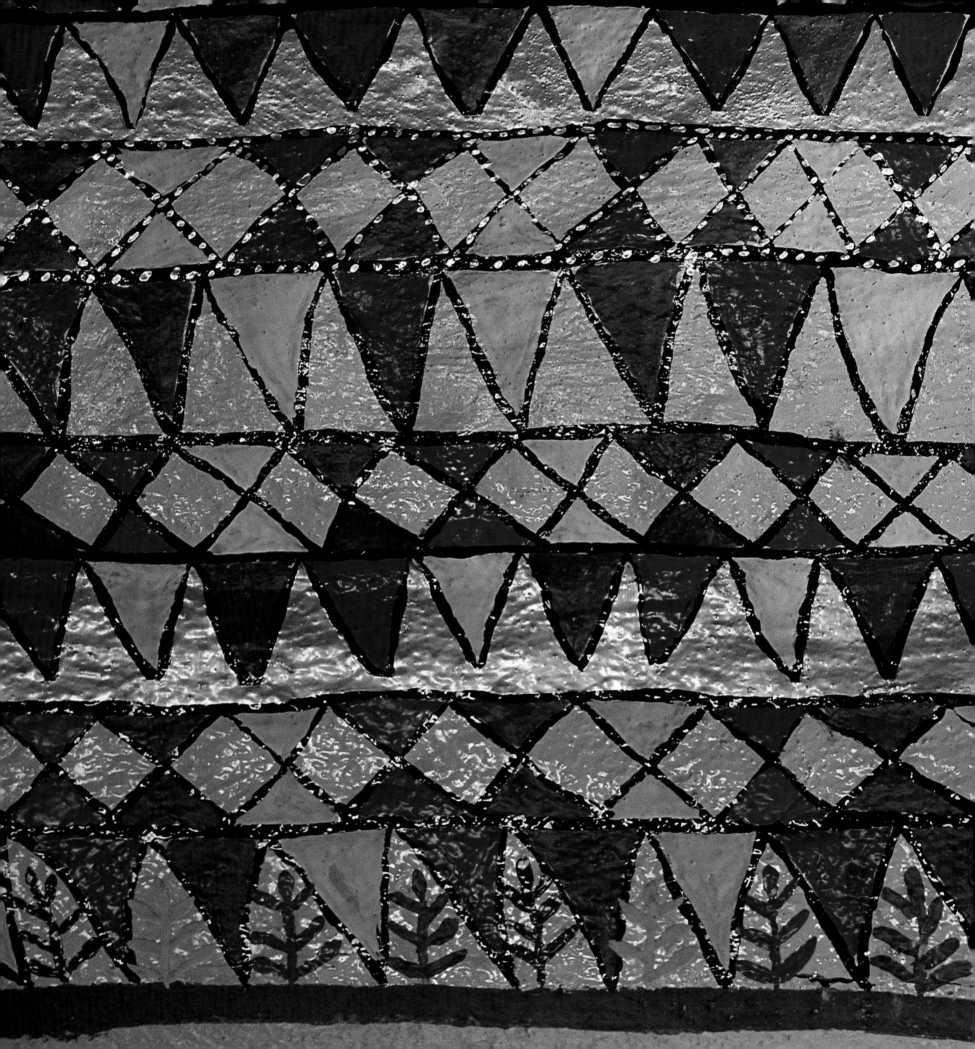

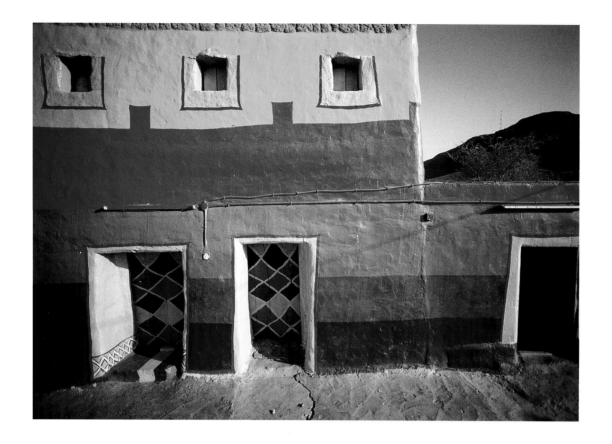

*Can it be denied that the women paint with relish? If this façade must be seen as a conflagration of color, the choice of shades and their distribution do create a somewhat heavy effect (Bilad Qahtan, Sinhan).*

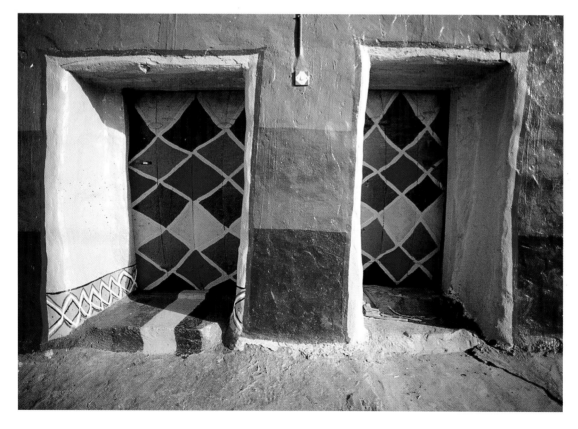

*These elaborately designed doors could be part of a harlequin costume.*

92

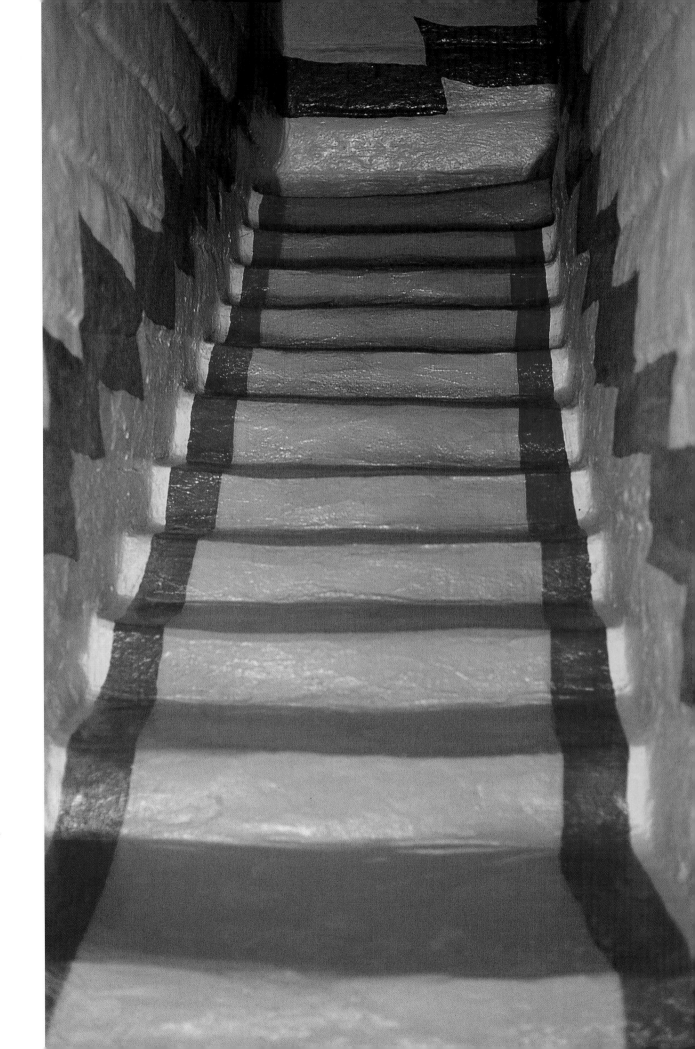

RIGHT: *A flight of stairs unrolling its painted carpet and casting a blue shadow on to its winged sides.*

FOLLOWING DOUBLES PAGES: *Coming in and going out are not symmetrical movements, nor do they have the same value. Passing from the outside to the inside is strongly marked by this staircase. Only the risers are decorated with diamond shapes, the treads being simply one color. Thus the staircase appears much more ostentatious on the way up than coming down (Bilad Qahtan, Sinhan).*

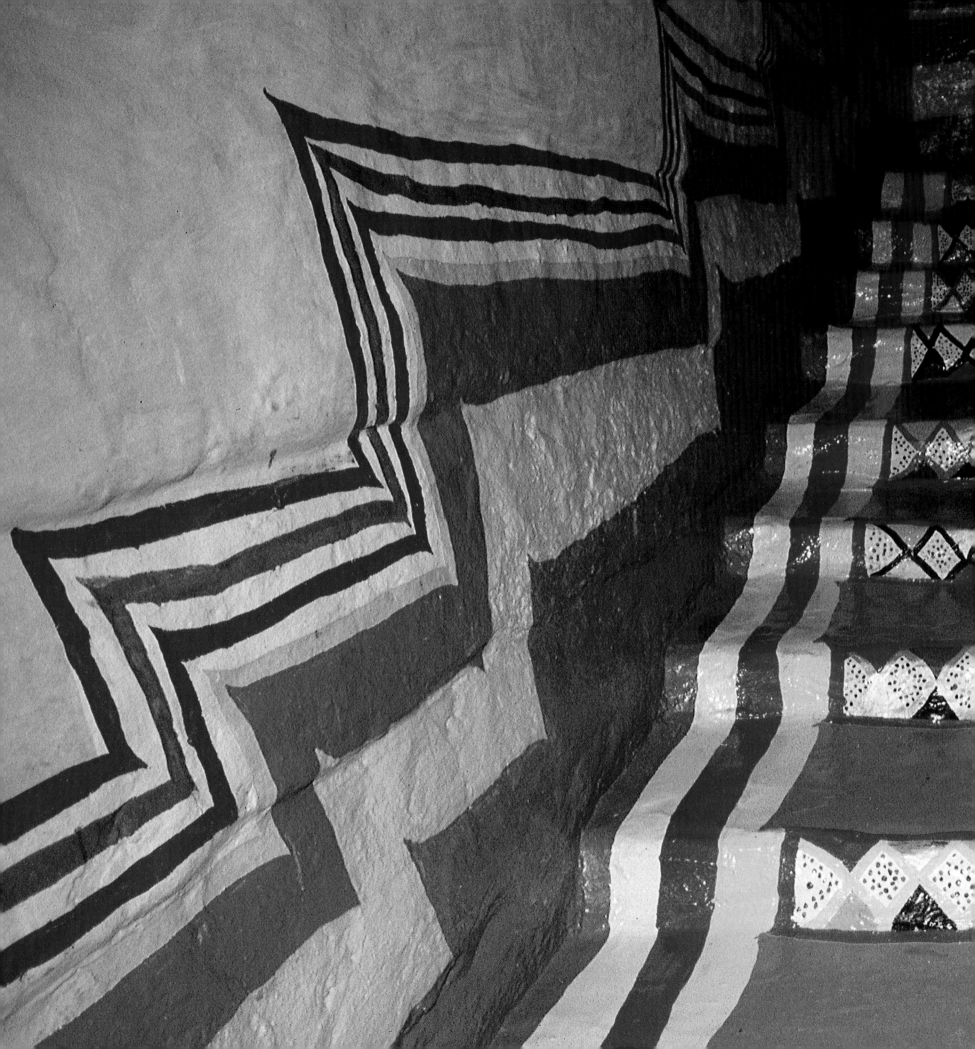

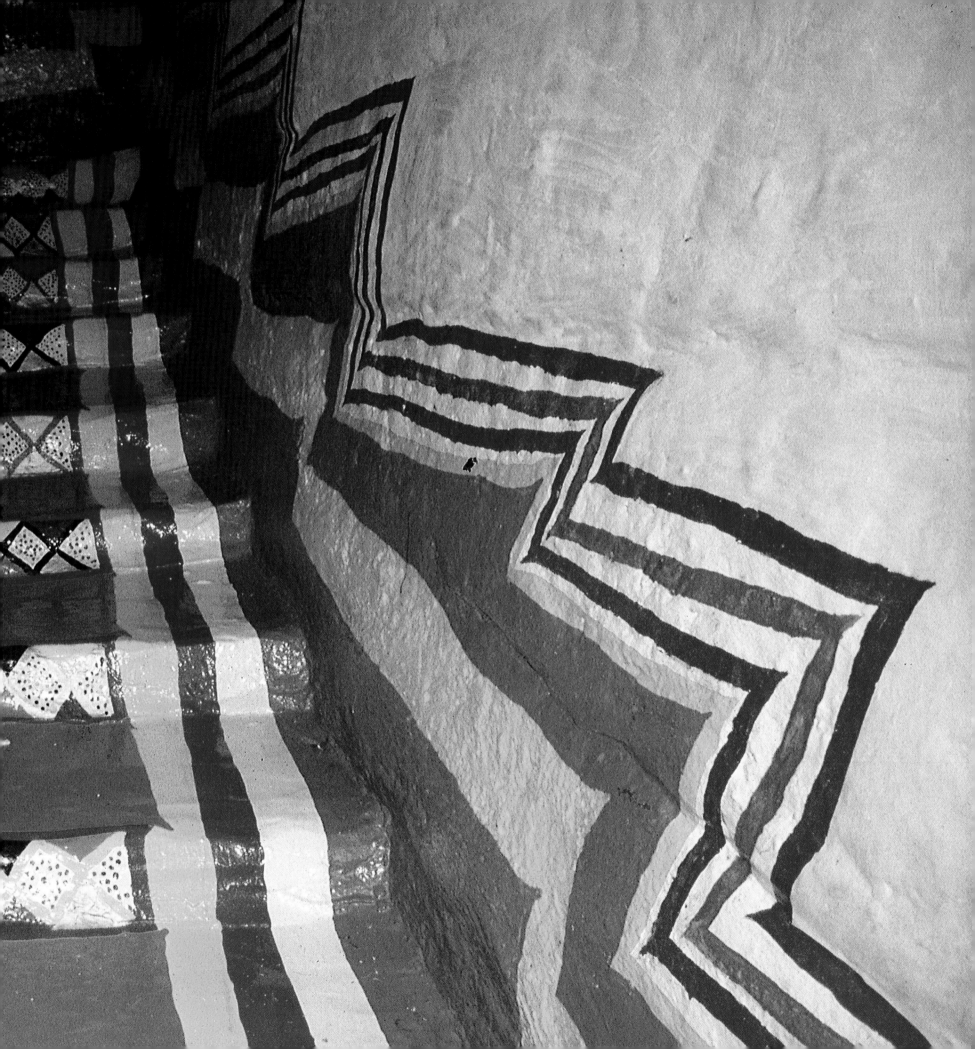

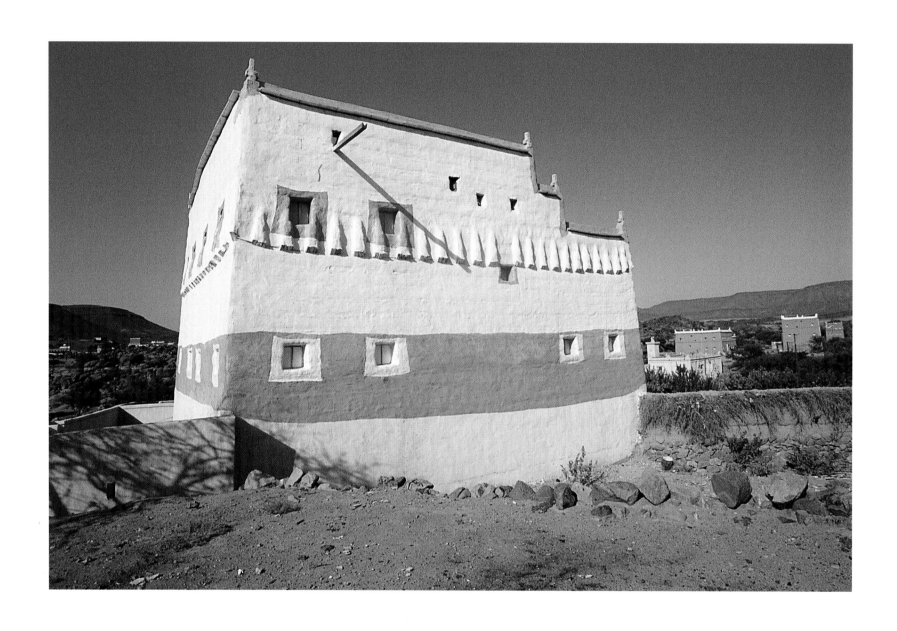

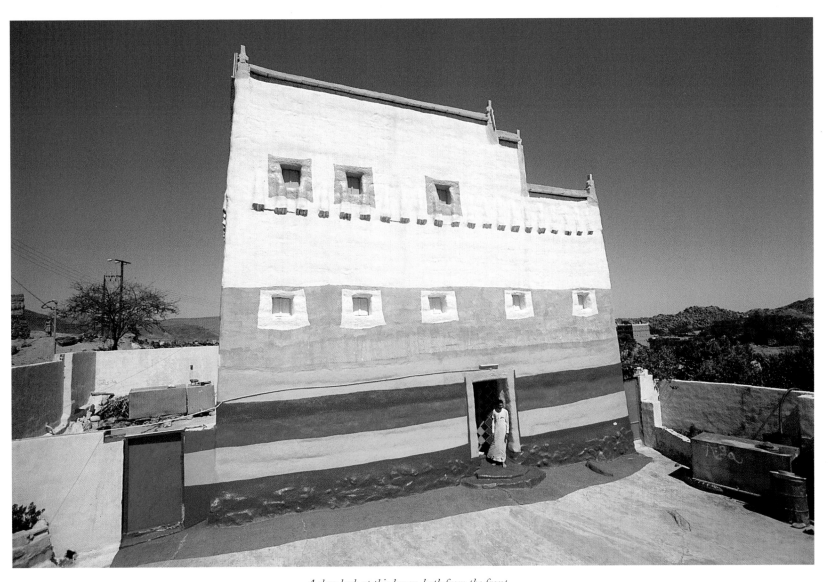

*A close look at this house, both from the front
and the back, shows that most effort went
into the appearance of the façade. For the rest,
the colorist played on a contrast of values,
sometimes positive, sometimes negative: blue on
white, white on blue (Bilad Qahtan, Sinhan).*

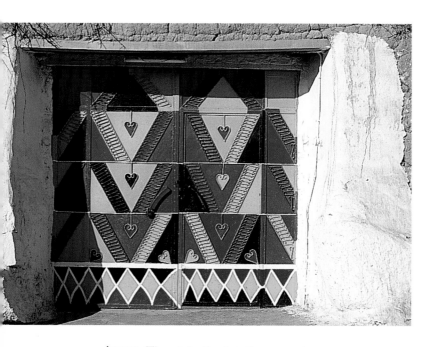

ABOVE: *The gate leading into the courtyard serves as the support for some ostentatious, esthetic expression (Bilad Qahtan, Sinhan).*

RIGHT: *Opening the right side, we glimpse the façade, where the same multicolored display is found.*

FOLLOWING PAGE: *Bare mud and multicolored fresco have equal shares of the façade. We can better appreciate the elegance of the materials and the beauty of the molding. The subtlety shown by the painter, in the color relationship between the door outlines with the yellow background, (a relationship which avoids any visual break), illustrates a search for perfection which will be confirmed by the interior frescoes.*

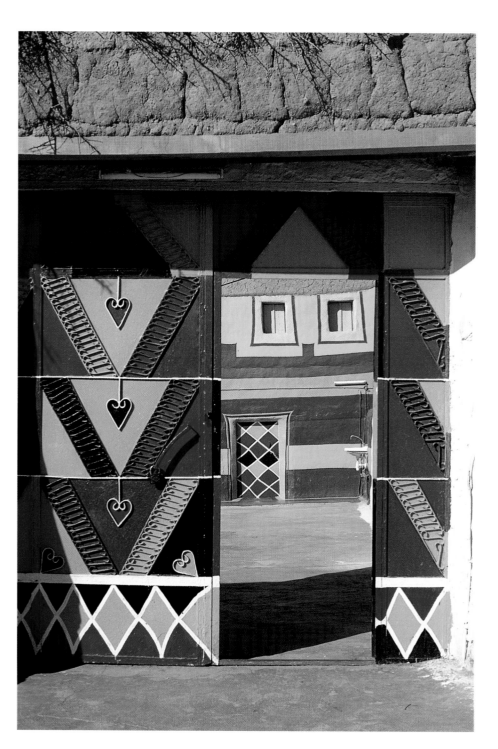

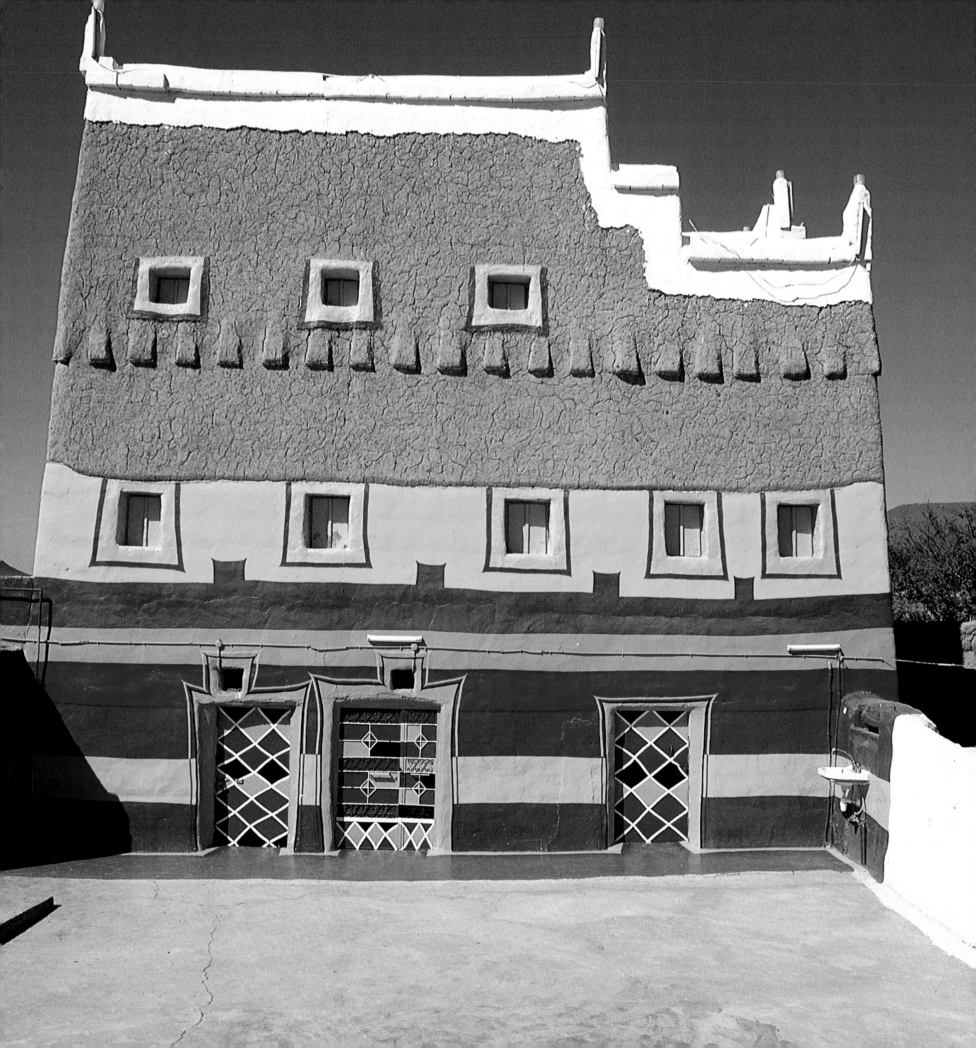

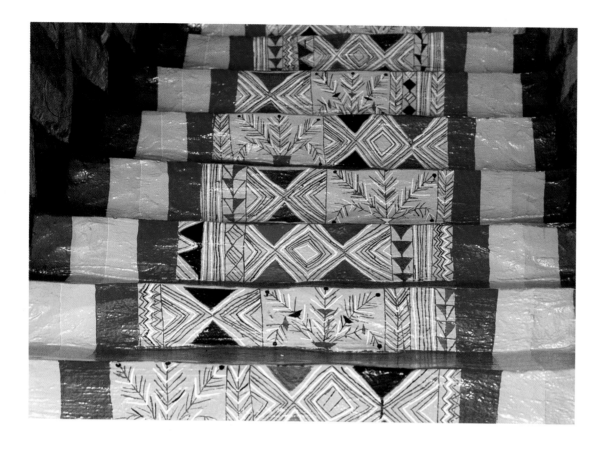

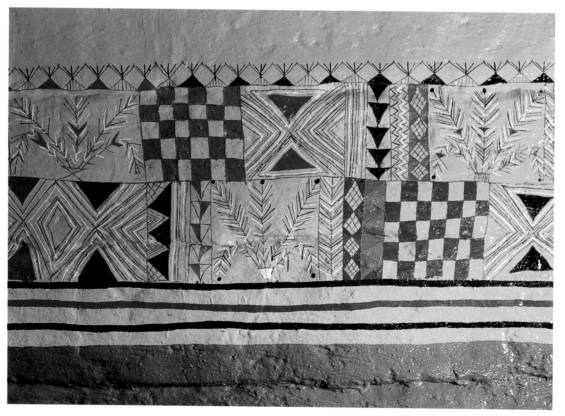

ABOVE AND LEFT: *From the façade to the interior frescoes, the painter shows a predilection for yellow. The subjects, based on a combination of geometric and floral styles, seem lacquered.*

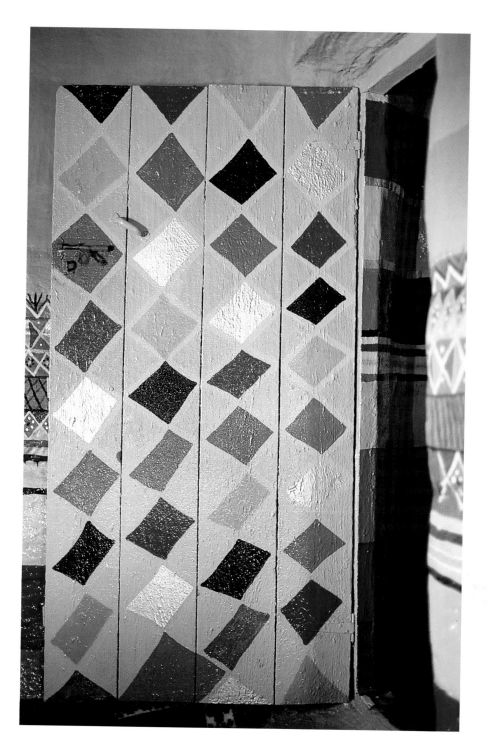

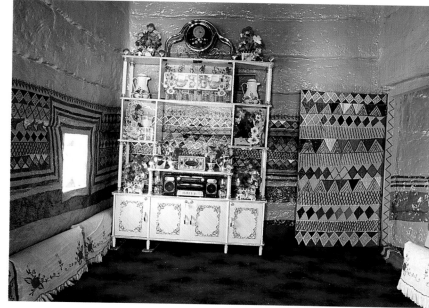

LEFT: *Breaking with the tonality
of the frescoes, this door leads to the* majlis.
*The boards making it up structure
the fresco in vertical lines, filled by the
diamond-squares pointing downwards.*

ABOVE: *Added to the frescoes are the
ostentatiously displayed signs of wealth:
the shelf-unit laden with bibelots,
a radio, clock, box of Kleenex, coffee pots,
artificial flowers, etc.*

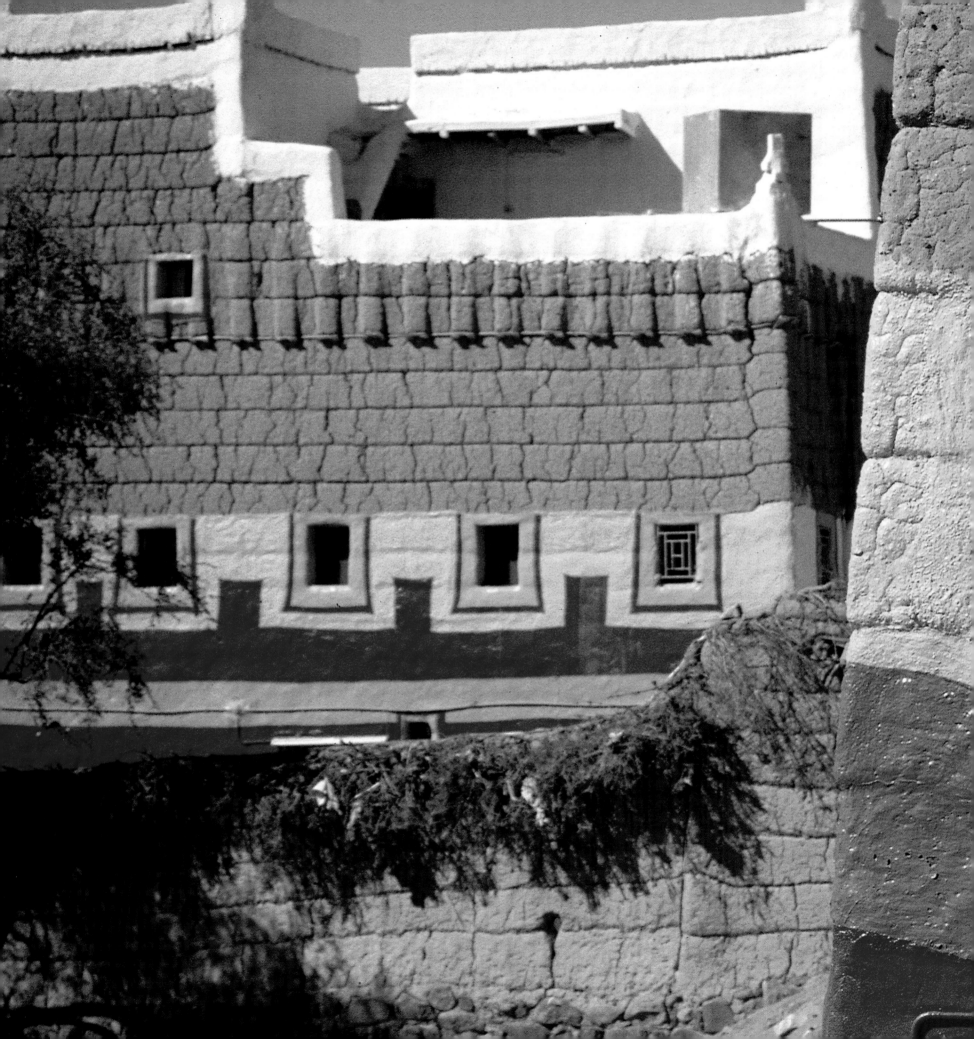

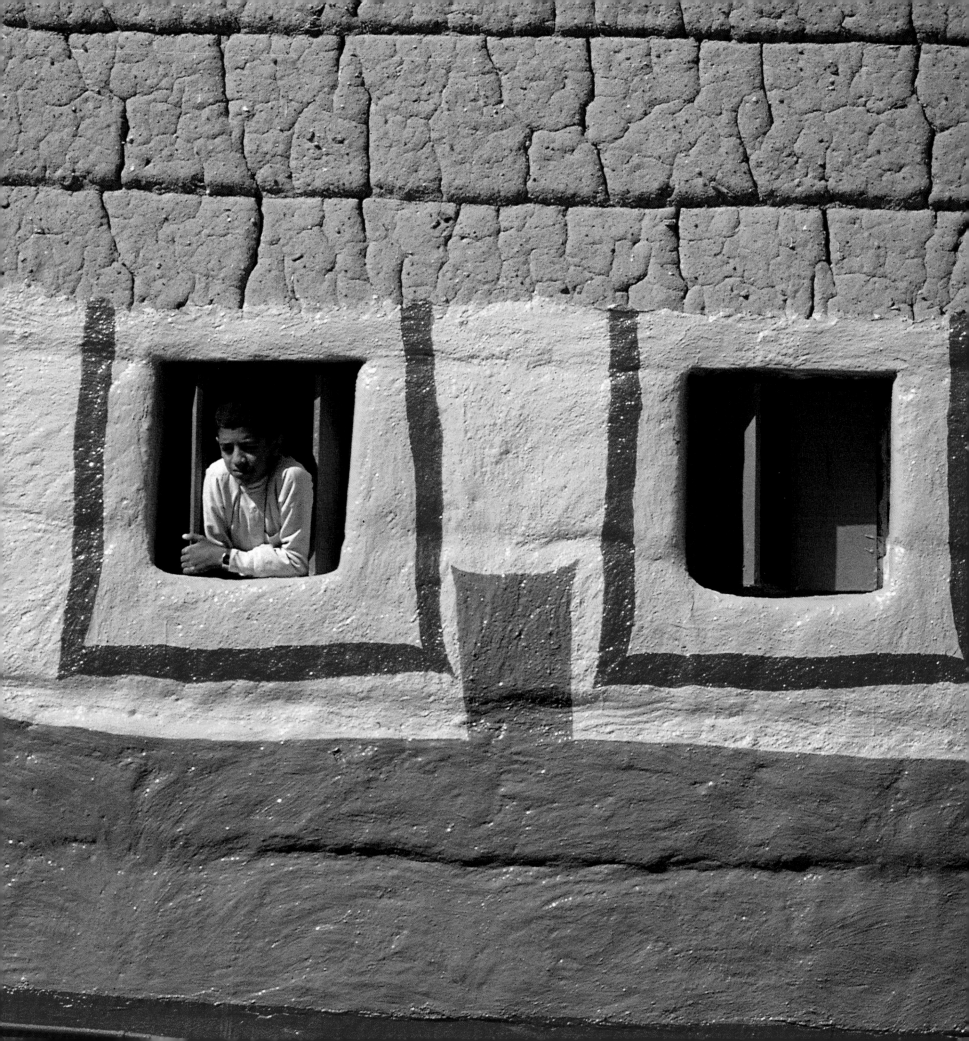

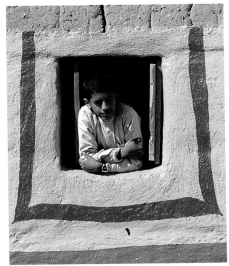

*This child's head bursts out of the painting formed by the colored façade.*

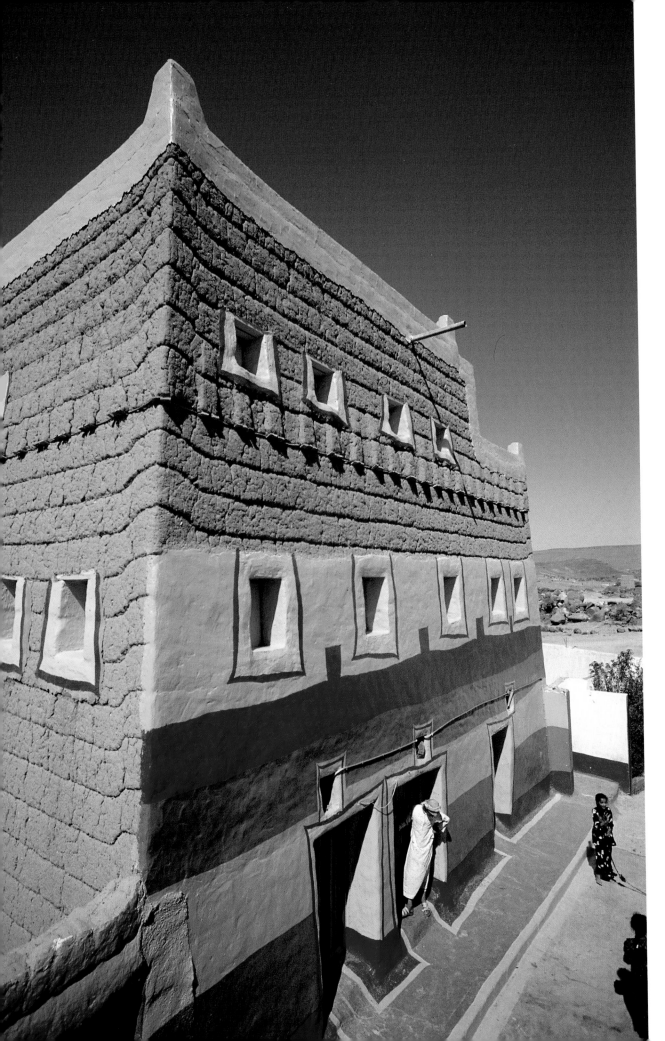

LEFT: *For reasons of accessibility, the bare mud and the colored area have equal shares of the façade.*

PREVIOUS DOUBLE PAGE: *The village of Zohra spreads its front of multicolored façades. From one house to the next, the window surrounds create a constant color link (Bilad Qahtan, Sinhan).*

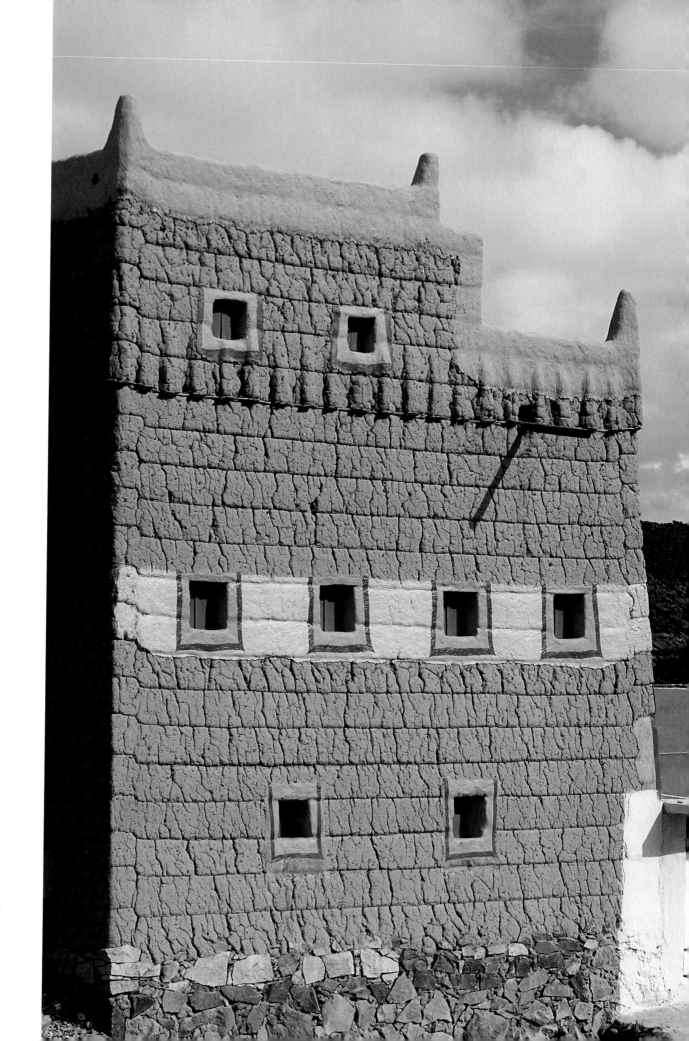

*The house's face becomes wrinkled due to its clay and straw mortar; over time, vertical fissures develop which do not usually pass from one layer to the next. The wall then looks as though it has been built of huge blocks piled on top of each other.*

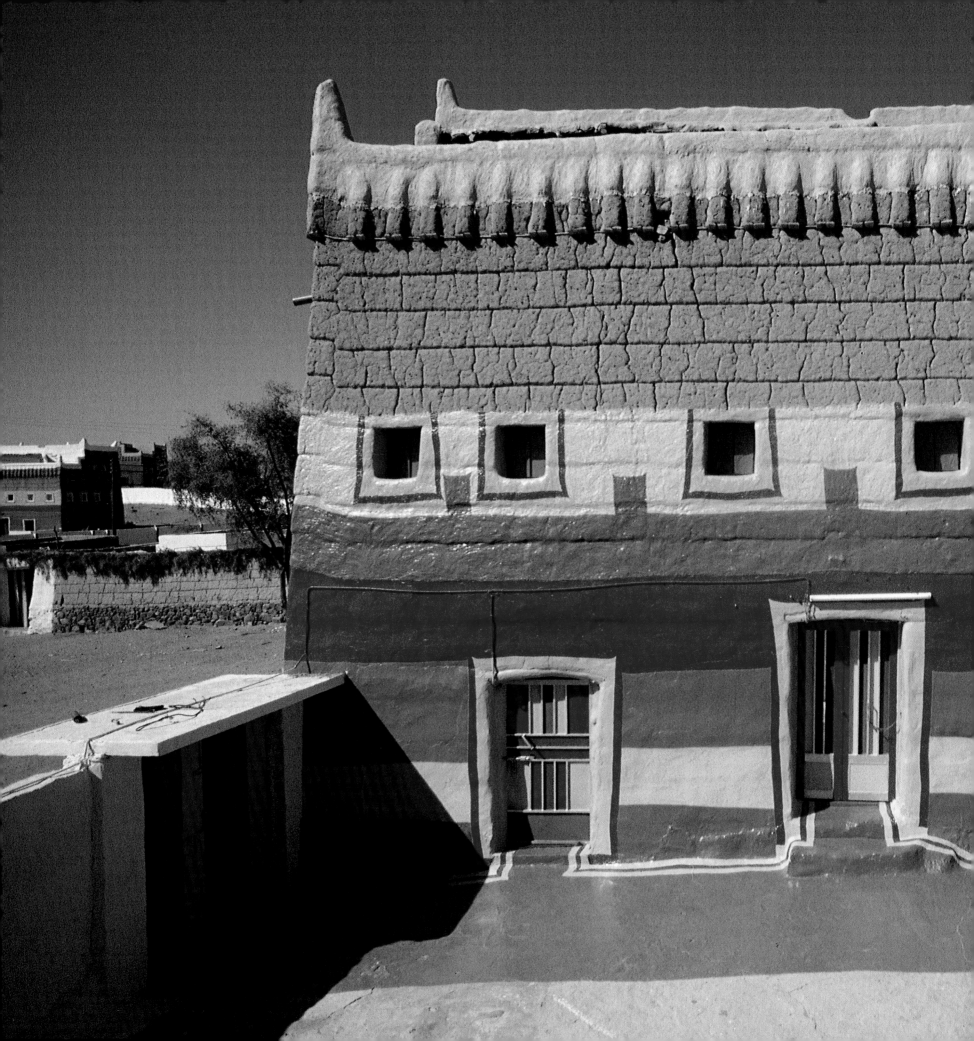

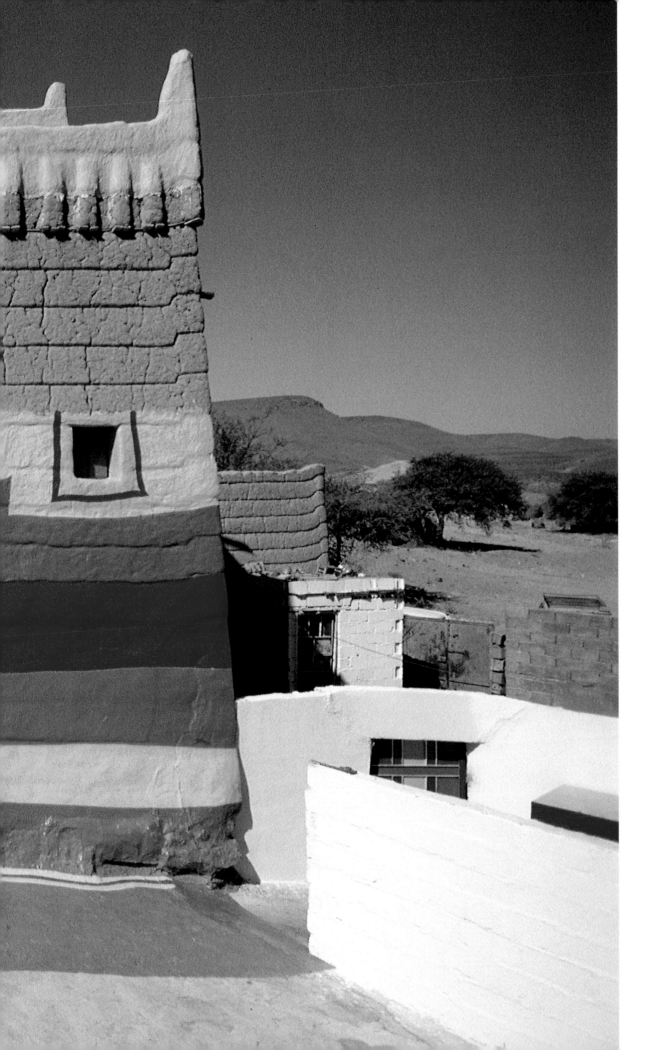

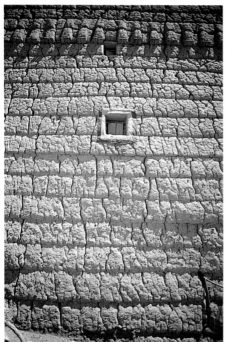

*If most effort went into the appearance of the façade, the back has at the same time been assigned a contrastive value. Only tiny openings sparingly light the staircase.*

*The colors chosen for the façade of the previous house are found again on this one, but they are arranged differently, giving the façade a character of its own (Bilad Qahtan, Sinhan).*

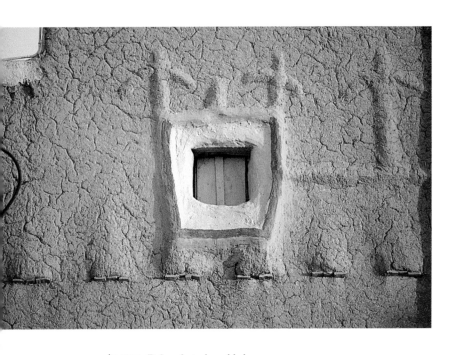

ABOVE: *Palm-shaped, molded designs above a window.*

RIGHT: *The interior is reflected by these painted shutters (Bilad Qahtan, Sinhan).*

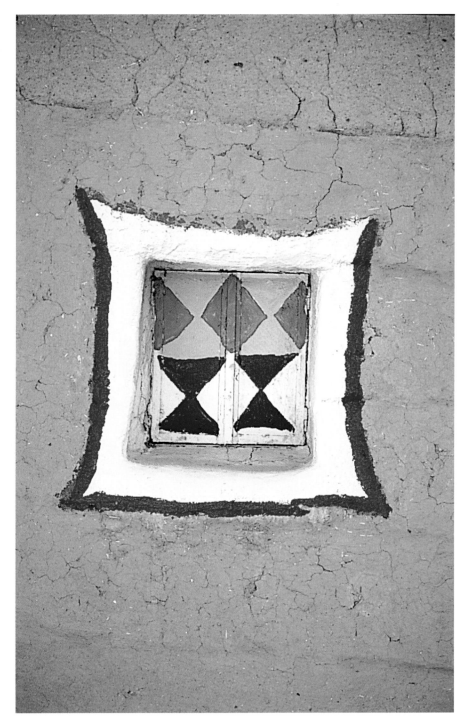

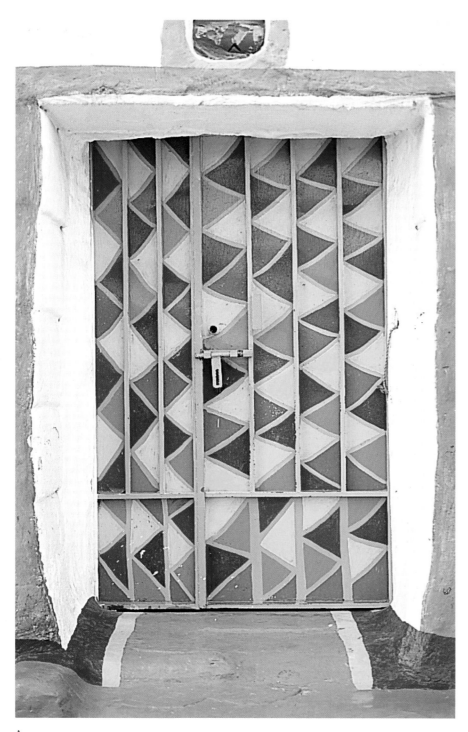

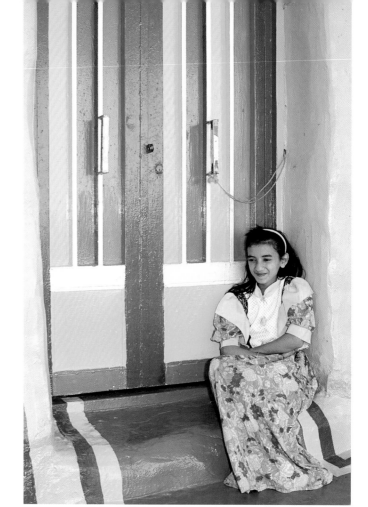

On this metal door, the colored area is expressed by an unbreakable solidarity with the metalwork, whose austerity is countered by this little girl's flowery dress.

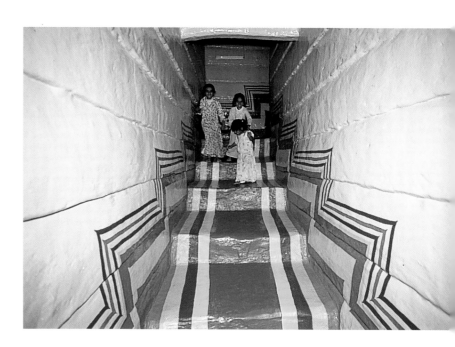

ABOVE AND BELOW RIGHT:
Although the designs are different, the doors and staircase are part of the same color scheme as the façade.

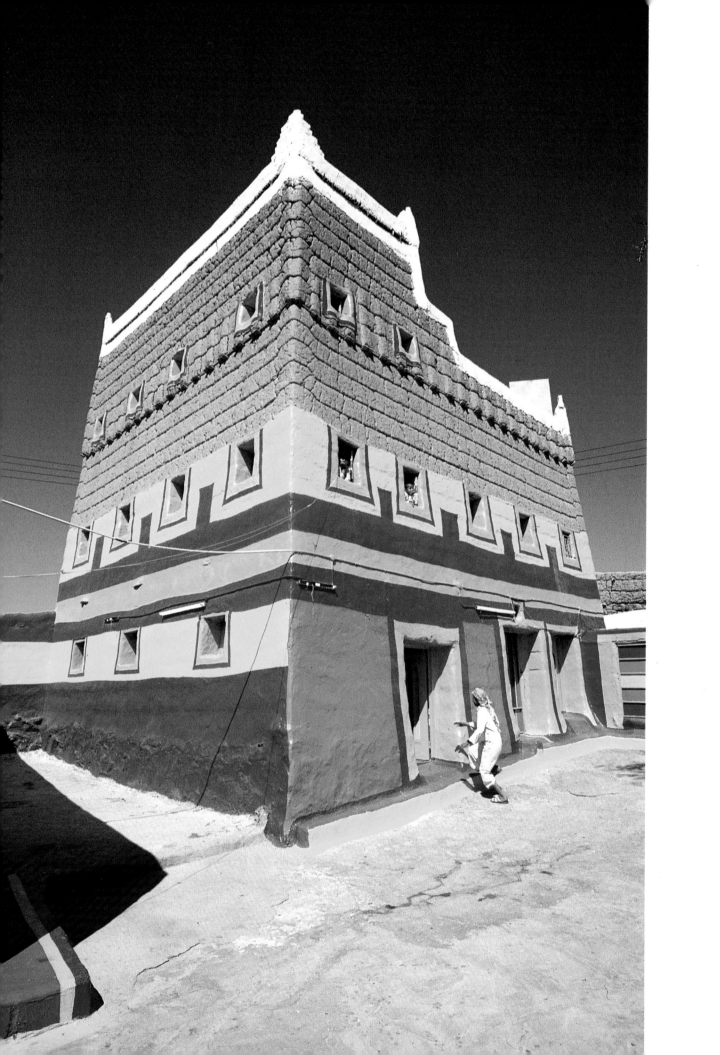

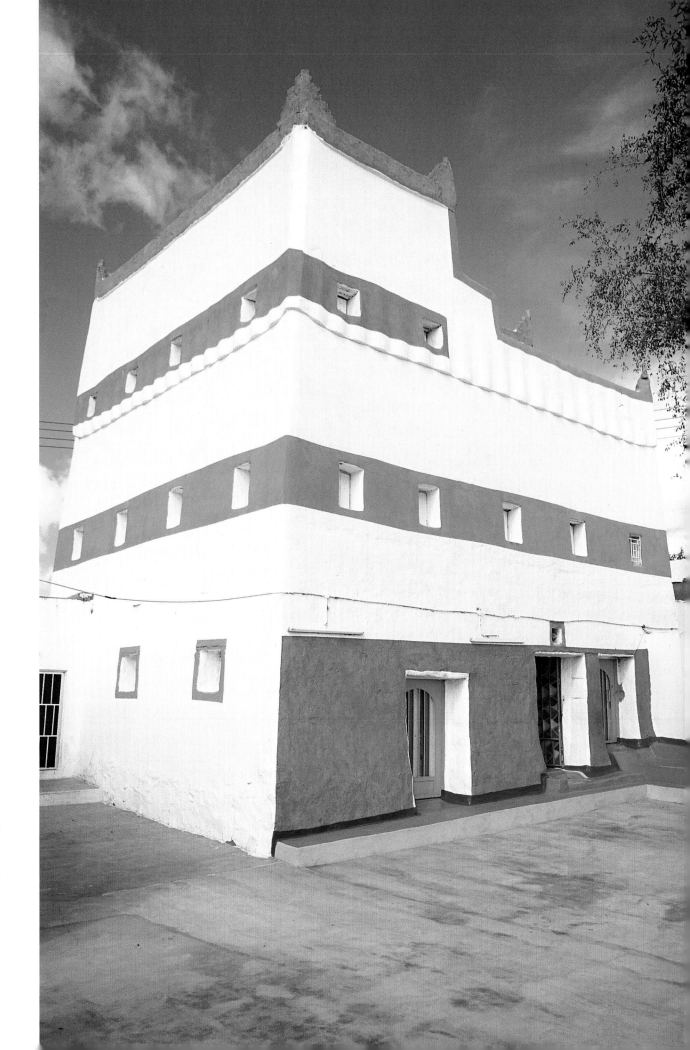

These two photographs taken at the same place, at an interval of several years, display considerable differences, so much as to make the original work unrecognizable, breaking the unity with the interior frescoes. This process seems to show that there is less enthusiasm for gaudy feats of daring. Only the openings still provide a colored counterpoint to this show of restraint. The top line of the house confirms that white and blue can be completely swapped over, in areas of exchange between exterior and interior.

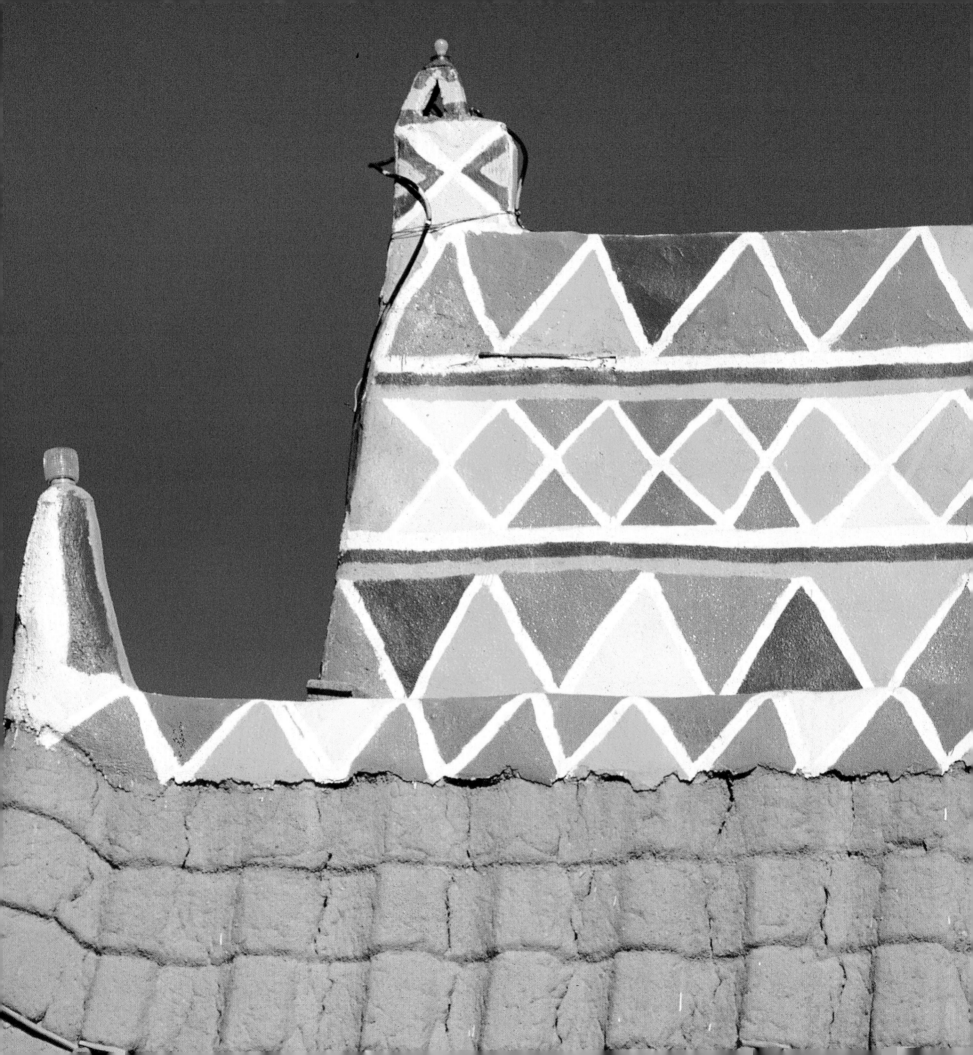

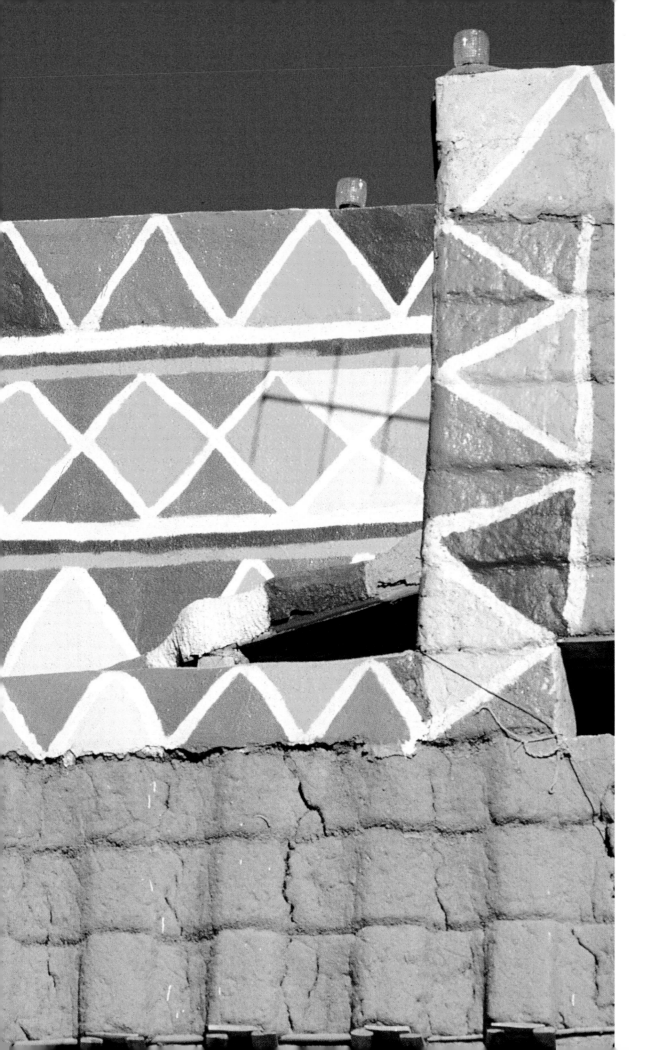

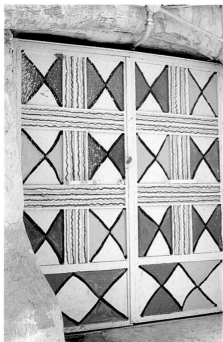

*On this gate, a "random" spread of colors saves it from the mechanical regularity of the designs. The only rule is that of conspicuousness, prohibiting the same color being used for contiguous designs.*

*The terrace protects the women's privacy from outside eyes, whose gaze is attracted however by the brightness of the painted sides. The acroteria are used for holding lights (Bilad Qahtan, Sinhan).*

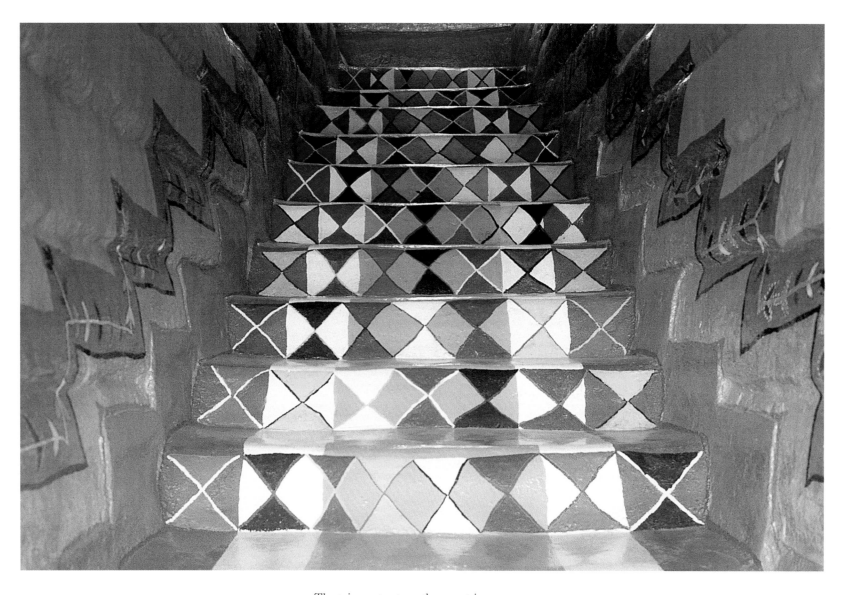

The staircase structures the geometric
arrangement spread over the risers: a frieze
of diamonds, of double triangles touching
at the base, or triangles linked at the apex.
The symmetry of the designs is completed
by an asymmetry of colors. The choice of
the latter is fundamental to bring out certain
designs, which exist only through color.
Overall, it is a highly "readable" fresco
(Bilad Qahtan, Sinhan).

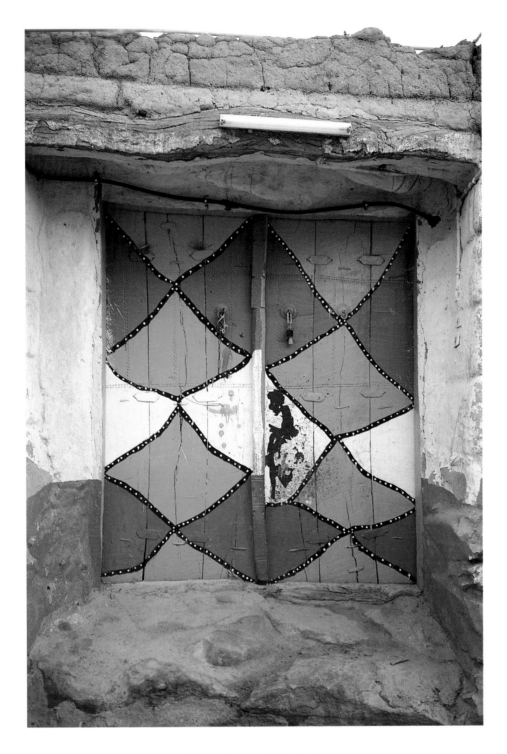

*A fresco like an old flag with tired colors—the background against which strangely buckled diamonds are flattened.*

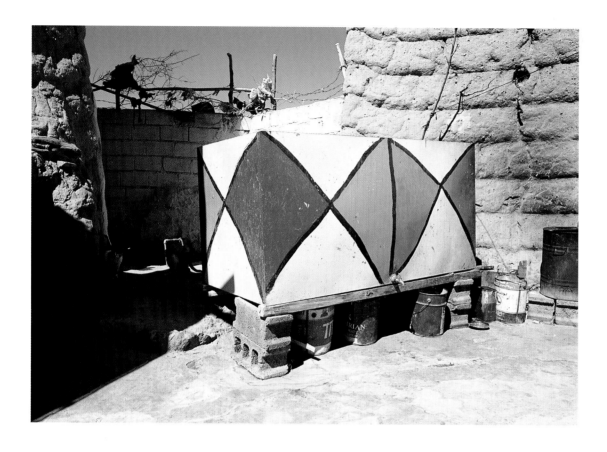

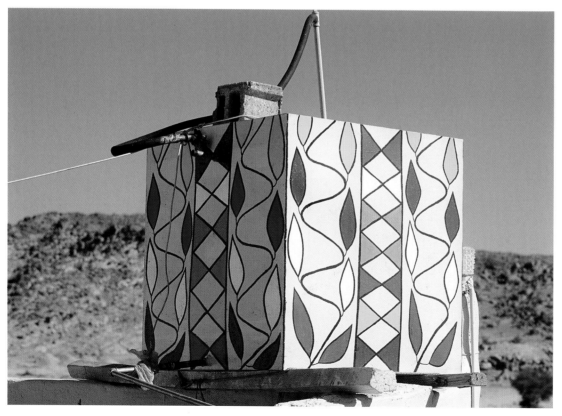

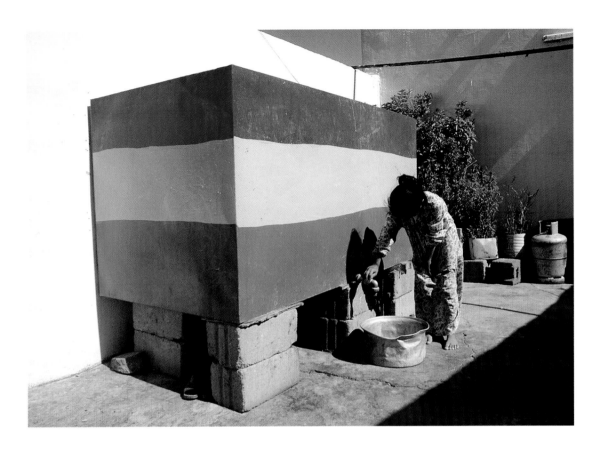

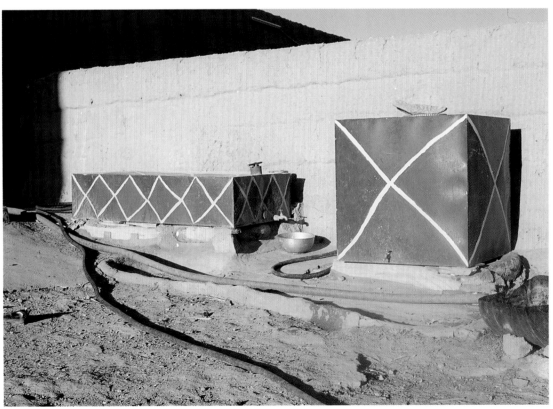

*Through their visual impact, the water cisterns seem to be signaling something. The spell would be broken by this poor alloying of mud and metal, were the cisterns not painted also (Bilad Qahtan, Sinhan).*

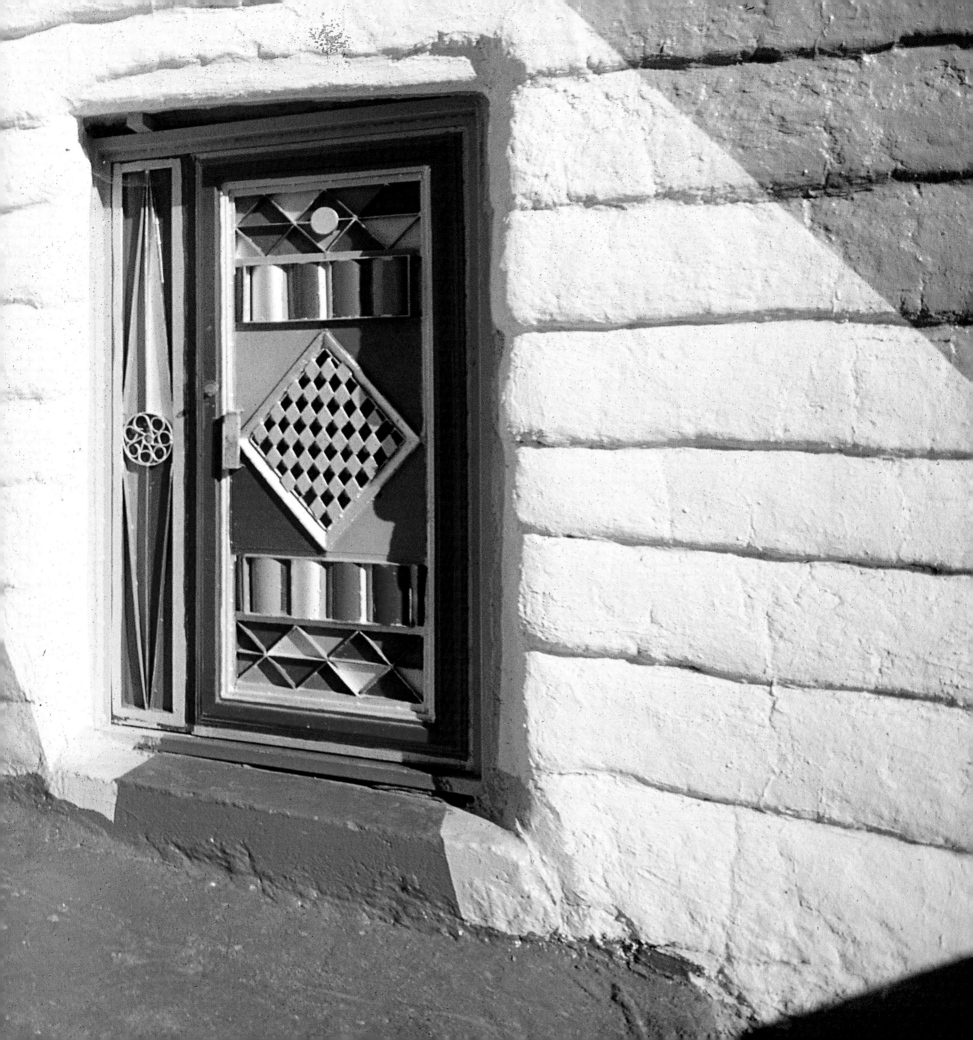

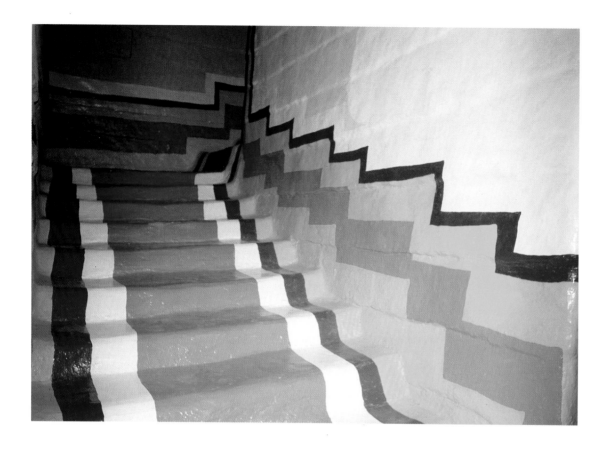

*The green wave tumbling down the staircase imposes its tonality on all the frescoes in the house (Bilad Qahtan, Sinhan).*

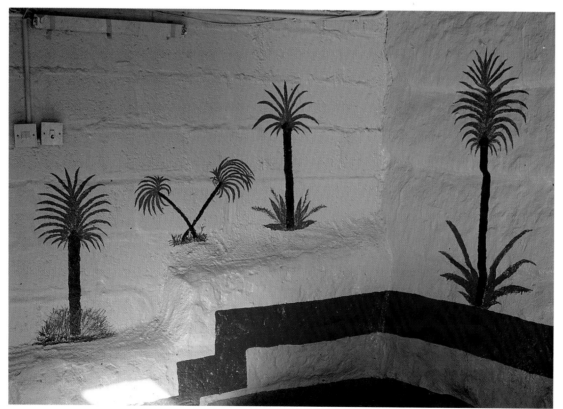

LEFT: *If there is total discontinuity between the preIslamic rock carvings and the mural frescoes, these naturalistic palms are the exception. This tree is highly charged symbolically, since it embodies fertility and abundance.*

PREVIOUS DOUBLE PAGE: *A unique example of a façade given rhythm by triangles alternately turned upwards or downwards and seeming to cancel each other out. The composition of the doors and their coloring derives from an arrangement linked to the metalwork (Bilad Qahtan, Sinhan).*

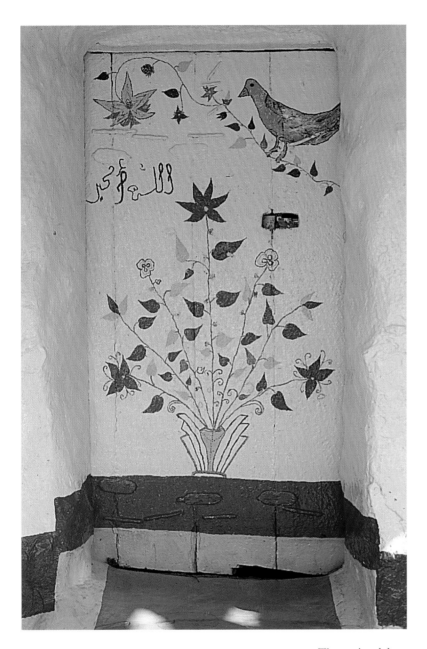

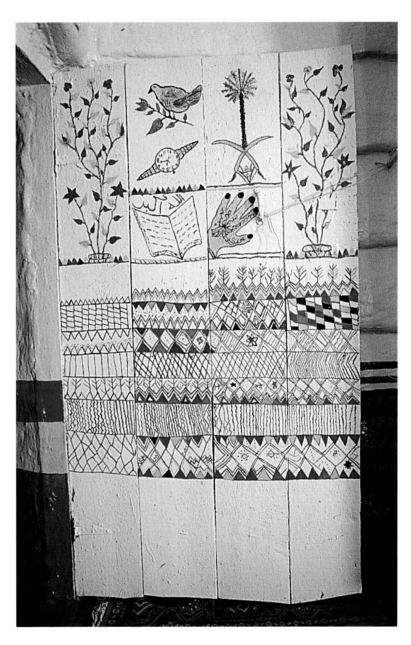

These painted doors are the nucleus of the lines of a new, more figurative theme: a bird, a watch with Arabic numerals and a decorated hand. So many untypical symbols, which are still exceptions. The depiction of an open Koran and the Kingdom's national emblem—two crossed swords beneath a palm-tree—embody the unity of the spiritual and the temporal.

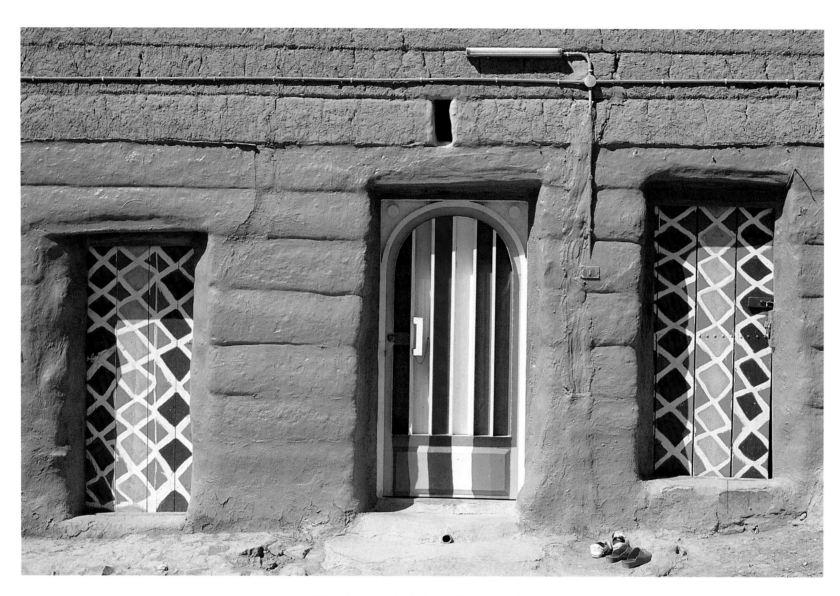

*Three doors open in the façade. The structural*
*surfaces have links with the usual materials*
*employed, metal for the main door, wood*
*for the other two (Bilad Qahtan, Sinhan).*

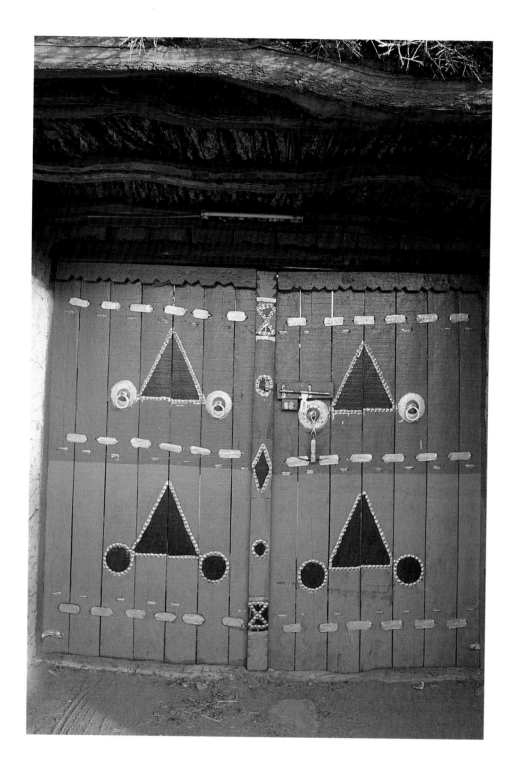

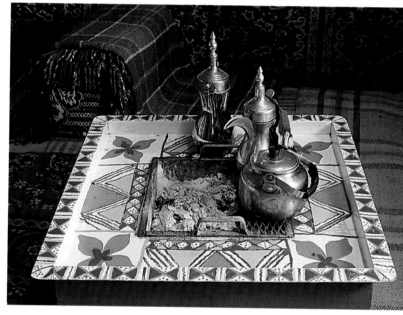

ABOVE:
*In the* majlis, *the hospitality coffeepots
and teapot are kept warm in a brazier.
A community of style characterizes the pictorial
productions, in spite of the diversity of media:
designs and colors applied to the walls are
also found on this metal brazier.*

LEFT:
*This two-paneled gate is ornamented
with ironwork and studded like a shield.
In coloring it, the painter has turned it
into a coat-of-arms.*

123

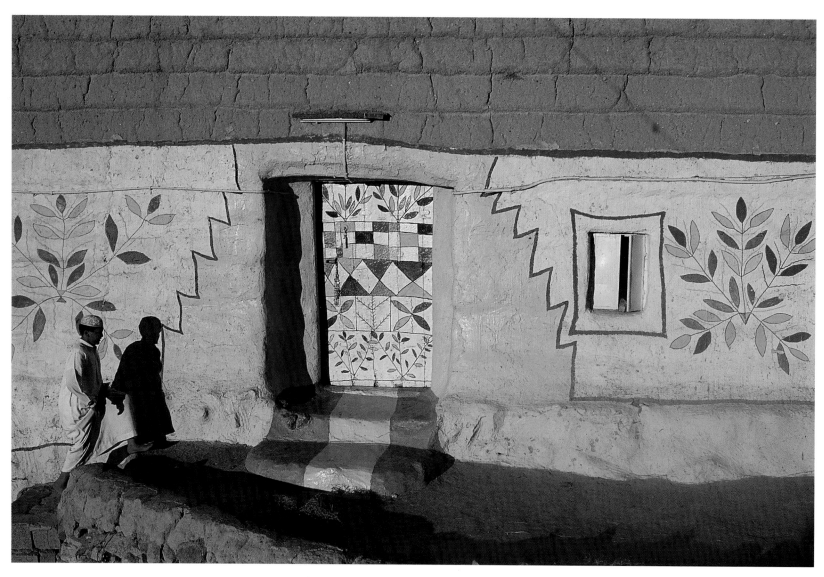

*The façade, painted as high as a man, serves*
*as a support for spreading floral decorations.*
*The geometric and floral themes on the door*
*are continued inside the house (Bilad Qahtan,*
*Sinhan).*

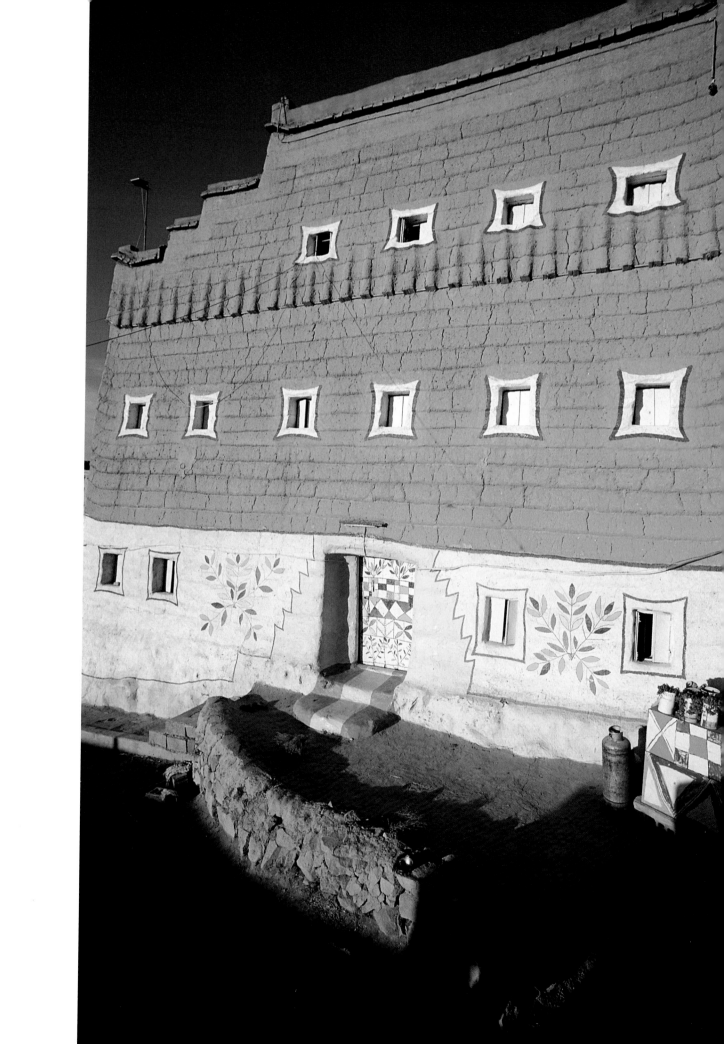

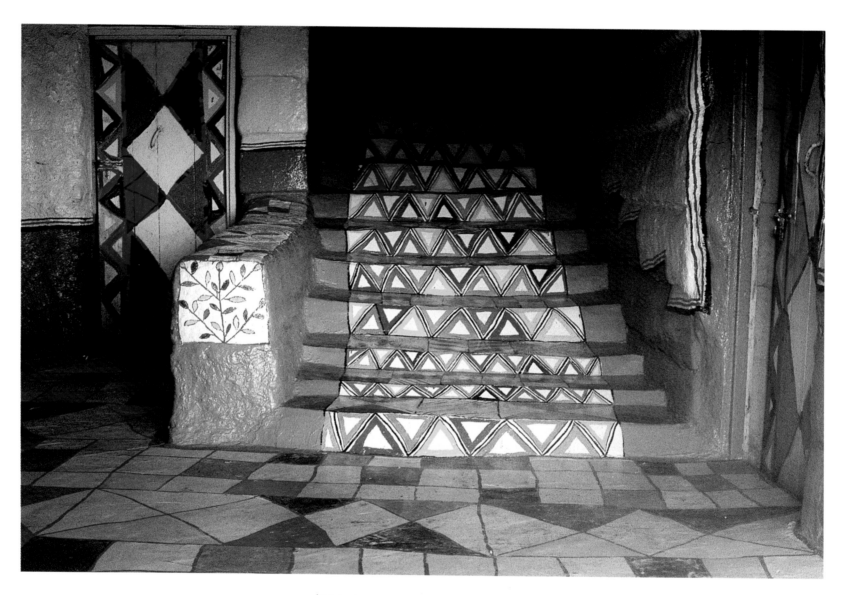

ABOVE AND FOLLOWING PAGES:
*We visit the house in a kind of cross-fade. Once
we are over the threshold, the risers display
their fronting of beveled triangles. As we come
closer, the treads reveal checkerboards, four-
petalled rosettes and floral designs combined.*

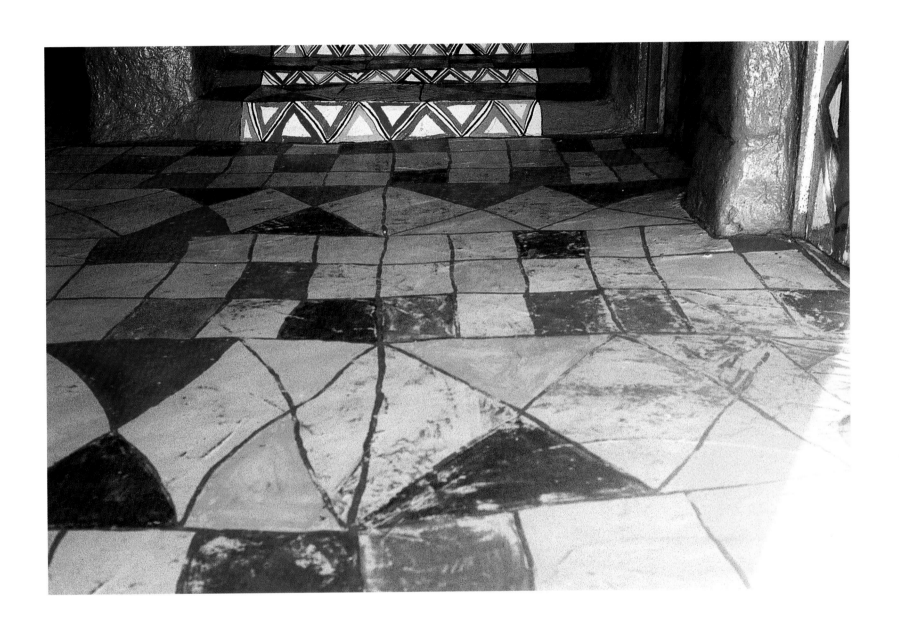

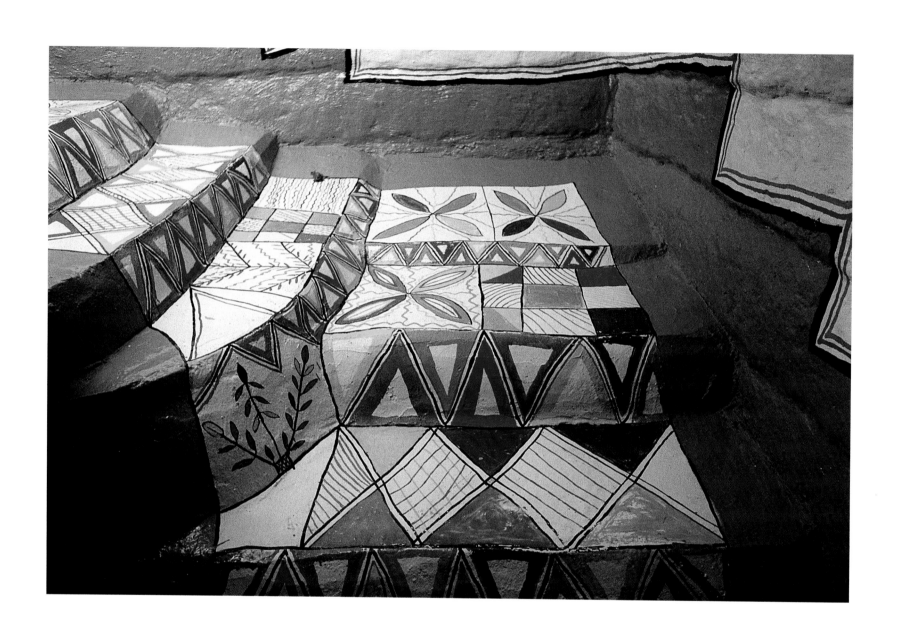

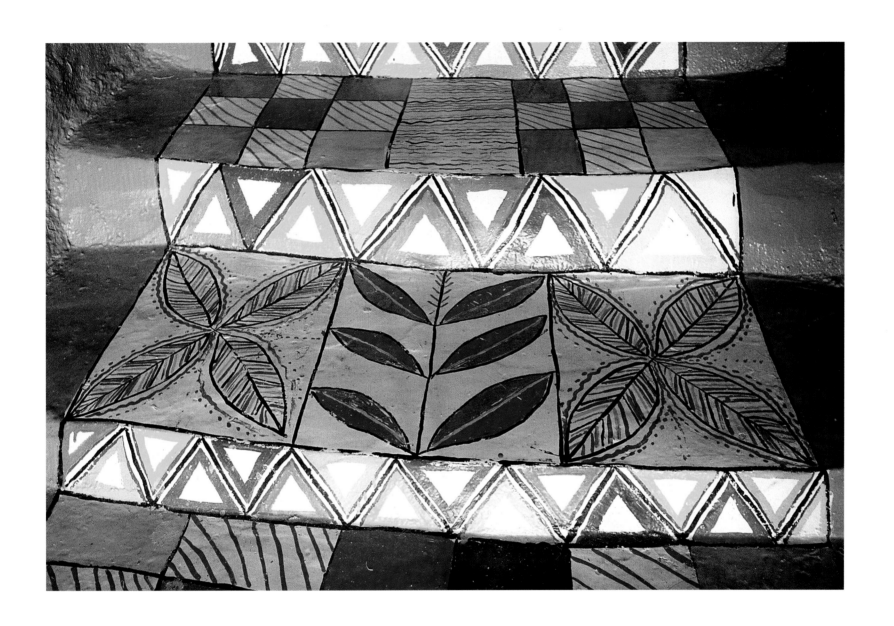

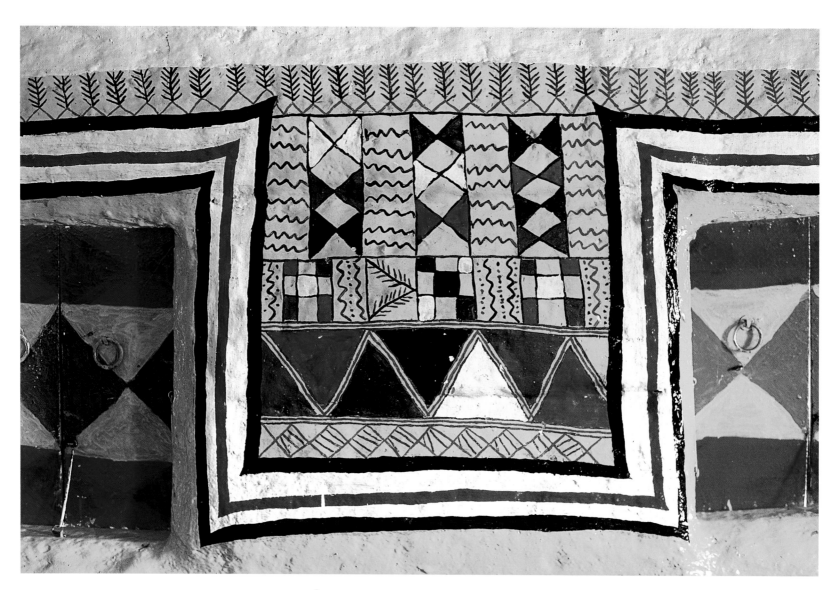

ABOVE AND FOLLOWING PAGE:
*The* majlis, *the reception room where the host
receives his guests, is a very special setting
for the master of the house. It is not at all
surprising, then, that great care has been taken
with the frescoes here (Bilad Qahtan, Sinhan).*

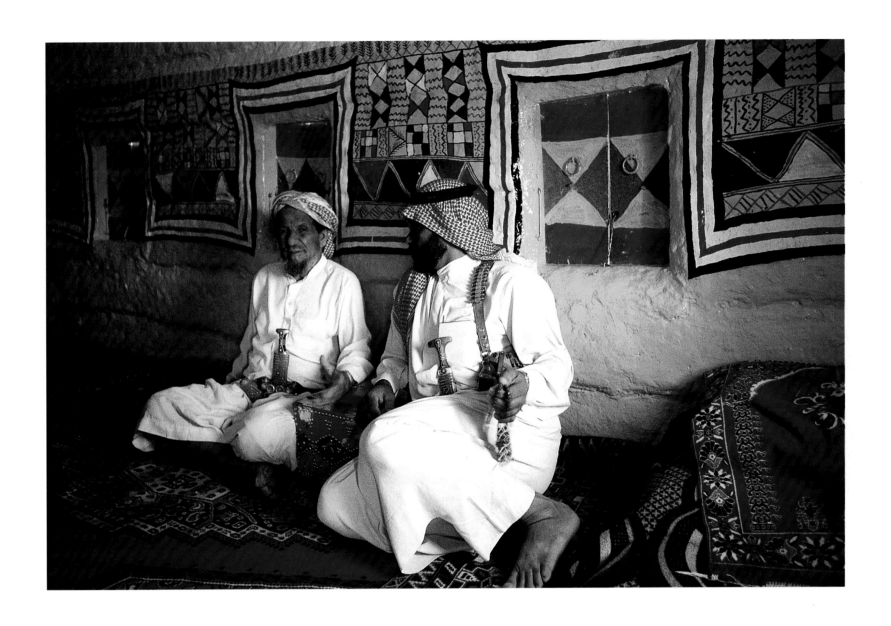

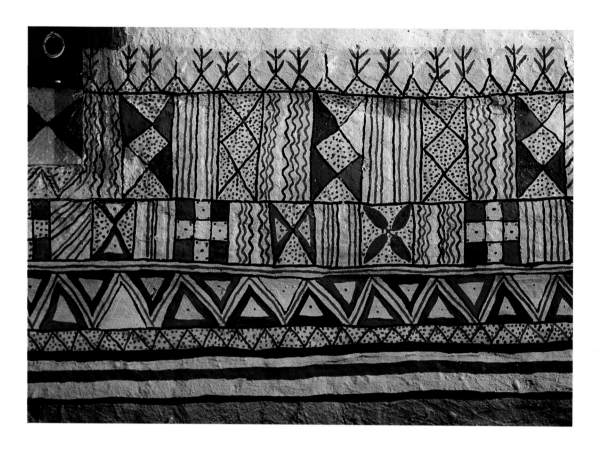

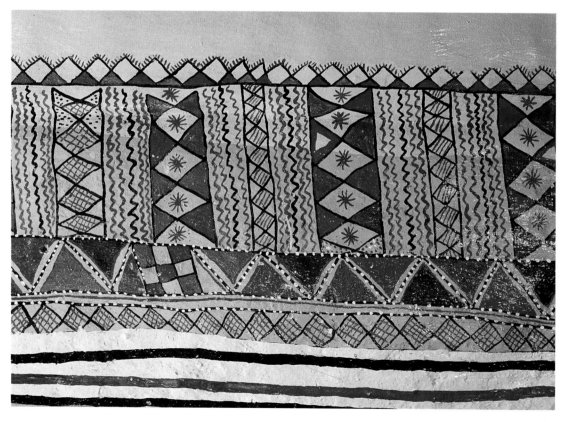

TOP AND LEFT:
*The designs combine, like a picture taking shape at the bottom of a kaleidoscope (Bilad Qahtan, Sinhan).*

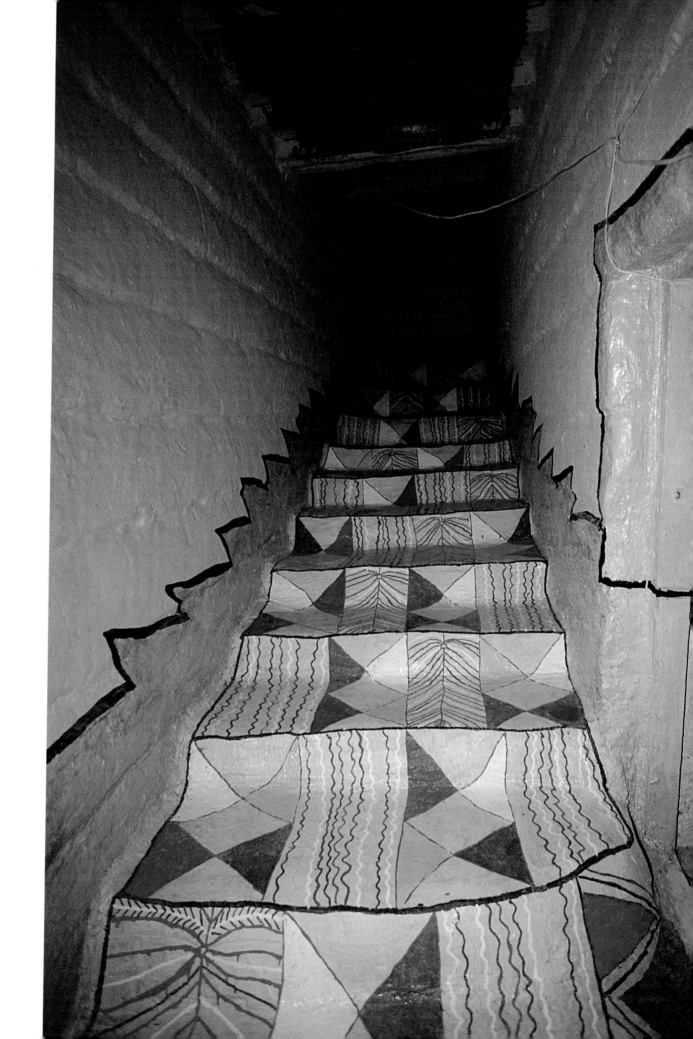

In spite of the break in color, this staircase and
the preceding frescoes do show up a common
register for the designs: pairs of diabolos and
wavy lines. So the themes circulate from house
to house, at times taken up in a different way,
but easily recognizable.

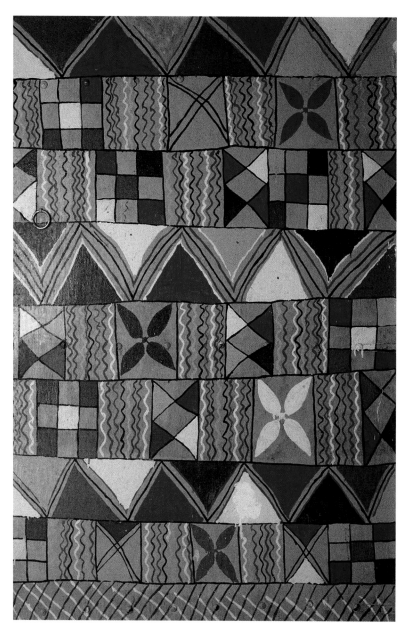

*This fresco is simply a flattening out
of the various designs spread over the preceding
staircases (Bilad Qahtan, Sinhan).*

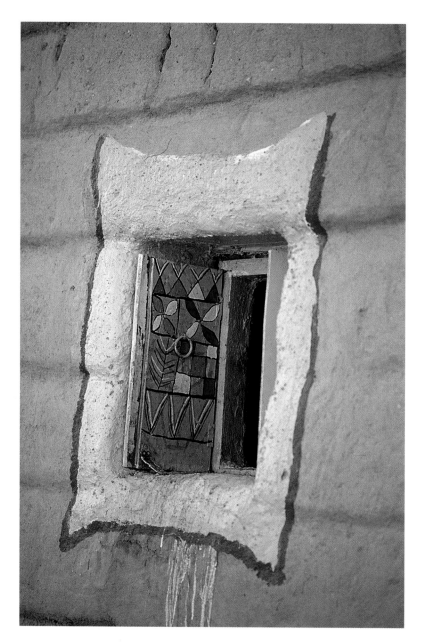

*When open, the shutters fold back against the
window recesses. They thus bring outside a sample
of the fresco that can be seen inside the room.*

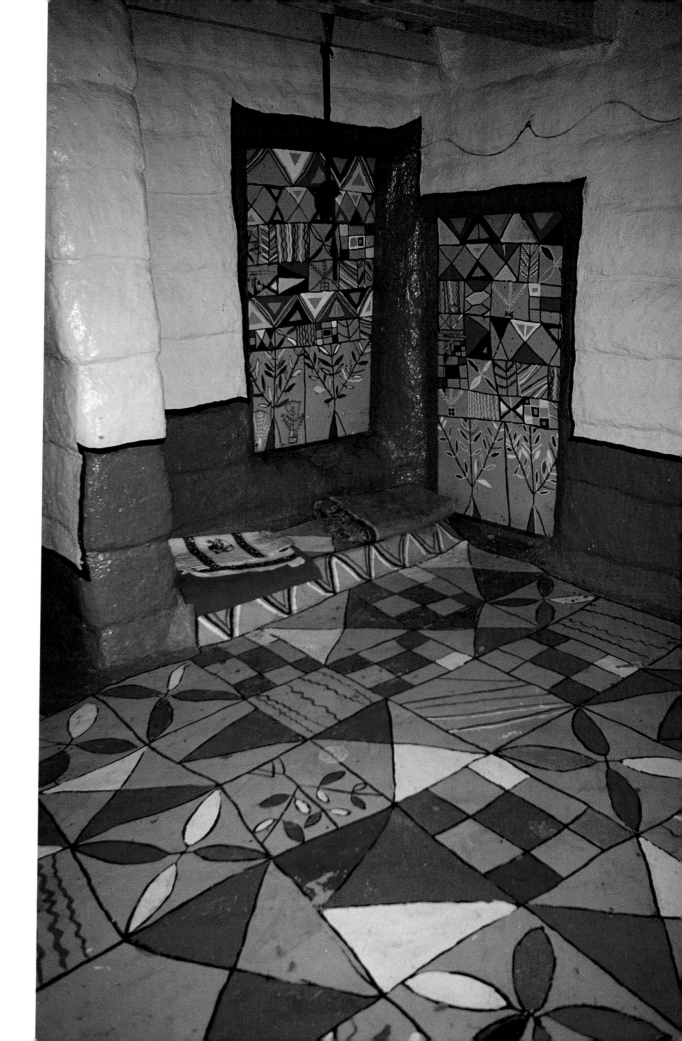

*Here we see a new break in tonality through which, however, the relationship with the previous frescoes still shows.*

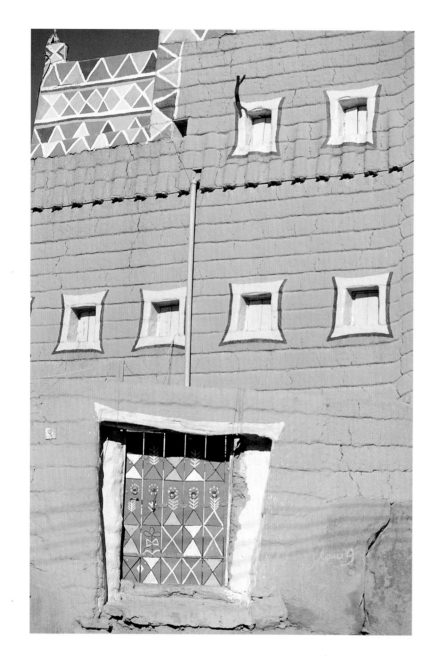

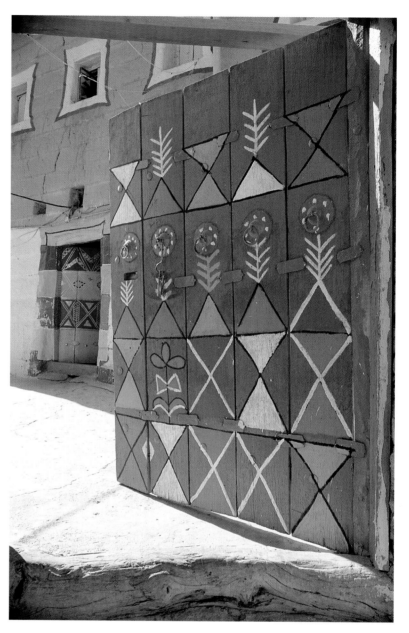

Aʙᴏᴠᴇ ᴀɴᴅ ꜰᴏʟʟᴏᴡɪɴɢ ᴘᴀɢᴇ:
*The reproduction of one door identical to
another, the latter metamorphosing after a
while: so many doors which seem to match each
other in the same house—and then change—
become disorientating after a while
(Bilad Qahtan, Sinhan).*

136

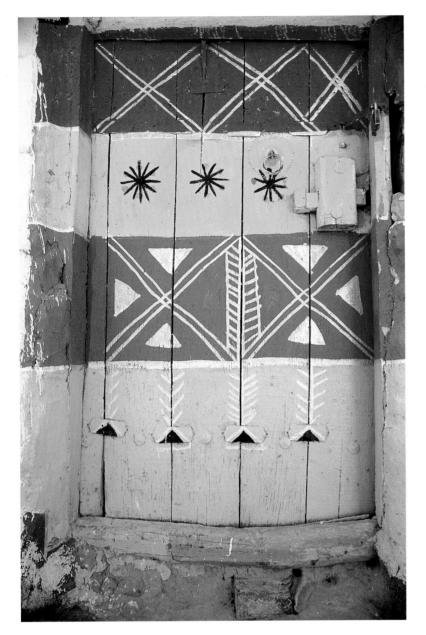
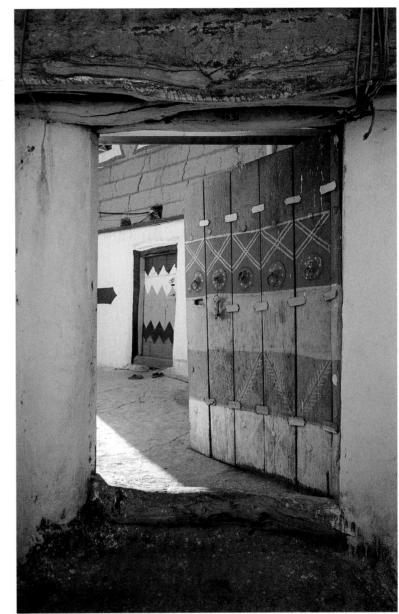

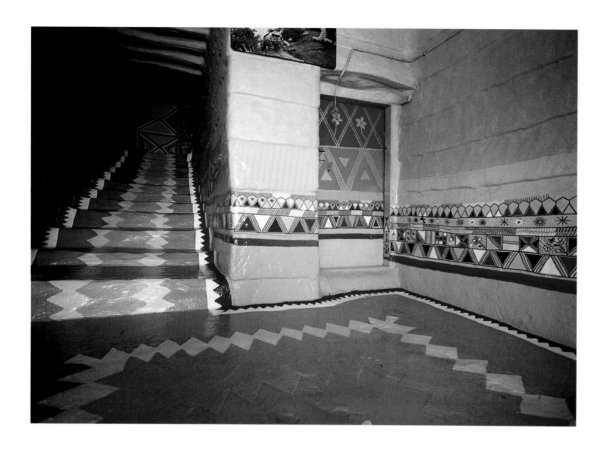

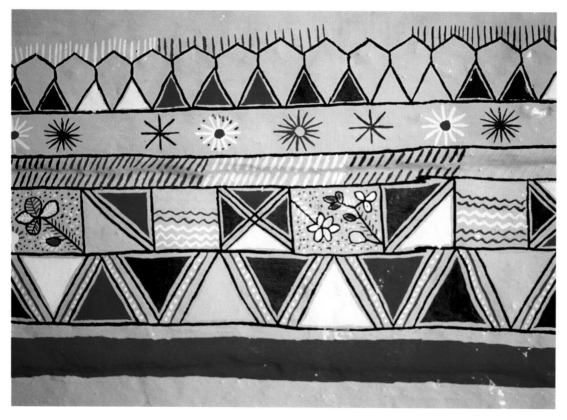

TOP AND LEFT:
*The cutouts in the colored areas create painted embroidery. Although enriched with visible designs on the surrounding frescoes, this door takes up the same layout, colors and designs as the gate seen previously; unity is assured.*

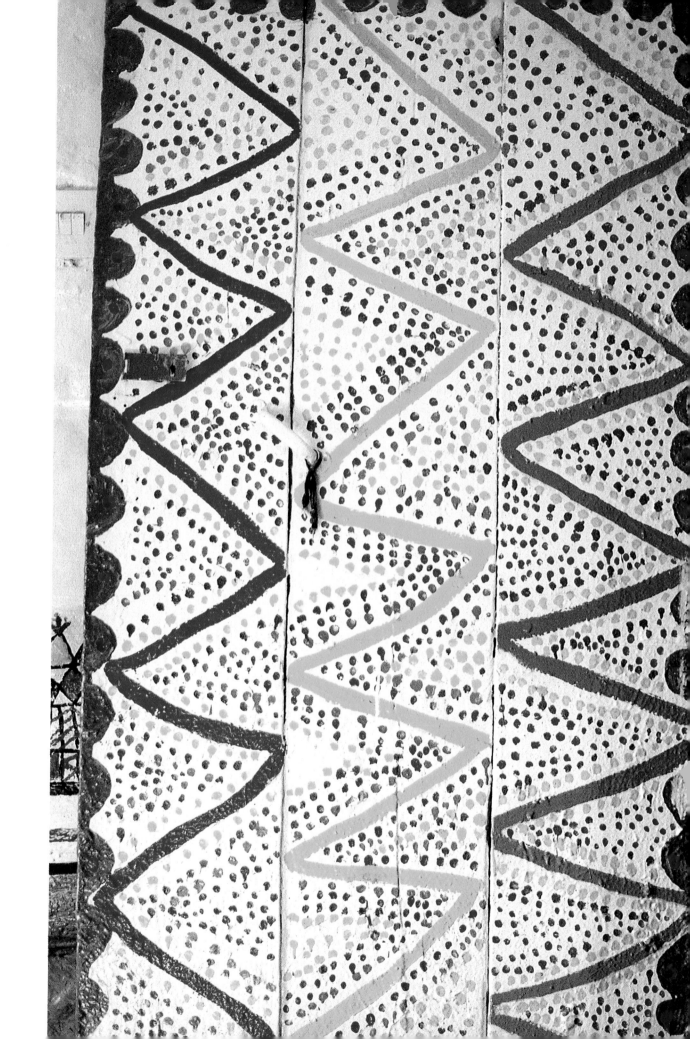

*This door strewn with dots of color is shot through with broken lines, giving the composition rhythm (Bilad Qahtan, Sinhan).*

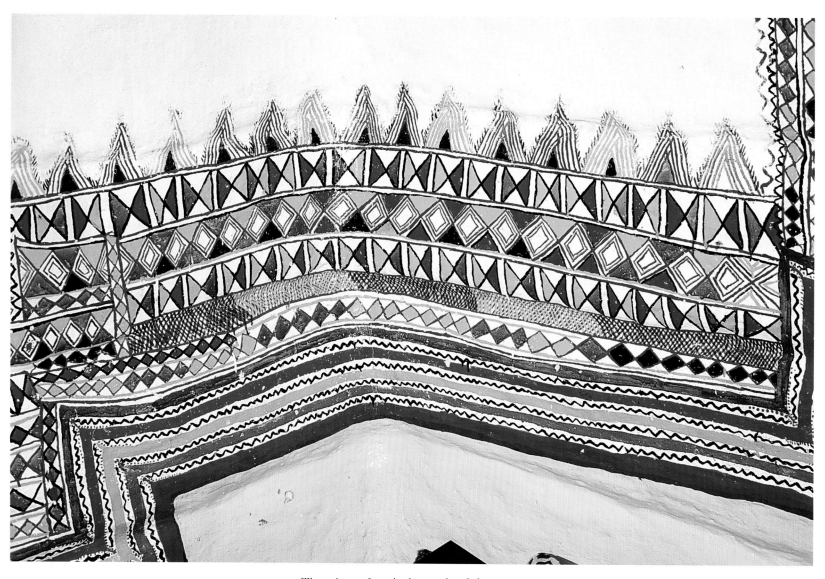

*The registers of seemingly recurring designs
characterize these meticulously painted frescoes
(Bilad Qahtan, Sinhan).*

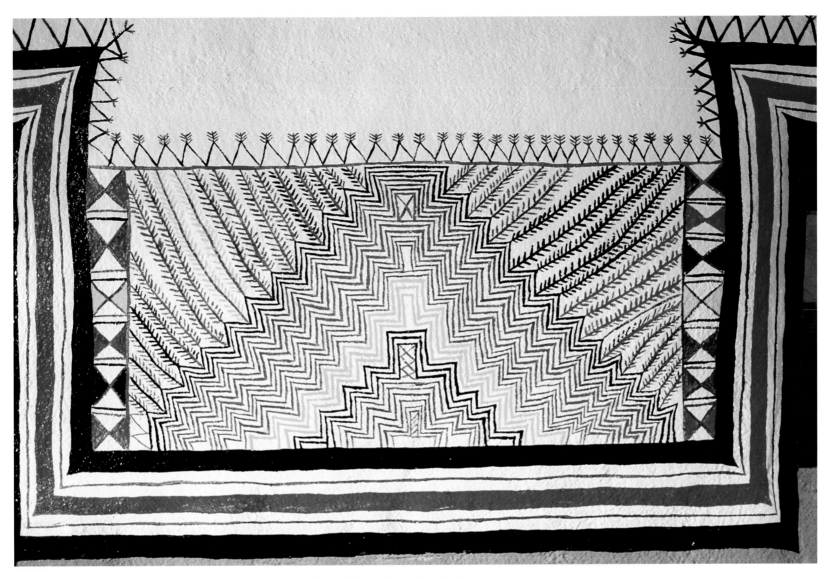

*In a wall done all over in sepia, tiers are embedded, a favorite decorative theme for door surrounds and the front panels on clothing (Bilad Qahtan, Sinhan).*

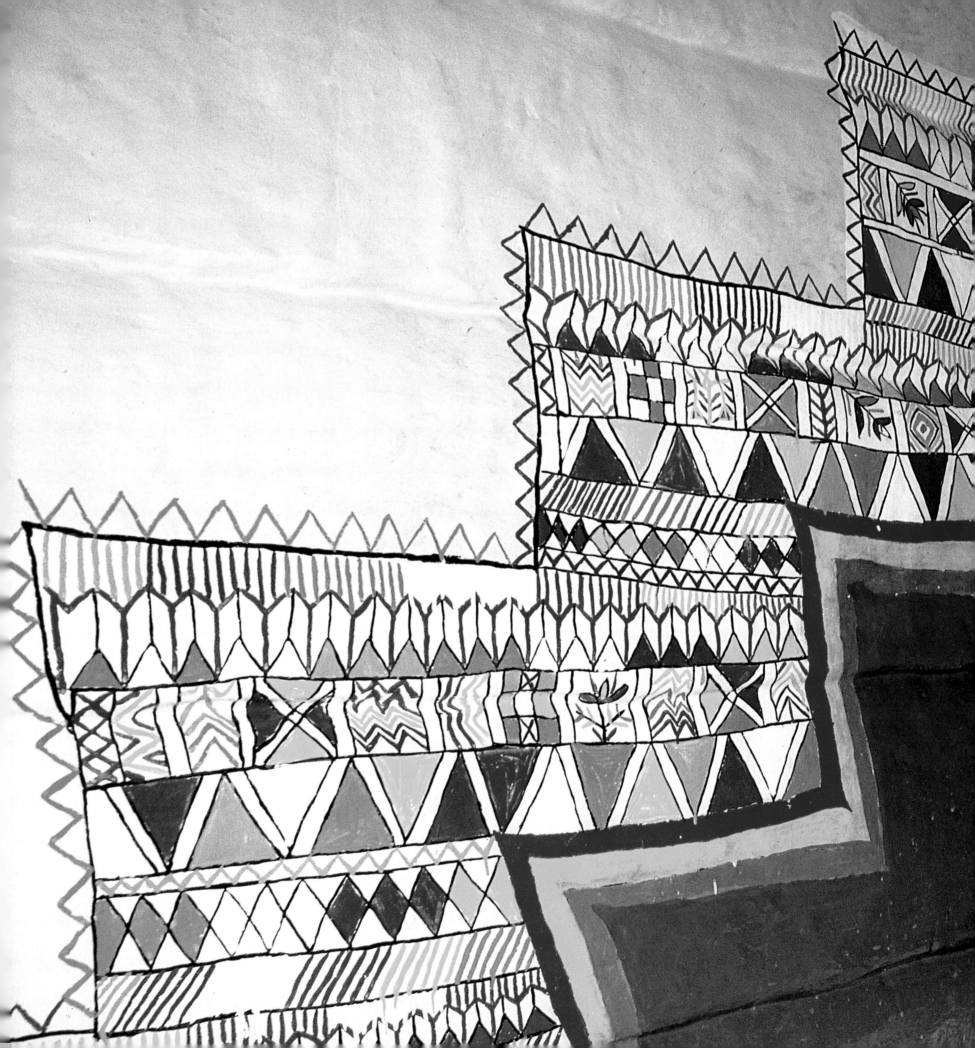

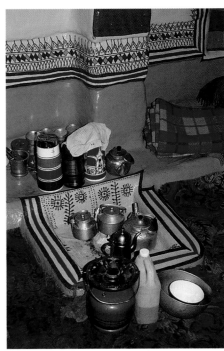

*A small room just off the* majlis *allows the women to prepare tea and coffee for the guests.*

*This firmly structured fresco, done with great finesse, flanks the staircase, following its changing levels (Bilad Qahtan, Sinhan).*

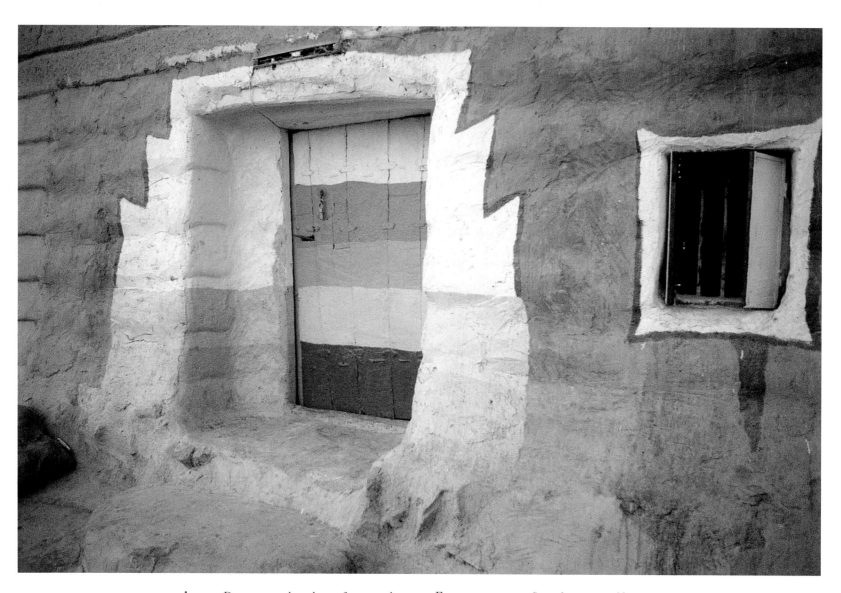

ABOVE: *Door surrounds and some front panels
on clothing take their "tiered" decorations from
the same pattern. The door and its surround
taken as one look like certain painted staircases,
if you flattened them out (Bilad Qahtan, Sinhan).*

FOLLOWING PAGE: *Stone houses are seldom
painted. With the sun, rain and passage of time,
the brightest façades fade away into precious
half-tones. This tower-house, typical
of the Jabal Fayfa, has had an extension added
on at a later date (Jabal Fayfa).*

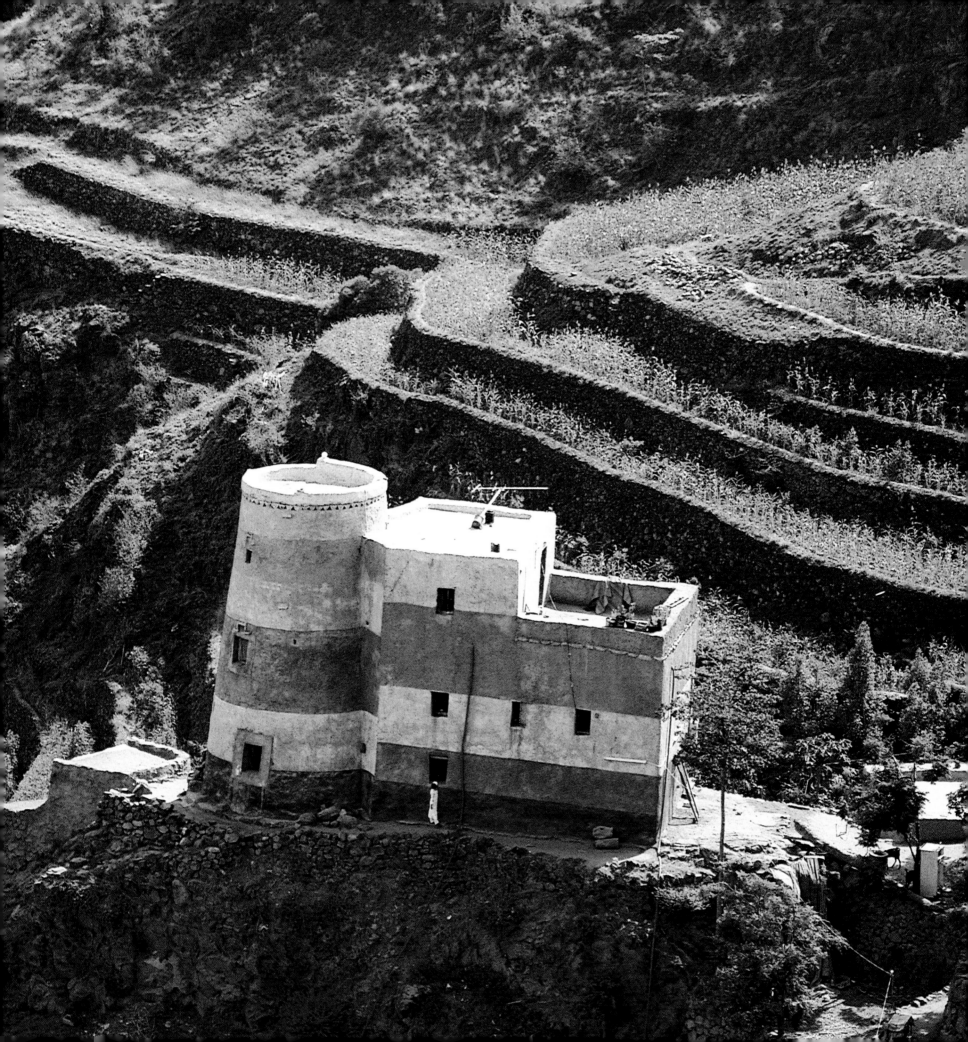

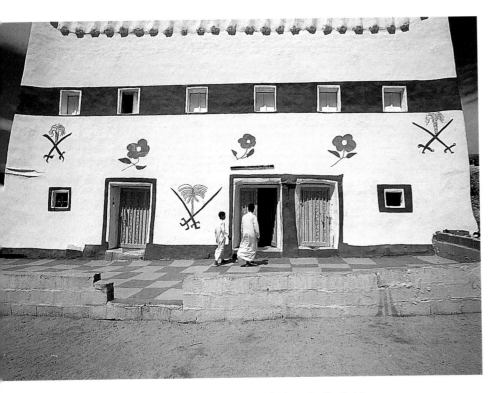

On this house façade the palm flanked by two swords asserts itself as the national emblem. Note that it bears fruit, expressing abundance and fertility (Bilad Qahtan, Sinhan).

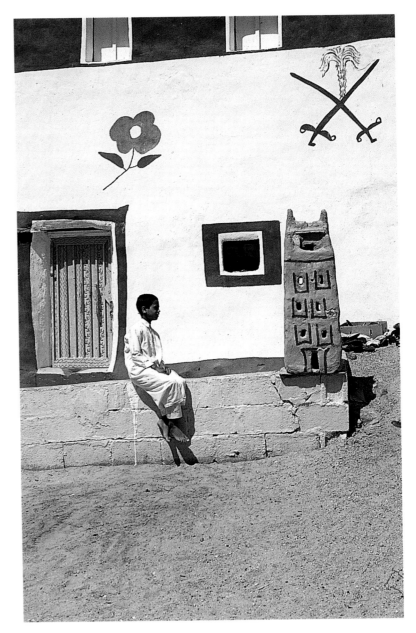

Is this an iconoclastic form of the gnomes standing in some of our gardens? Made for fun? This model tower-house, which a woman has shaped out of mud, has an inscription below, the always repeated phrase for: "Welcome."

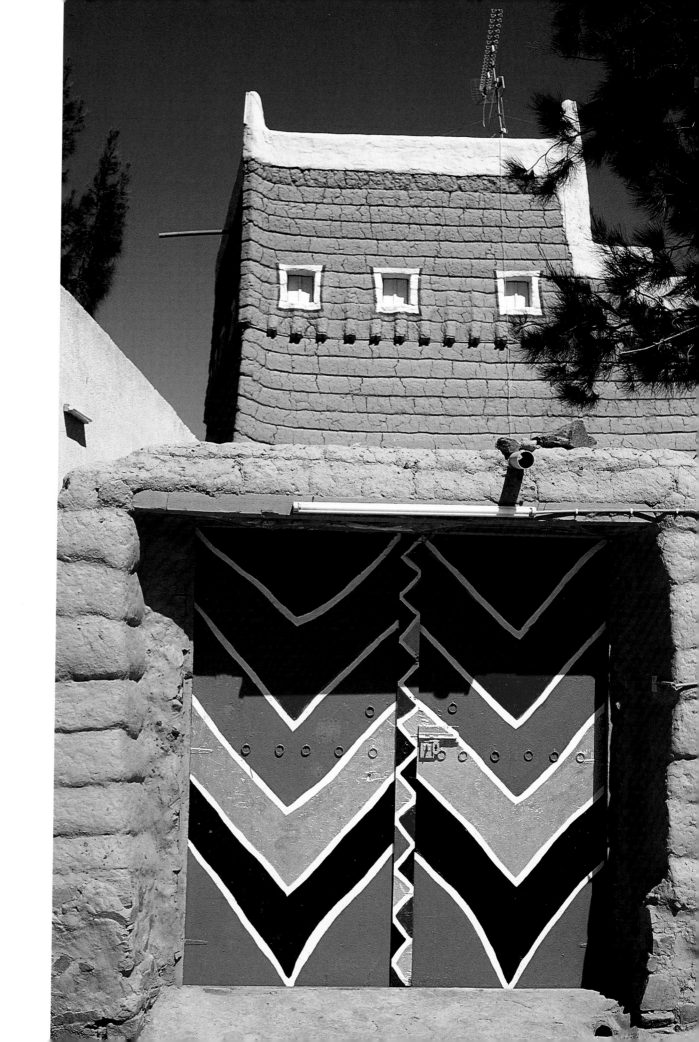

*The coloring of this door with chevrons shows a color acculturation, due to the use of silver white.*

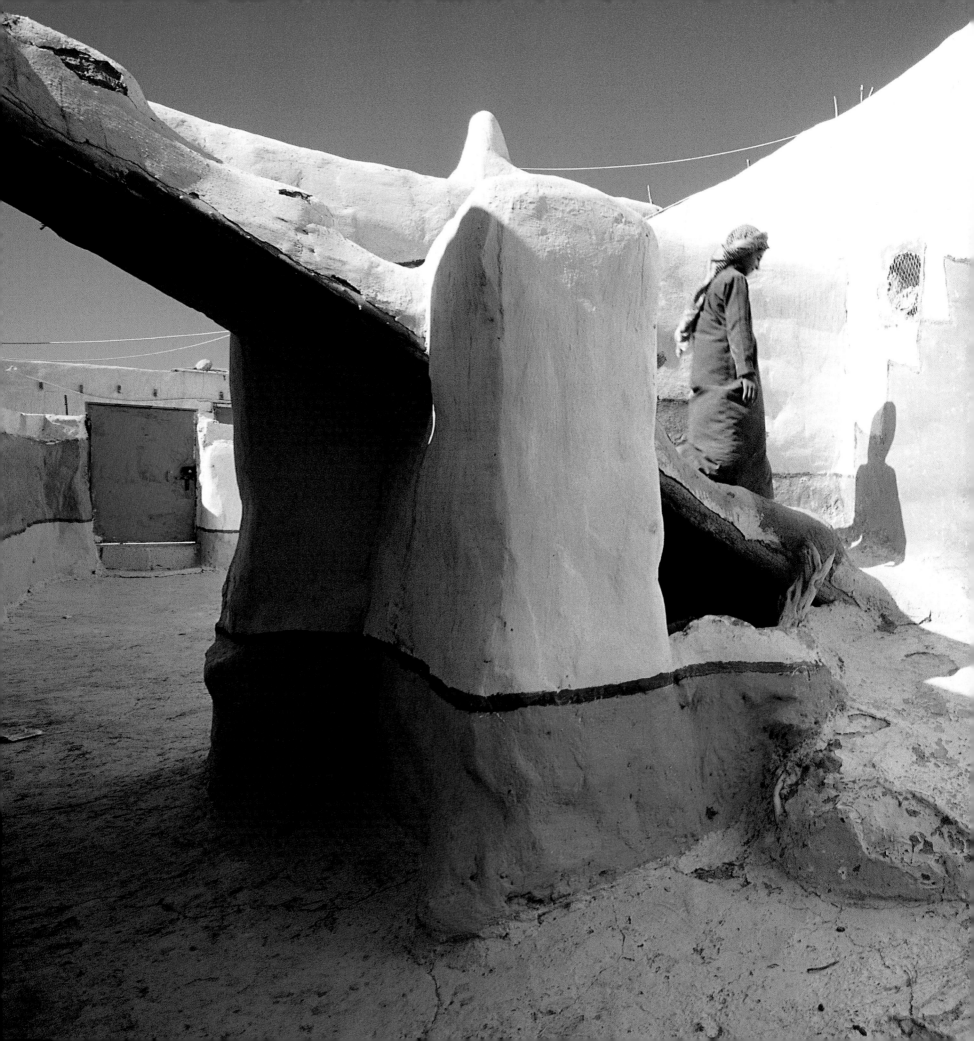

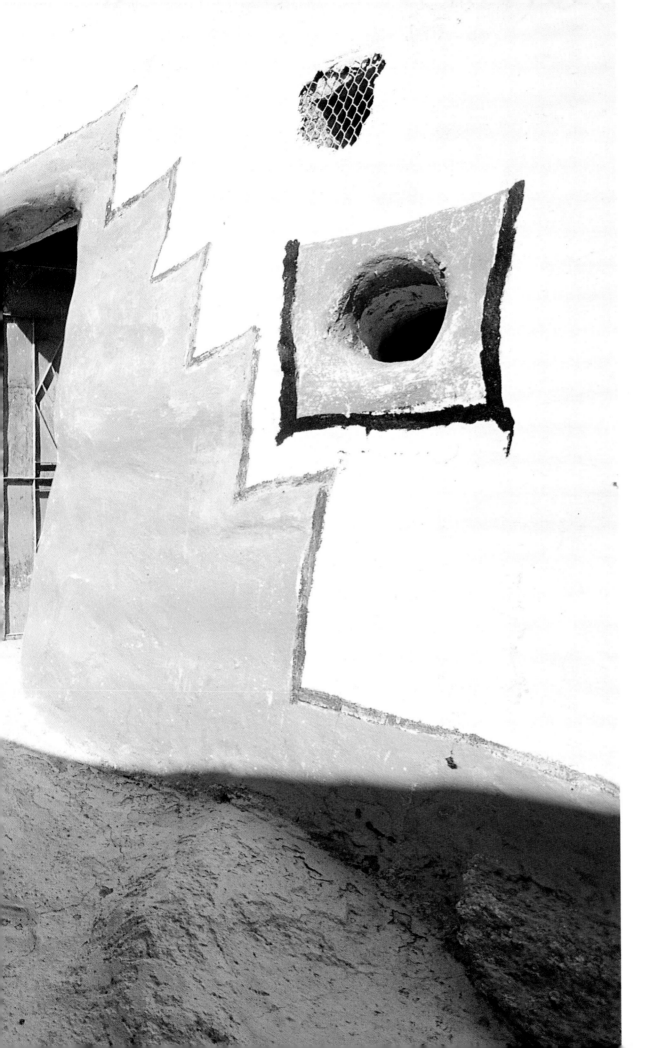

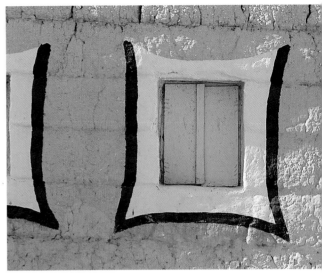

*The almost systematic use, by the Sinhan,
of the red penciling round the windows
is belied here, with the appearance of black.*

*Color is alive; it changes with the trials
of the elements, the sun, the passing months.
More fragile than the walls supporting it,
color fades away (Bilad Qahtan, Sinhan).*

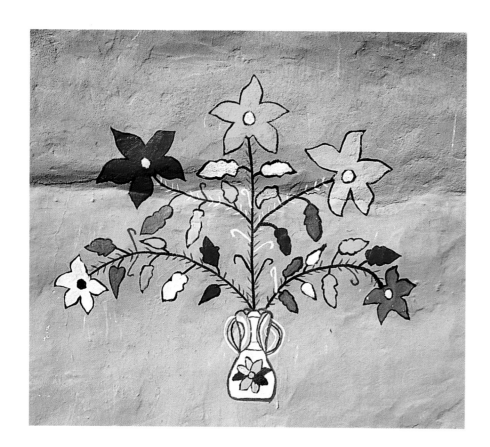

*The only symmetry that the floral decorations usually have is that of the stems, emerging from a single source, here a flowerpot.*

*Some women dare to paint frescoes in which the break in form and tone attract attention. Among the floral and bird designs the emblem of the kingdom emerges, with a multicolored palm (Bilad Qahtan, Sinhan).*

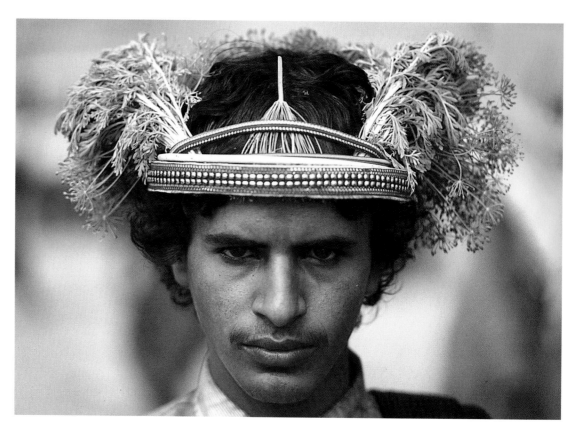

*The women of Bilad Qahtan throw on to the walls the same floral decorations that the flowered men wear on their heads. The latter use vegetable matter like painters, a palette they can play on for ever, creating subtle or outstanding nuances (Tihamat Qahtan).*

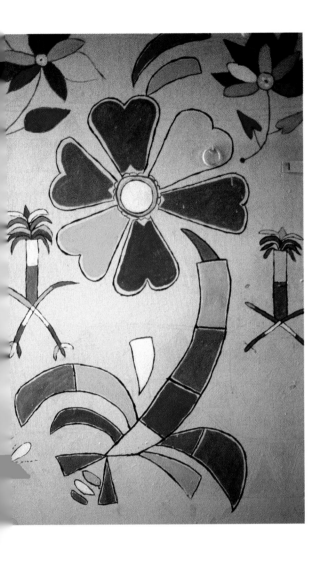

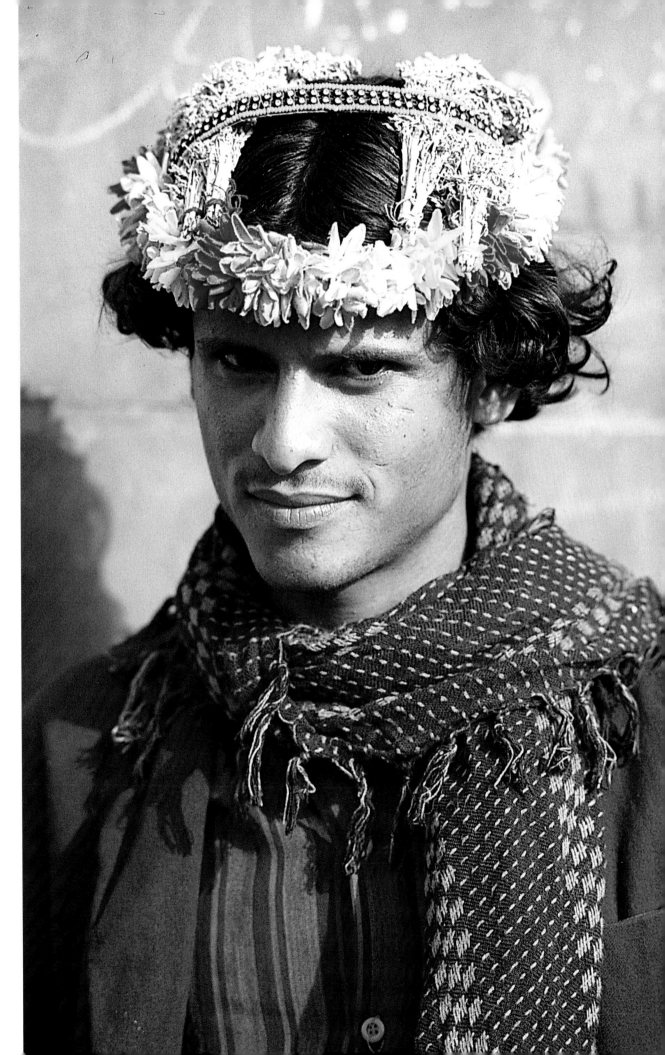

*By making them known, I earned the right to call them "flowered men." These goatherds of the Tihama wear their art like a tree bears blossoms. Fleeting art, ephemeral by its very nature, which must be renewed every day. Crowns of artificial flowers have the advantage of not wilting.*

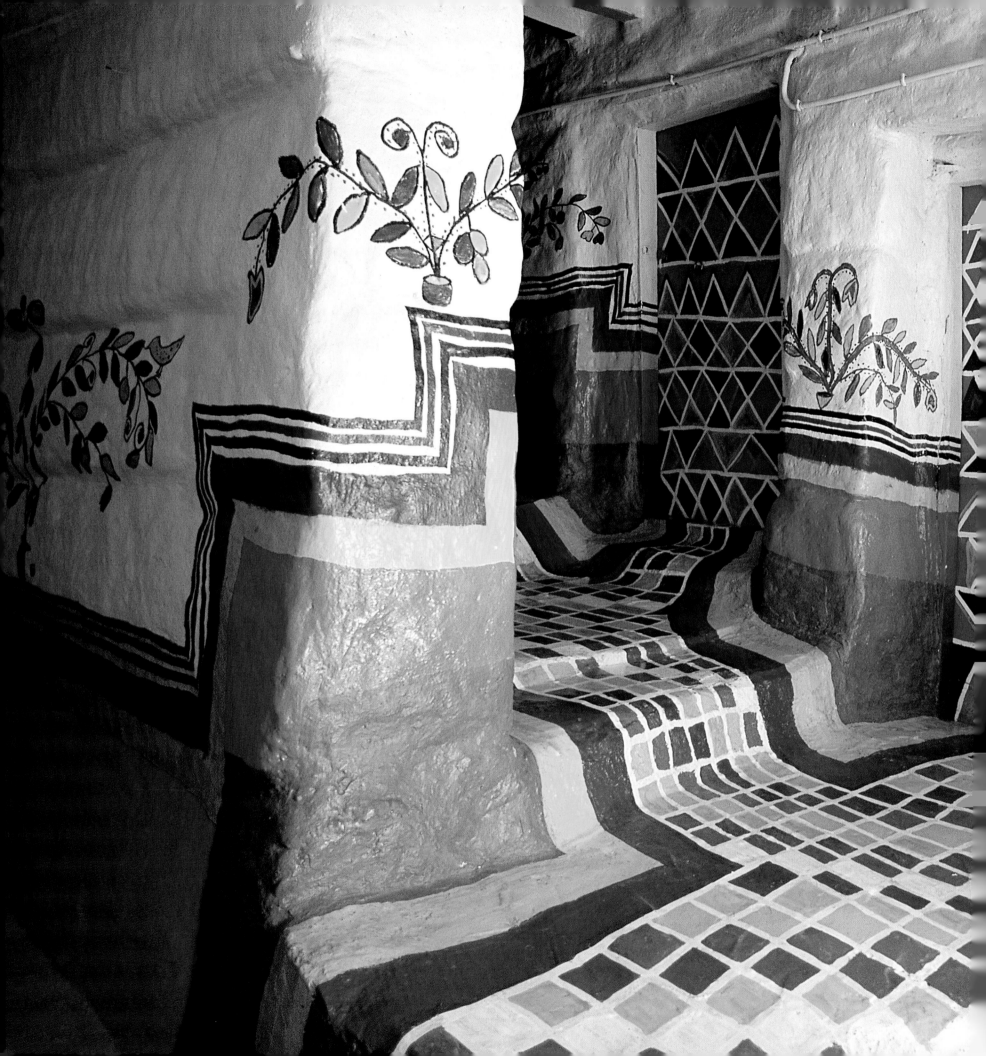

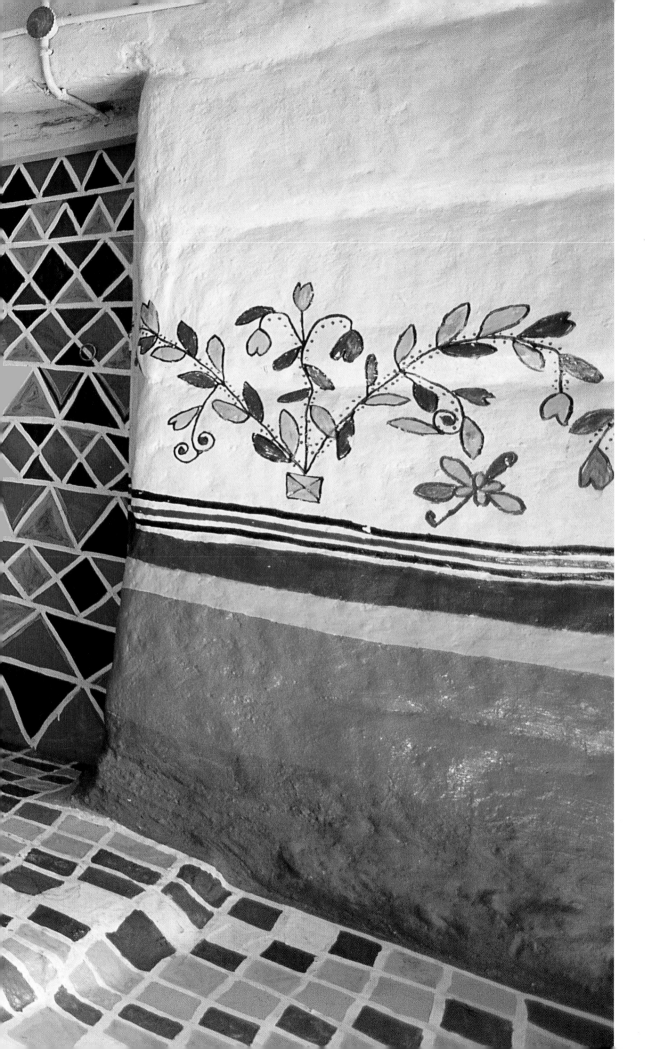

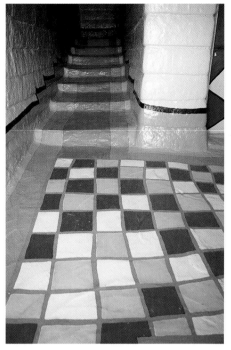

*A checkerboard seems to be pouring its colored squares down the steps. The underlying rhythm comes from applying a simple rule: shift the colors one space to the right as you go down the stairs (Bilad Qahtan, Sinhan).*

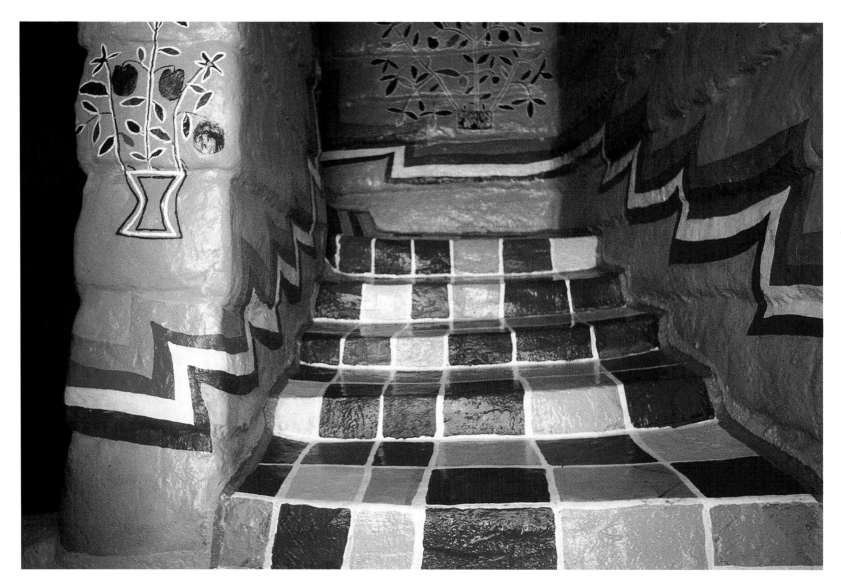

ABOVE AND PREVIOUS PAGE, TOP:
*Structures made from checkerboards and
games of chance with no hazard: tight order,
loose order tangle together, with no two squares
of the same color touching.*

FOLLOWING PAGE: *A soft-shaded checkerboard
flattened on a door, a painting Paul Klee
would probably not have disowned
(Bilad Qahtan, Sinhan).*

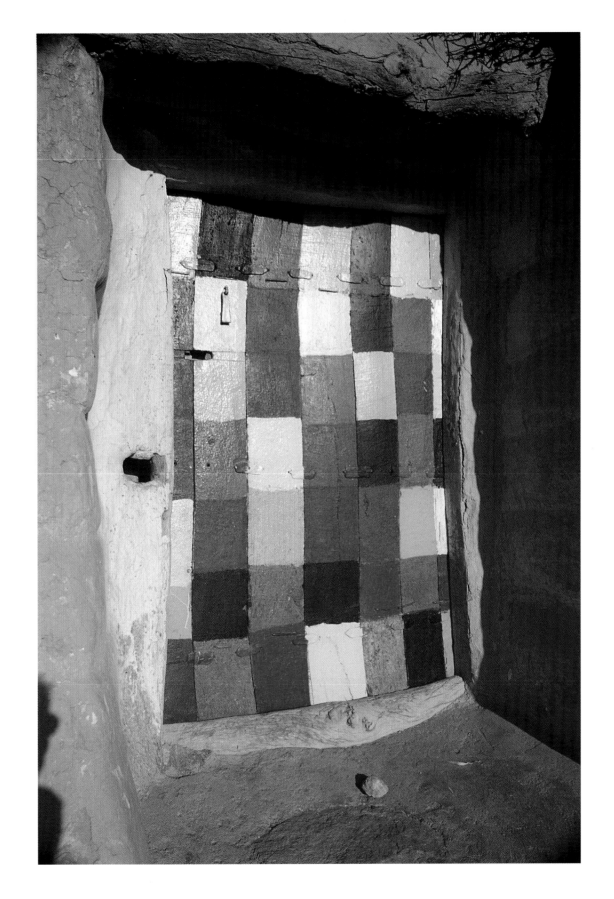

155

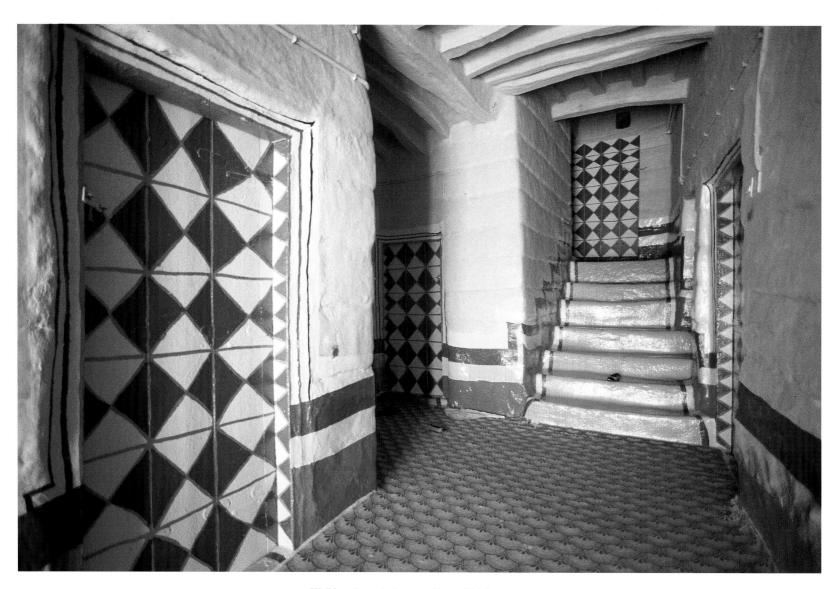

*Walking through the art gallery which is the hall of this house, leaves no respite for the eye: walls soaked in laundry blue, blood-red diamond trellises (Bilad Qahtan, Sinhan).*

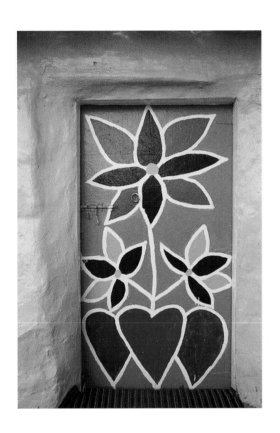

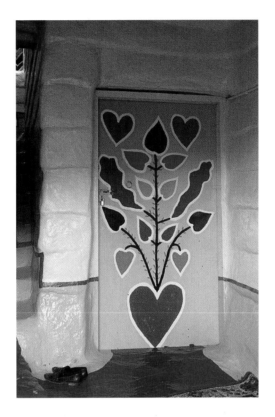

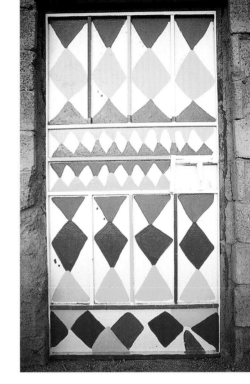

ABOVE AND LEFT: *Through its size and composition, this floral decoration strays from the traditional path.*

RIGHT: *The rhythm of color on this metal door is provided by vertical lines of triangles and diamonds.*

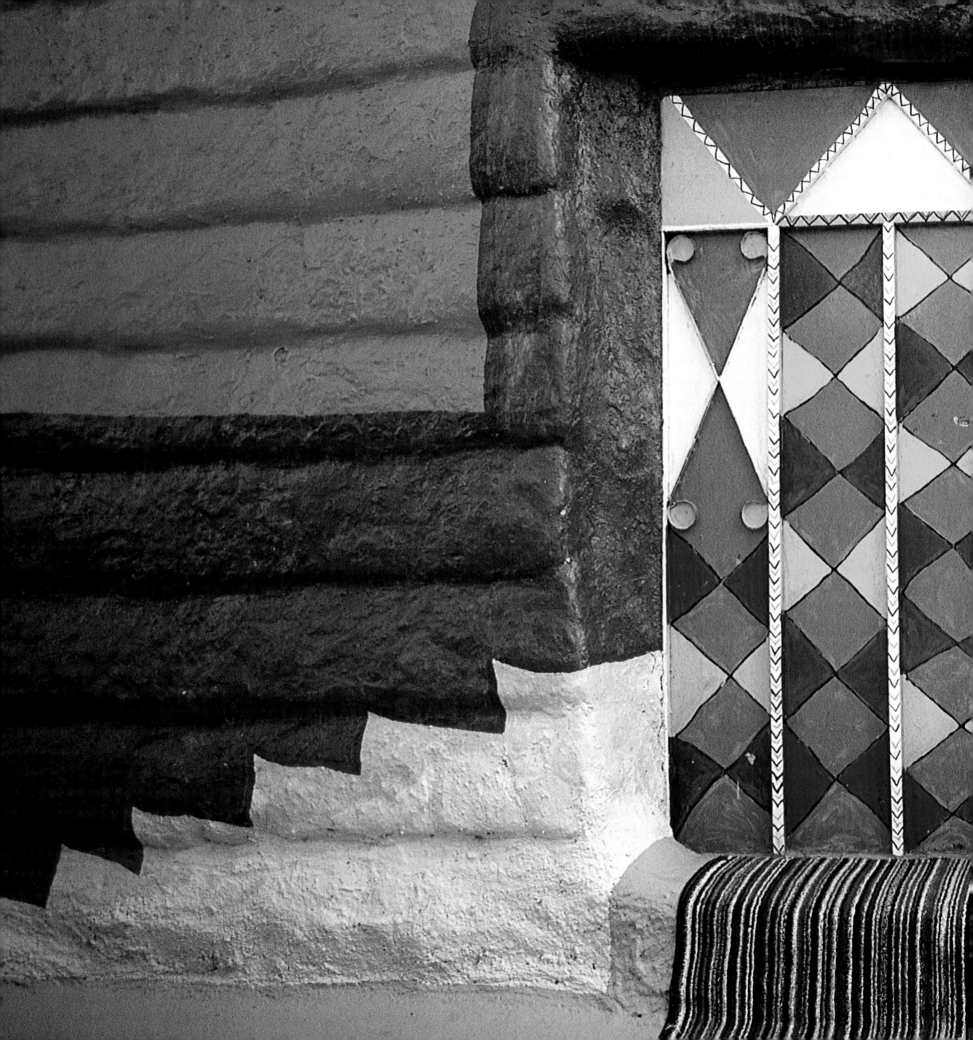

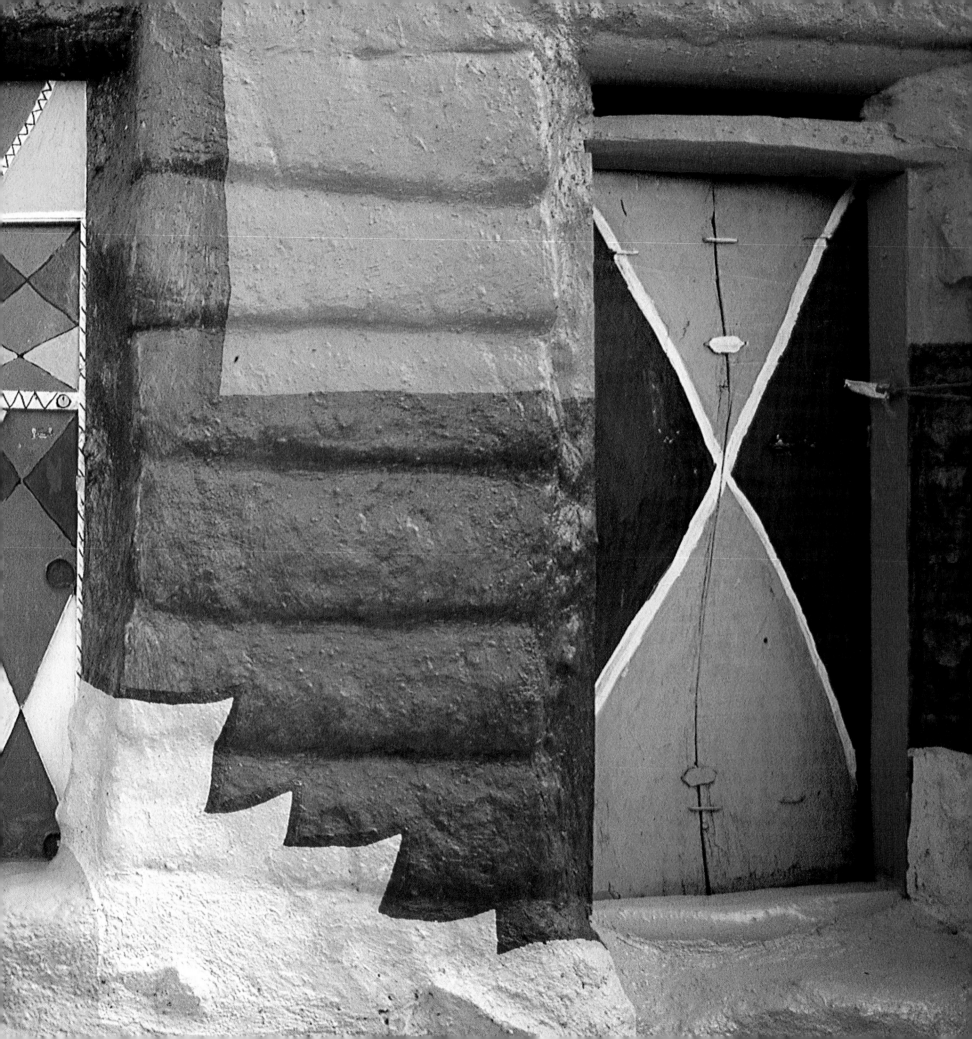

*Floral abundance distinguishes the sides
of this alley leading to a house
(Bilad Qahtan, Sinhan).*

RIGHT:
*The colored area of this roof-terrace seems
to express an unbreakable solidarity between
the support and the spread of colors.*

PREVIOUS DOUBLE PAGE:
*Daringly fresh colors characterize
the steps leading up to this mud house
(Bilad Qahtan, Sinhan).*

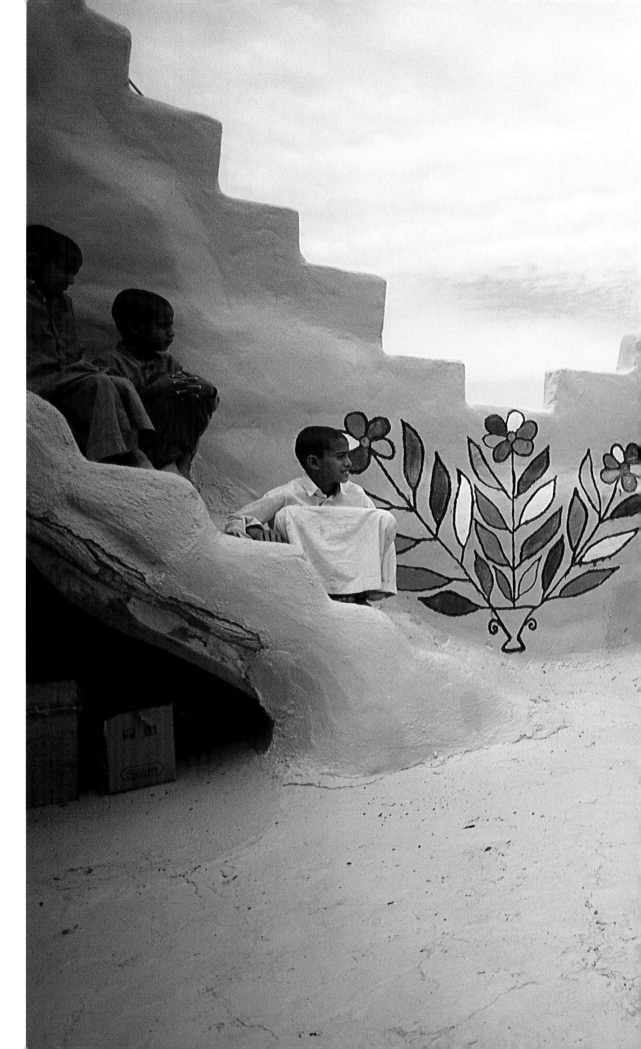

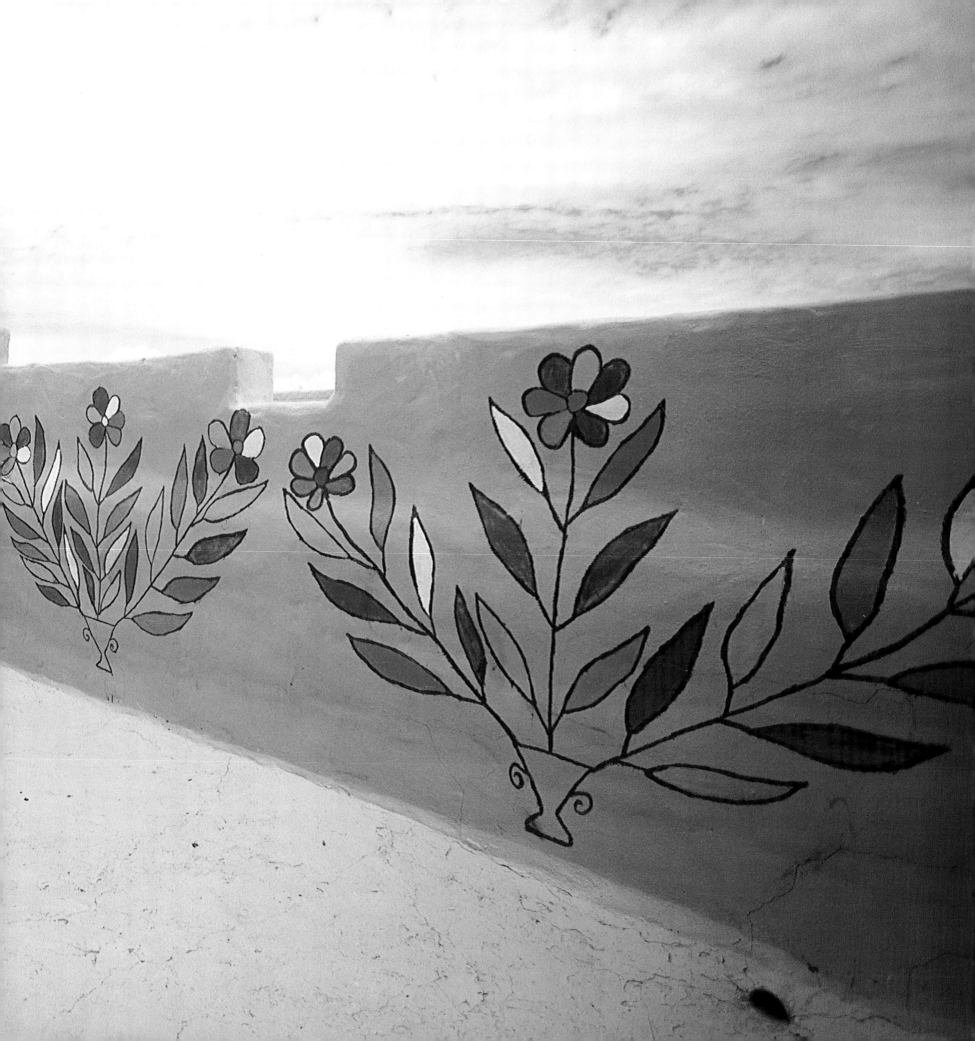

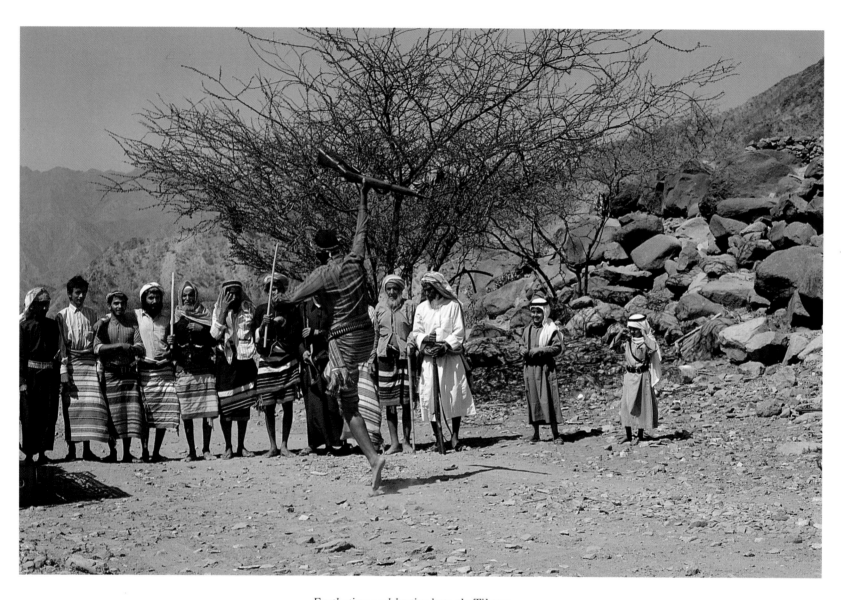

*For the time a celebration lasts, the Tihama goatherds feel they are once more the warriors they used to be. They brandish their rifles, challenge, threaten, attack an invisible enemy.... Color unfolds as much in the movement of the dances as in the beautiful mural art of the sedentary tribes (Tihamat Asir, Rabiyah).*

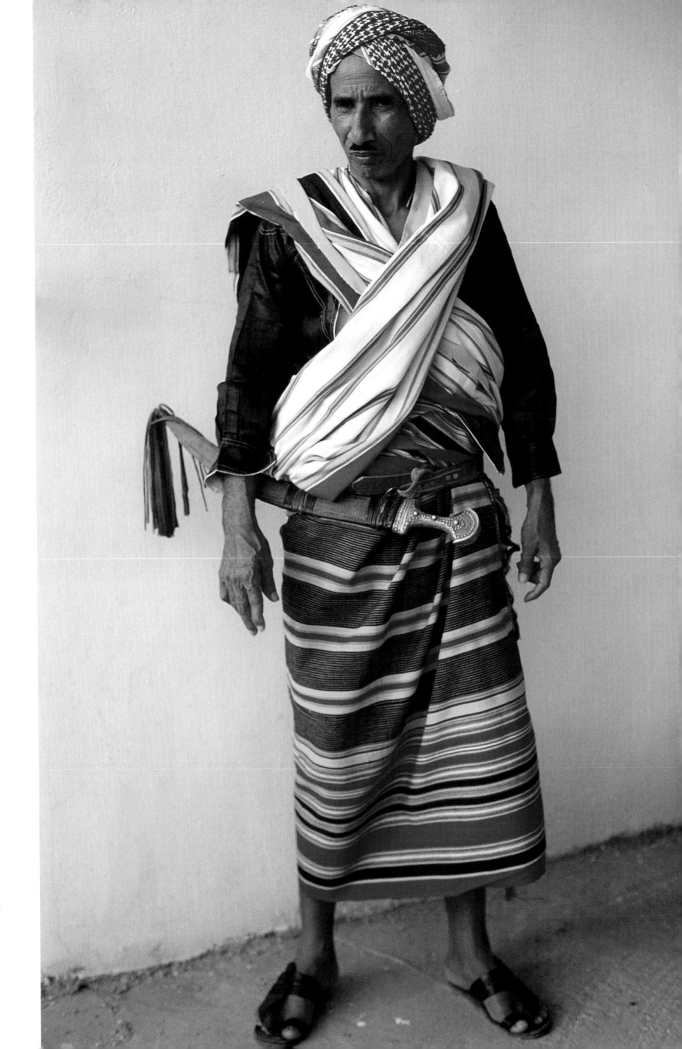

Here, my informant and friend, Muhammad
Hasan Garib Al-Alma, former curator of
Rijal Museum, is wearing the traditional
costume, consisting of a loincloth and a band
of material crisscrossed over the chest.
There is no break between the costume and
the frescoes. The bayadere striped loincloth gives
a structured oneness reminiscent of certain
frescoes in Rijal houses.

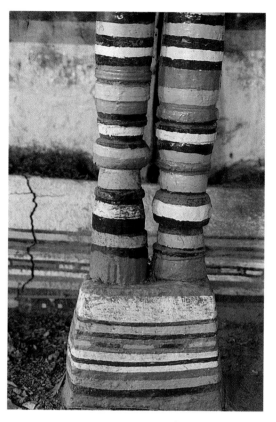 

ABOVE: *The sides of the benches
and the main beam of the* majlis,
*or reception room, echo the themes and colors
on the walls. These bayadere decors show
unquestionable unity with the stripes
in the traditional costume (Rijal Alma, Rijal.
The artist is Sherifa).*

FOLLOWING PAGE: *This multicolored
ceiling with wrong-angled beams gives
the impression of raw art. The distribution
of colors creates chromatic rhythm,
the predominance of yellow helps brighten
up the room.*

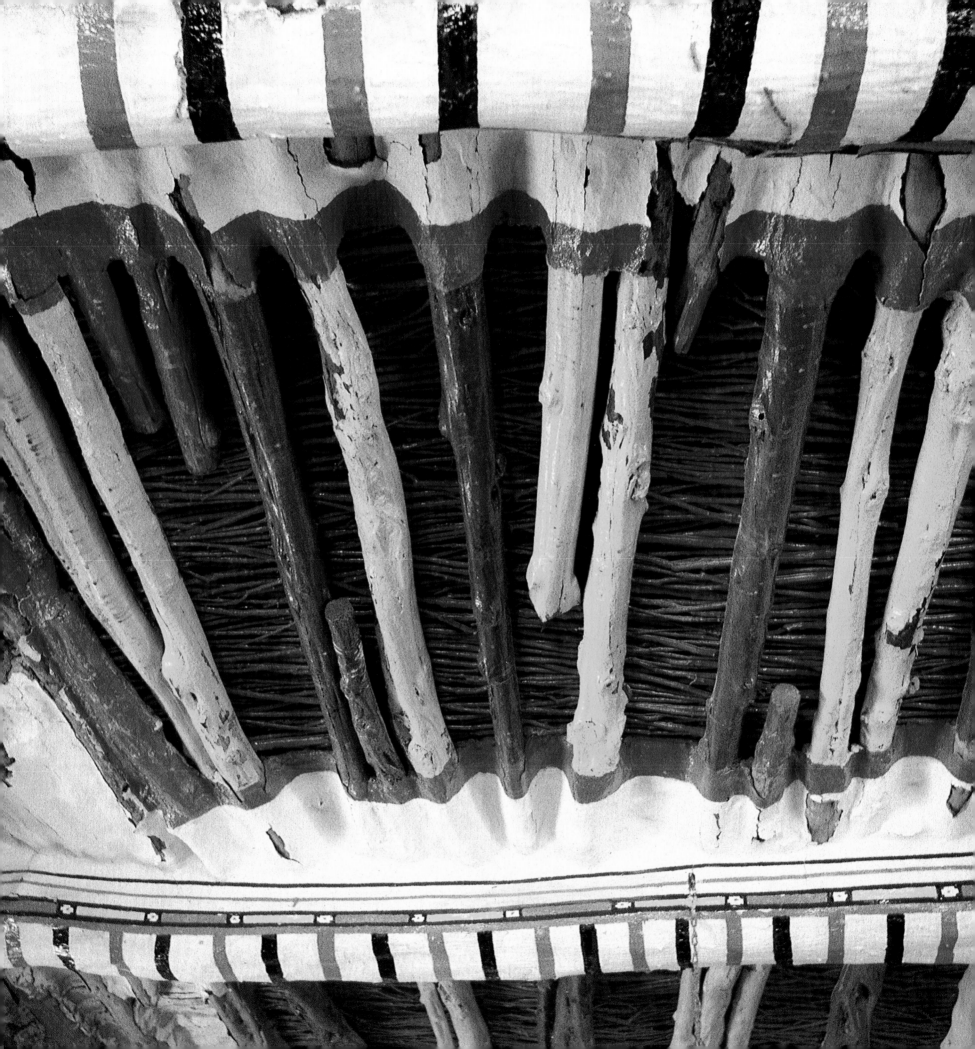

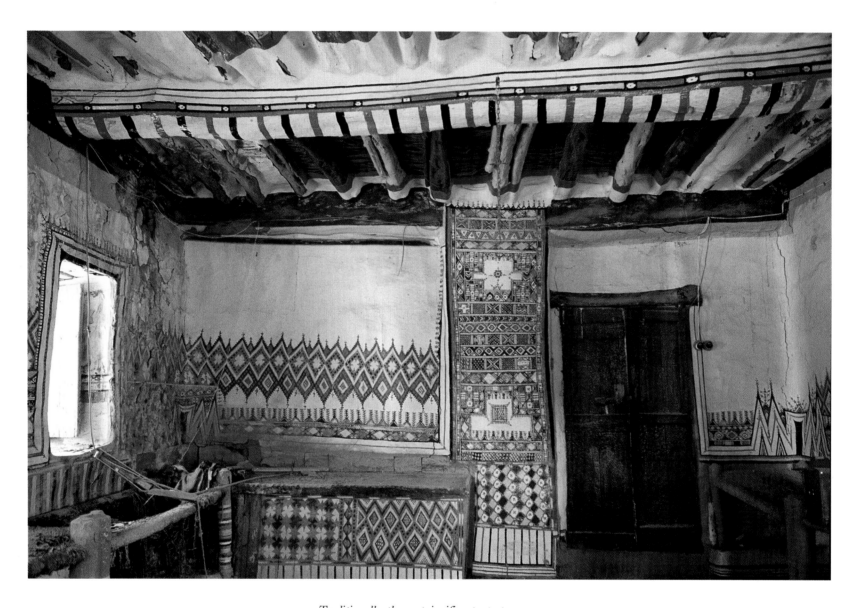

*Traditionally, the most significant aspects
of fresco art are those used in the* majlis,
*the rest of the house simply being covered
with expanses of color.*

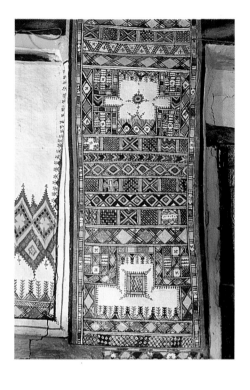

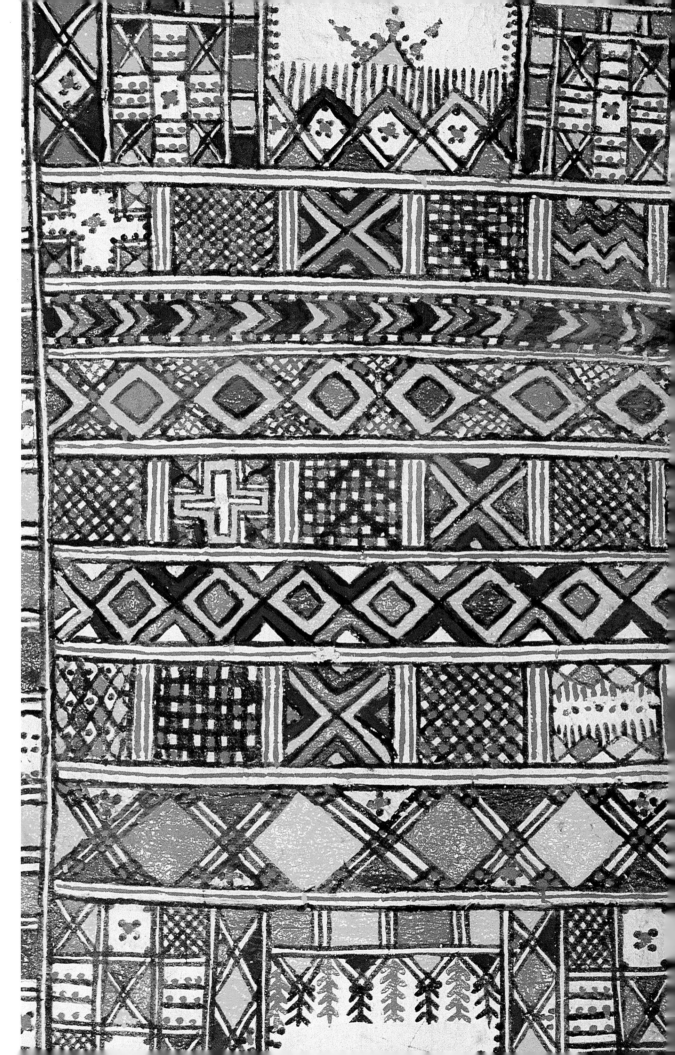

*On this pillar set against the wall (*batrah*), the designs are exquisite in their composition and coloring, which has kept all its original freshness. They draw peculiar strength from the precision of detail.*

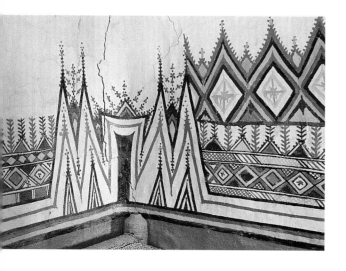

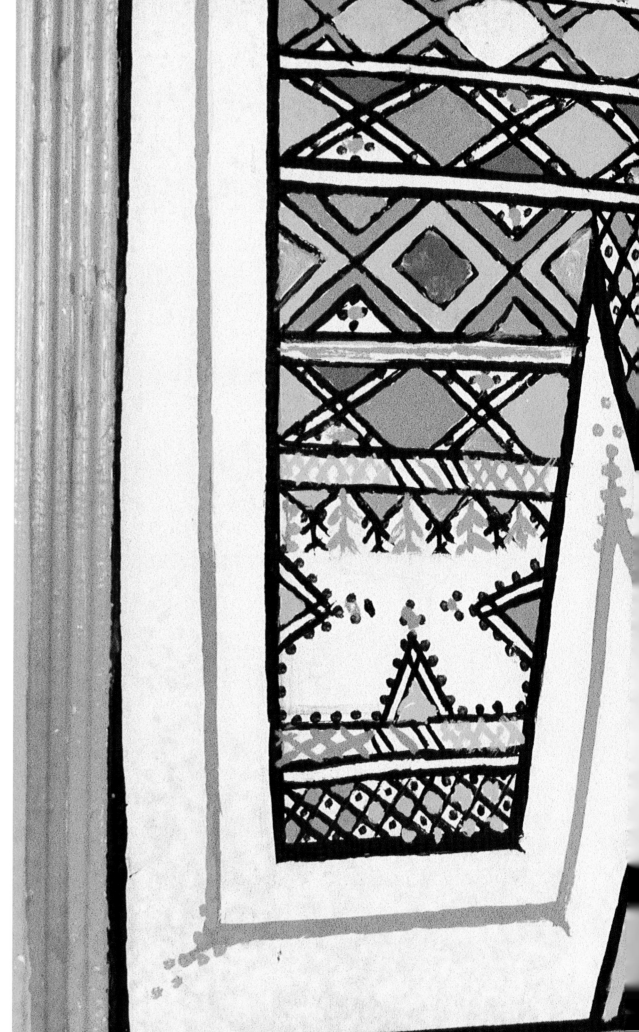

*Comparison, fifty years on, of these corner designs representing mihrabs clearly shows a remarkable permanence of style and tonality (Rijal Alma, Rijal, and Shabayn. The artist is Sherifa).*

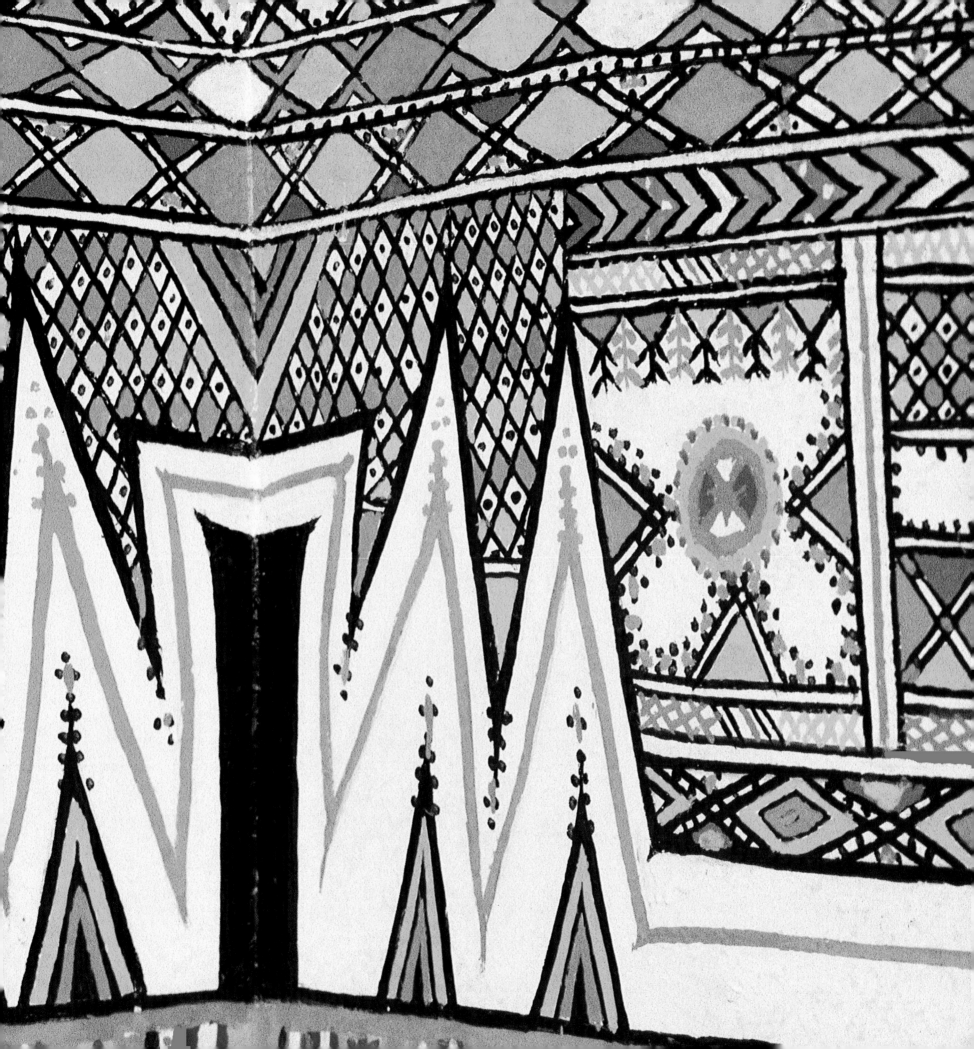

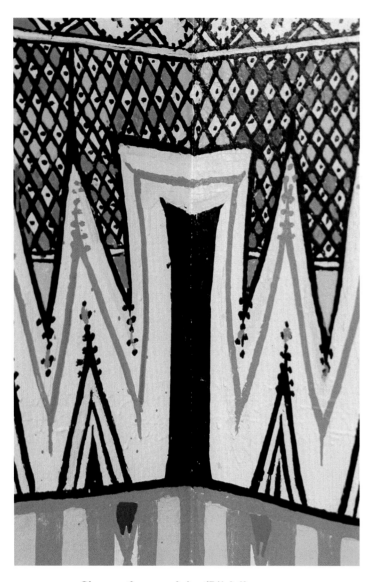

*Close-up of a corner design (Rijal Alma,
Muhayil. The artist is Sherifa).*

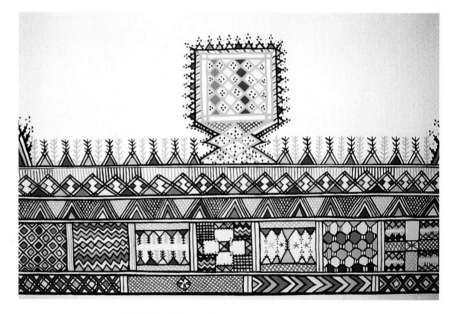

*Rijal pictorial creation possesses a decorative
style that is geometrically very strict
(Rijal Alma, Rijal. Work done by Fatma).*

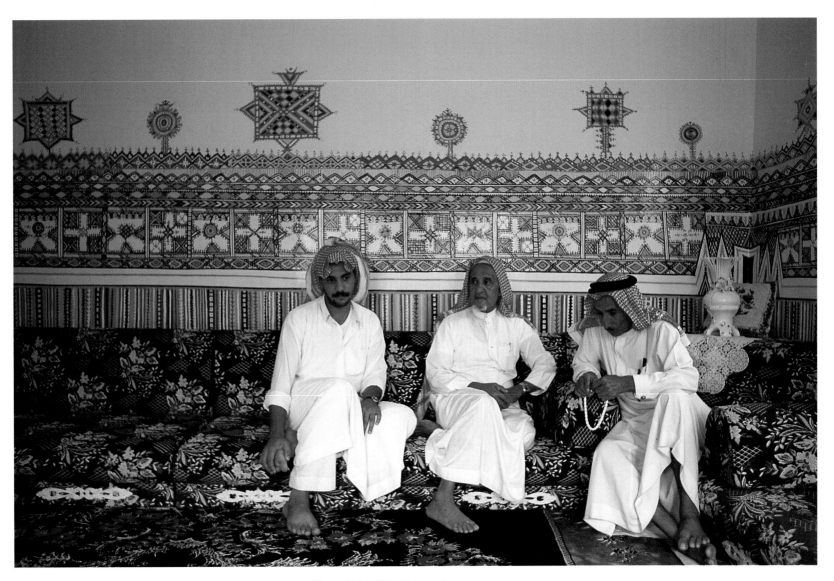

*The traditional high benches have given way*
*to sofas. The putting together of Western*
*furniture and frescoes, in the men's* majlis,
*is the compromise between a desire to be*
*"with it" and concern to keep something of local*
*traditions (Shabayn. The artist is Sherifa).*

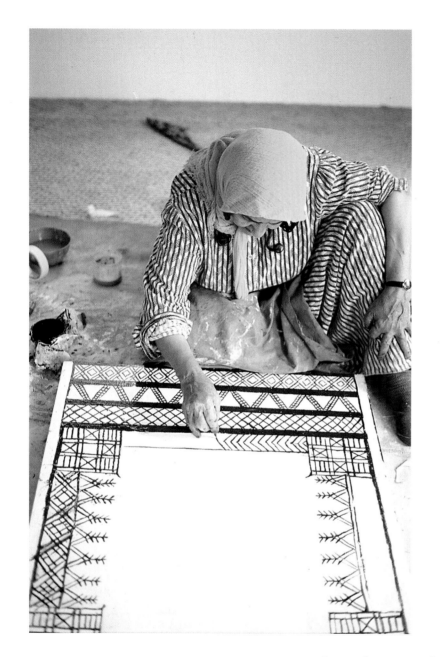

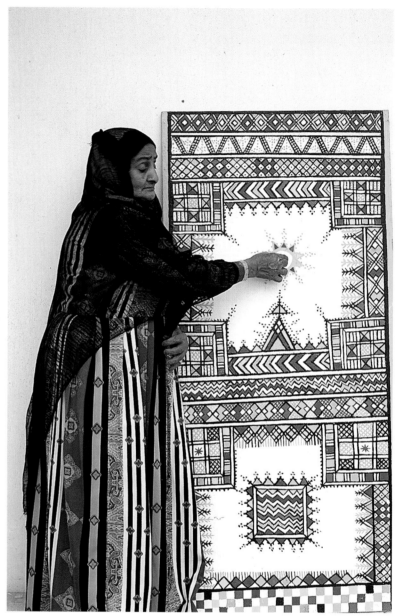

*It seems the ornamentation on this pillar*
*(*batrah*) in the* majlis *can easily leave*
*its support and reappear on a plank*
*(Rijal Alma, Rijal. Work done by Fatma).*

172

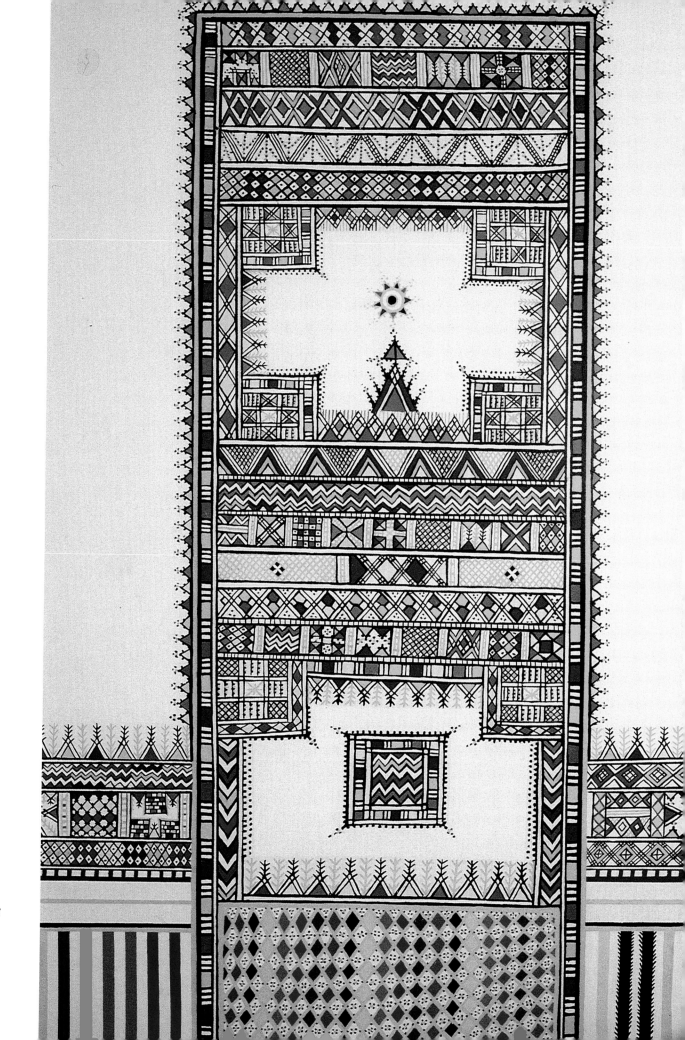

*The pillar (*batrah*) against the wall,
which characterized the traditional* majlis,
*is nowadays alluded to in the middle of the wall
and becomes the major decorative item.*

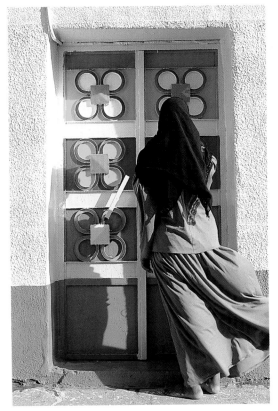

TOP LEFT: *These two young girls are taking their first steps in the difficult task of fresco creation using a board and felt-pens (Rijal Alma, Rijal. Zeid family).*

BOTTOM LEFT AND TOP RIGHT: *Fresco creation is most often the fruit of collective work. The mother (with the yellow scarf) is at once the initiator, inspirer and coordinator. Her daughters follow her instructions before working alone.*

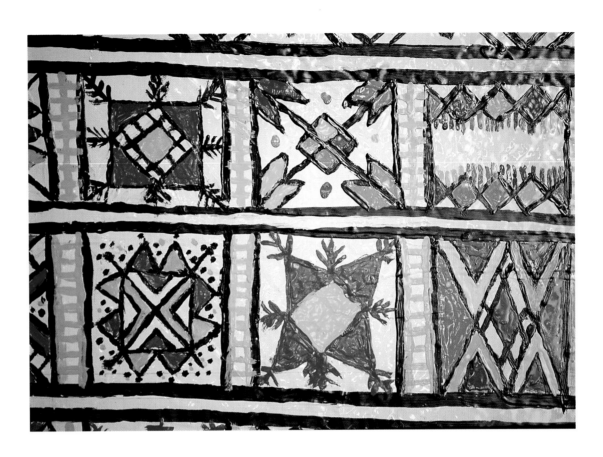

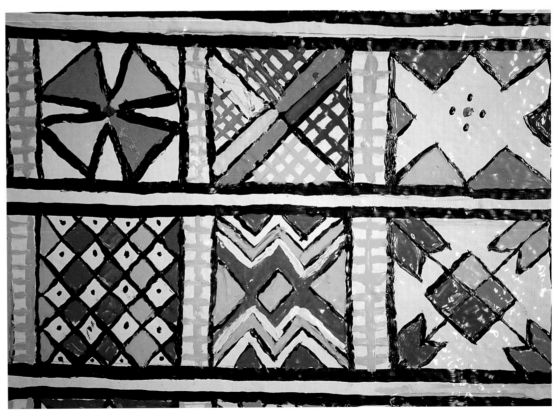

*Certain designs refer to commonplace objects, such as this fan (top left) or these arrow-feathers (bottom right), but their relationship to tangible reality is only a distant one. Rather than represent these objects, they resume them in graphic form.*

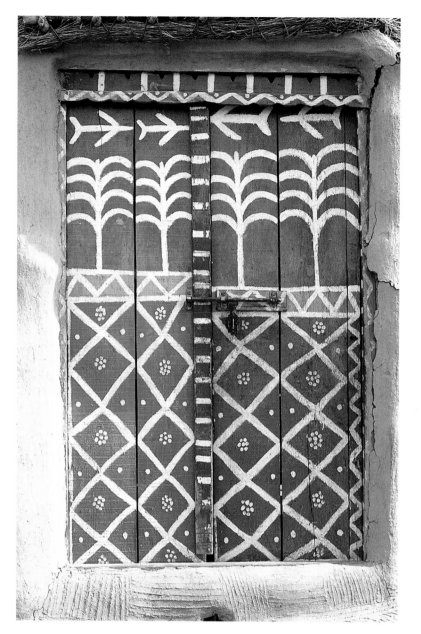 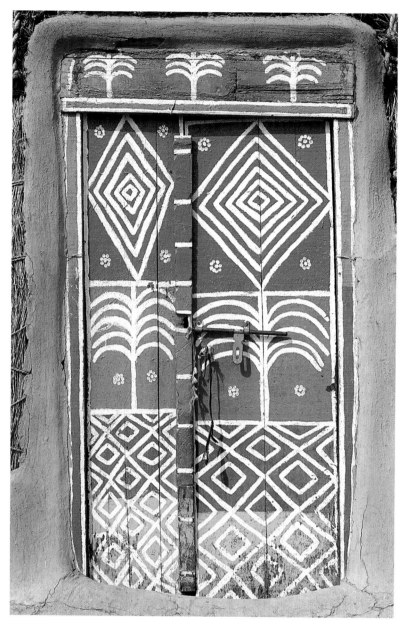

*The inhabitants of the Tihama use their doors*
*in an attempt to individualize their huts,*
*which are never painted on the outside.*
*On these two doors are juxtaposed geometric*
*designs, drawings of palm-trees and...*
*airplanes (Tihama).*

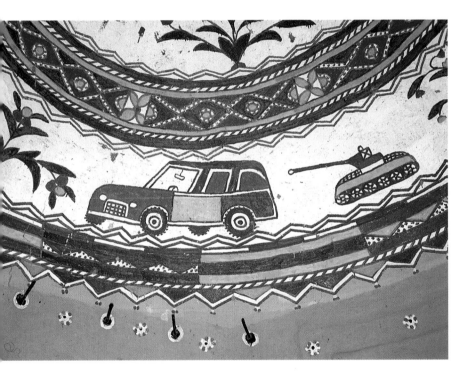

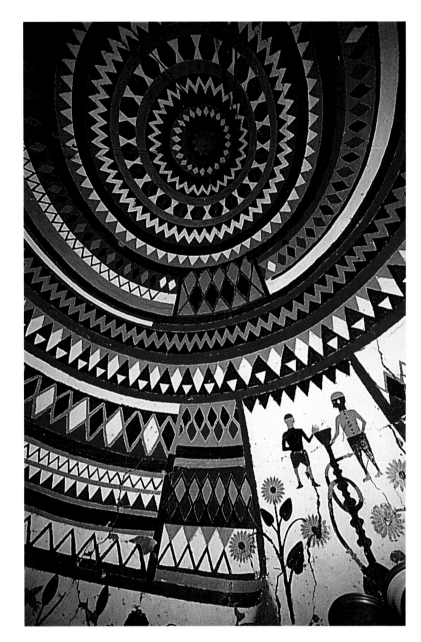

Inside the Tihama huts, decors are organized
concentrically. A naïve art, close to people's
own realities, characterizes the frescoes, as much
in Saudi Arabia as on the Yemeni side. Men,
flowers and a hookah on one side, a car and
a tank on the other. Looking at the two frescoes
side by side, we clearly see the problems of
perspective in both.

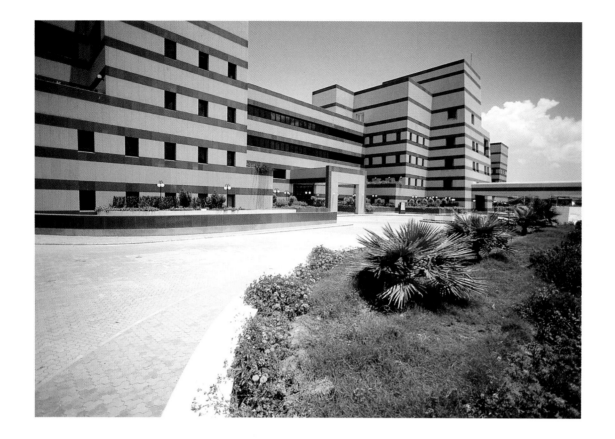

*The seat of the governor bears down its haughty bulk in Abha center.*

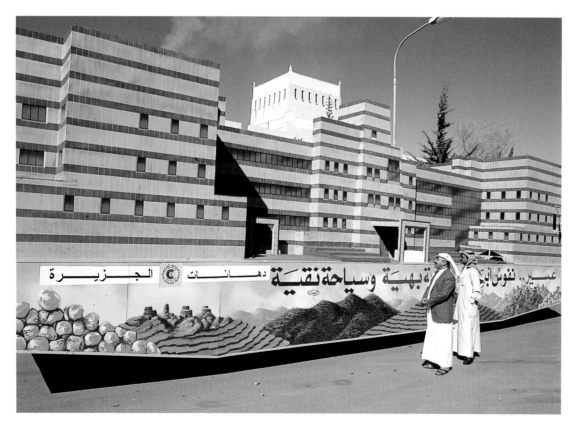

*This scale-model of the governor's headquarters, mounted on a trailer, reproduces the original down to the last detail, with this slogan: "The Asir: a warm, proud people, beautiful surroundings, healthy tourist activities."*

# ARCHITECTURAL TRANSITIONS

## *Unity in uniformity*

The relationship between the verticality of the mountains and the horizontality of the terraced fields finds a parallel in the verticality of the houses and the horizontal illustrations on the façades. In tune with these rhythms, the traditional costume still worn in the hilly Tihama[31] imposes a similar pattern: shirts with vertical stripes and loincloths with horizontal stripes. In both cases, vertical and horizontal rhythms are integrated: these two halves combine like the warp and weft of a loom. Although these correspondences may be external and formal in character, they cannot be reduced to coincidence. Indeed one must assume that the design of the clothing follows the same rules as the architecture. This relationship obeys the same dynamics; and the social norms, inspired by an ideology which aims at cultural uniformity, are manifest in both.

If one accepts the principle that the state aims to strengthen the unity of the different regions over and above tribal membership and loyalty, the implementation of these goals appears as a manipulation of cultural symbols. Riyadh, the capital city, brings the provinces into its own orbit and dynamics, invading this vast land, and covering it with a communications network, once loose, now progressively narrower and tighter, until even the inaccessible regions of Asir are opened up. The dialectical interaction between tribal diversity and political unity is particularly manifested in clothing, the visual indicators of the different tribes. To create a cultural community, it is necessary to foster collective consciousness. Created in the image of society, the school provides a forum in which the students must adopt the Saudi costume which they will wear all their lives. Uniformity of dress forms the national identity of the Saudi and is a sign of his interchangeability as a member of a unique and undifferentiated territory. Through the influence of internal migration and the impetus of urbanization, there is now a disappearance of the tribal territories, and this is particularly felt in cities, where populations and neighborhood identities are blurred and intermingled.

# A break with the traditional world

The same principle applies in a more abstract way to the house. If the rejection of regional variances in costume[32] was the clearest sign of allegiance to the Saudi dynasty,[33] the abandonment of regional architecture followed quickly in its wake. Paul Bonnenfant, who studied the Asir highlands in 1979, arrived before the great upheavals caused by oil revenues. In the decade that followed, I have seen the foundations of rural society disintegrate, accompanied by an opening up of isolated regions, road construction, the introduction of electricity supplies to villages, and rapid urbanization.

Construction is characterized, to varying degrees, by an abandonment of regional models and the adoption of a "standard" architecture, a process that André Leroi-Gourhan defines as being a creeping uniformity in an average type of housing. This appears in the form of a gradual levelling down of individualities. A form of sclerosis seems to force architects to "cast" their constructions from a rigid and invariable mold. [34]

Modern materials are not as appropriate to the climatic conditions as older ones. The walls are built of hollow cement blocks which are coated: they no longer offer thermal inertia, which means that they are hot by day and cold by night. The extreme differences in temperature also cause the structure and the exterior of the buildings to deteriorate. Houses of identical design built in Tihama also suffer damage due to inadequate ventilation; concrete and plaster degenerate rapidly due to the very high humidity and the salinity of the soil. New materials are also appearing in domestic spaces in the form of tiling and metal doors.

The window openings have become larger and more numerous as a result of the pacification of the region and possibilities offered by Western technologies. The use of modern materials means that the structure of the walls is no longer fragile. Frosted glass windows now serve to maintain the privacy of the home as in the past. Today air-conditioning makes up for the loss of thermal insulation. At its extreme, the trend is for transparency with walls made entirely of aluminium and clear glass, which frame the surrounding landscape, as for example in the PTT (Post Office) building in Abha.

# Causes of architectural change

It is mainly in the cities that concrete is replacing traditional houses. This is because the urban environment acts as an intermediary between the semi-autonomous tribal groups and the central source of political and cultural influence. The traditional architecture is

fast being diluted by governmental attempts to modernize urban areas. It is not surprizing to find types of vernacular architecture alongside non-native constructions built at the imposition of the ruling groups, the former being gradually absorbed by the latter.[35]

While the causes of these architectural changes can be found in the political arena, they also reflect a desire for modernization, and while the prestige of new materials plays a role, other more pragmatic reasons must be invoked. Climatic influences can limit the choice of materials, but as we have seen this can at least partially be circumvented. For example, mud is used in rainy areas, where projecting slates[36] and spouts made from hollowed wood can effectively divert water from the walls and so prevent the erosion of the soil around the foundations. Hollow cement blocks no longer offer the insulation provided by mud, but air conditioners can do the job in a country where energy is cheap. Traditional rain spouts are gradually being supplanted by metal or asbestos-cement pipes which disfigure the walls. Water is now stored in tanks on the roof, transported upstairs thanks to the electricity supplies to the villages. In areas of heavy rainfall, the flat roof made of traditional materials cannot withstand the weather. The inhabitants have made successive improvements to their houses. The roof can be reinforced by a layer of cement.[37] Even if this means losing the terrace roof (an area for drying, rest and communication), the recent addition of a metallic structure supporting corrugated sheet iron offers a definitive solution which does not affect the intrinsic architectural style. This provides the opportunity for potential expansion by gradually covering the whole area.

The huge demand for buildings has produced standardized houses which lack any identity. "Traditional building is expensive," one Saudi said with a tinge of nostalgia. If mud has been abandoned, this is not only because of the social depreciation associated with this material, but also because its use requires specialist work. Man has a special relationship to the soil, distinguished by an almost physical intimacy: the choice of a good mud is vital because it expands when wet and shrinks on drying, resulting in cracks. Few, if any, craftsmen can be found who are capable of erecting drystone houses today: it is easier to cast hollow blocks of cement than to cut stones. Yet the expression "architecture without architects,"[38] to describe traditional houses, is not entirely appropriate. While mutual aid and cooperation were certainly involved in the construction and upkeep of a house, symbolizing the dominant forms of solidarity (familial, lineal, etc.), the contribution of different trades was nevertheless indispensable. Today, mutual aid can no longer be counted on, skilled workers have to be enlisted, and their services are as expensive as they are scarce.

The agricultural space is also built up. The terraced plots are the result of farmers' stubbornness and of working practices whose results are constantly being renewed. As village solidarities fade there is a rural exodus to the towns.[39] The farmers' sons prefer administrative office and army posts to working a difficult soil. The proliferation of second homes has also radically altered the rural habitat. Rampant urbanization has deconstructed what many generations of farmers have succeeded in organizing into an impressive equilibrium: terraced plots prepared for cultivation have now been taken over by

builders. The abandoned terraces, stripped of their original function, could be seen as an objective parameter for assessing change.

A courtyard is provided in front of each house,[40] and closes it off from the exterior. The need to protect the privacy of family life is especially strong in modern residential areas.[41] Paradoxically tribal pacification has meant that the territories are more accessible to outsiders: the village now contains government employees from the Najd and other foreign workers such as teachers, tradesmen and craftsmen, and this has made for more rigid social codes the better to guarantee effective isolation. Edward Hall tried to demonstrate the importance of the concept of proxemia by examining the cultural imbalances caused by architectural upheavals. His assertions that Arabs do not mind being surrounded by crowds, but hate to be enclosed within walls, is not borne out here. It seems, rather, that the reverse is true: architectural imbalance is caused by cultural and social upheavals, since the Saudi attributes to the walled enclosure the needs for protection and privacy imposed by the new context.

Despite a relative standardization of the architectural landscape through the spread of these new models, and the persistence of a few archaic areas, modernity is also bringing about a trend towards stylistic individualization. Each new form, in the specific meaning of the group, signals real change when individual innovation is not restrained by rigid standarization. Tradition, as a regulating force, has clearly disappeared. The desire to stand out often takes the form of competition which distorts the notion of originality into the concept of pure and simple divergence. This trend is not lacking in extravagances, and house owners are still tempted to highlight the distinctive character of their house in comparison with the neighbors'. It is the prerogative of the nouveaux riches to express themselves in this way.

# In praise of tradition

Two competing alternatives are gradually emerging from this contradictory situation. While the rejection of traditional forms is due to the prestige of the new, there are also numerous examples of an opposing trend. To satisfy the taste of a clientele desirous of an attractive environment as well as comfort, some architects are attempting to restore the traditional style, and develop a cultural sensibility. They are managing to some extent to fit a locally inspired architecture into the voids left by their predecessors. Yet the critical gaze of the modernists suspects a regressive tendency. Equally, the newly arrived population, mainly made up of Najdi government employees, has little sympathy for the rural environment which they consider to be old fashioned and pervaded with preIslamic superstitions. Thus they reject wholeheartedly any signs of traditional lifestyles.

Fashion has often been dictated by a few prestigious initiatives. The Chamber of Commerce of Abha is a good example, and perhaps the most successful local instance of a perfect symbiosis between modern materials and regional style. The Governor's palace has adopted the colors, forms, and spaces of the local vernacular architecture.

This trend is increasing and gaining in influence. During my second visit in 1994, I found that the newly built houses had drawn their inspiration from the traditional style. The trend is also reflected systematically by the public buildings and mosques. The new administrative headquarters of the Emirate, which dominates the centre of Abha, has decorative bands of alternating colors on its walls.[42] It occupies the position of the former Shada palace,[43] the fortress residence that the explorer Wilfred Thesiger photographed in 1946. All that remains of this is a squat tower preserved as a historical landmark.[44] The disproportion between the two buildings makes it difficult to integrate them into a single image. Despite their contiguity we cannot take them in at once, although locally such a refusal is tantamount to a denial of the power located in their architectural continuity. Some ministries have deliberately made their buildings quite different from their rivals, and have thereby contributed to preserving the architectural heritage—a praiseworthy initiative. I learned from the manager of a tourist village that the Ministry of Planning required promoters and architects to introduce traditional elements[45] into new buildings.[46] In more restrained terms, the former director of the King Fahd Cultural Center explained that the ministry controlled the process thereafter in order to avoid any undesirable deviation. The urban planning policy was changing its guidelines, from a standardizing approach to a regional specificity. From one area to another, the differences can be appreciated according to the age of the urban network. This explanation was certainly convincing but there were deeper reasons to be appreciated. The Wahhabi example, in which regional diversity is abolished, highlights the importance of the policy reversal in Asir, an action which has certainly enhanced the individuality of the province. Yet contradictions remain between the invoking of national principles and the local government drive for individuality.

## The neotraditional model

This tension expresses the ambiguities of the cultural ethos: one must distance oneself from traditional architecture in order to be able to refer back to it—that is, the spirit of the place can be respected while adopting a modern standpoint. From now on the aim is to follow the course of regional style as it is expressed in modern buildings.

Architects have tried to emulate the traditional style, even if many of these reinterpretations are mediocre imitations. Some attempts at the old style are seen in the details such

as projecting slates, the use of the truncated pyramid profile, merlons which emphasize corners, door frames and windows. Projecting slates,[47] which are symbolic of the Asir region, have been replaced by a simplified version of the old style; slates have been replaced by courses of projecting bricks, generally positioned in threes as a border. They have been reduced to residual grooves or black lines, stripped of their original function and are now purely decorative. As a result, architectural details have been degenerated to the point that they are unrecognizable, proof of the transformation that a process can inflict upon architectural details.

## The dynamics of cultural policy

The break with tradition is so severe that the cultural precedents seem to be in the process of absorption or extinction. Saudi Arabia, by adopting the modernity of the West, feels itself forced to resort to compensatory expedients to counteract its alienation. "Modernization, not Westernization," was one slogan used in an advertisement[48] for the 62nd Anniversary of the Kingdom of Saudi Arabia.

Following a classic pattern, folklore moves in where traditional life recedes. Culture is never manifested more strongly as folklore than when its existence is endangered, or rather neutralized. Asir had to fall into line at the annual Janadriyah festival, where the distinctive features of the region reappeared in traditional folk groups.[49] The catalyst for cultural regeneration in Abha is the creation of the Muftaha, an abandoned village 150 years old, renovated to become the King Fahd Cultural Center. This has acted as a stimulus to artistic creativity, particularly in the pictorial arts. It is an intelligent model of restoration, with blue shutters and doors punctuating the ocher and white of the façades. According to its former director, the architect in charge of the project kept intact the original layout and style. One can only regret that just one such old house remains, a trace forgotten on the margins of the village.

In the midst of the decline in traditional crafts, a "tourist" craft workshop has been organized at the Muftaha, with carpet weaving as its focus. The weaver is Egyptian, and works on an upright loom, a model that is not indigenous to the Arabian Peninsula. The decorative themes are borrowed from the architecture and thus lack any reference to the traditional culture.[50] An anecdote illustrates the problem of taking an artefact out of context and thereby reaching misleading conclusions. Mud models of the local architecture are sold at the Muftaha Museum. I imagined that I had found a product designed for the tourist market. But to my amazement, I found similar replicas in a remote village[51] displayed in front of houses, or standing on a periphery wall, and in this context the significance of these objects becomes apparent. These scale models seem to obey an

esthetic intent, a hypothesis backed up by the fact that they are made by women. They might even have been made as a form of amusement. They can be seen both as artefacts (the equivalent of pottery)[52] and as replicas: the windows, outlined by red-edged blue frames, all have the same configuration as displayed among the Sinhan. For the rest of the model the arrangement of the colors is arbitrary.

When I commented to the former director of the King Fahd Cultural Centre what a shame it was that the decorative art of Rijal Alma was being continued only by two elderly women,[53] he replied that it was just a technique, and, like any other technique, it could be learned. Nevertheless, while the frescoes are to some extent mechanically executed, each one bears the imprint of its creator. The increasing emphasis placed on technique in all the crafts is gradually turning the artist into an automaton.

The desire to forge a new identity for the national culture has effectively revived the art of the fresco. No longer an integral part of a living tradition, the pastiche work of professional painters can be seen in the streets of Abha, in the hotels and the tourist villages. They do not produce frescoes, but representations of frescoes. Their overly perfect stencilled work imitates the old paintings, but are generally of poor quality, lacking even the deliberate flaws that can be found in carpets. Standard geometric abstractions repeat triangles and lines, devoid of individual variation and harmonics. A result of esthetic cowardice, this convenient and tiresome repetition has become the rule. One can only hope that the authorities, rather than promoting folklore, will strive to encourage artisans to continue the endangered art of mural painting. Only by allowing skilled artisans to continue their art can their work be saved from the mists of ignorance, or from the fate of transformation into a museum-piece from a disappearing past.

*An example of neotraditional architecture:
the vernacular style is preserved in the details
but adapted to new materials (Asir, Abha).*

*Against a backdrop of mountains with
cotton-wool clouds, this tourist village looks
proud of itself; it is part of the promotion
of neotraditional architecture (Jabal Sawdah).*

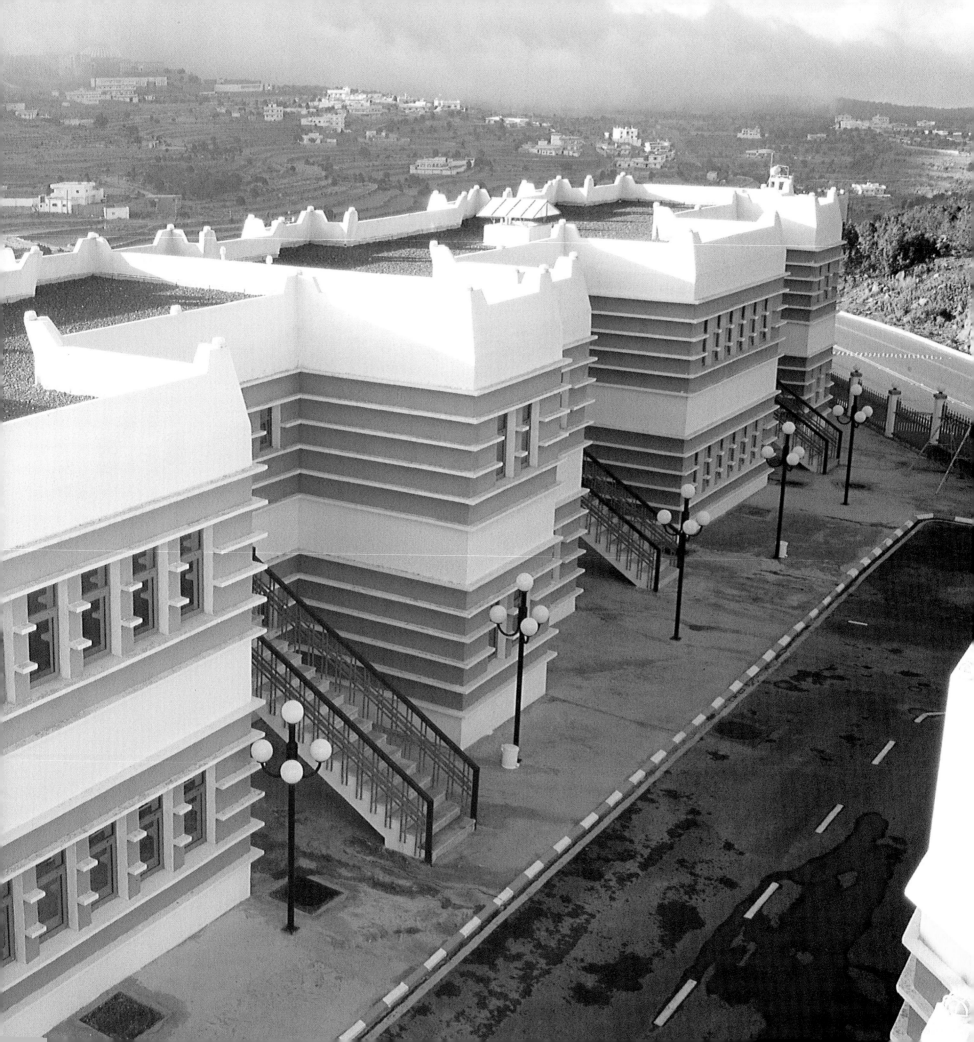

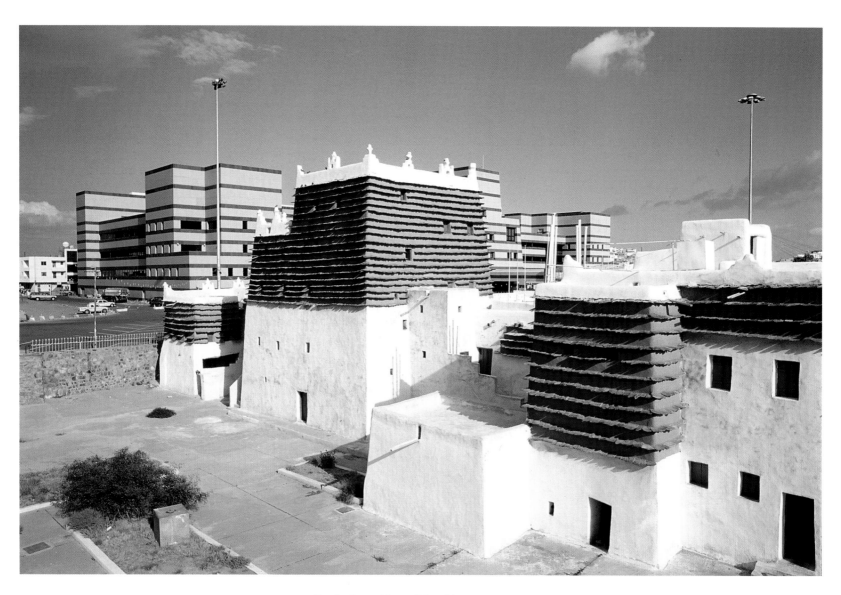

*Partly obscured by traditional houses,*
*the Emirate's new administrative headquarters*
*(Asir, Abha).*

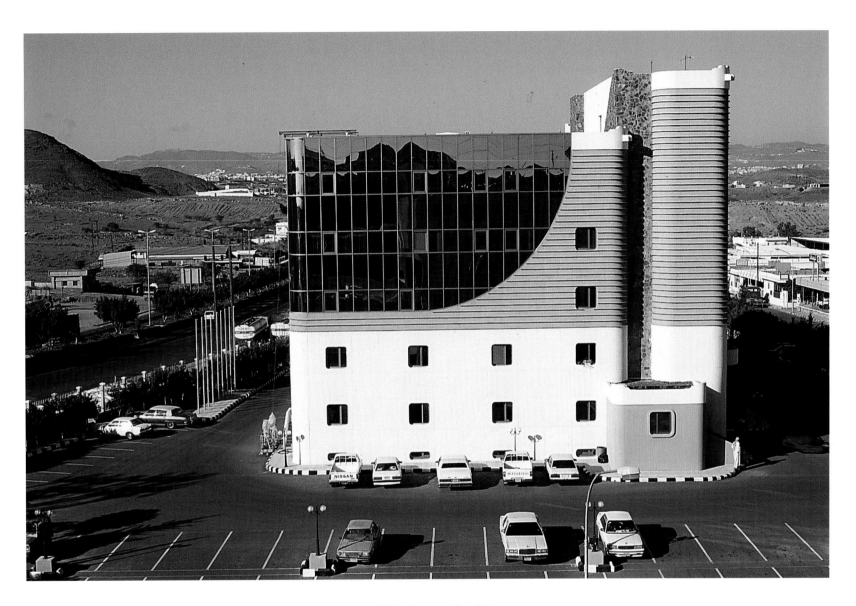

*Some neotraditional constructions illustrate
that architects bend techniques to suit their
esthetic tastes. The Chamber of Commerce
is a fine illustration, and perhaps the most
accomplished example of perfect symbiosis
between modern materials and regional style.*

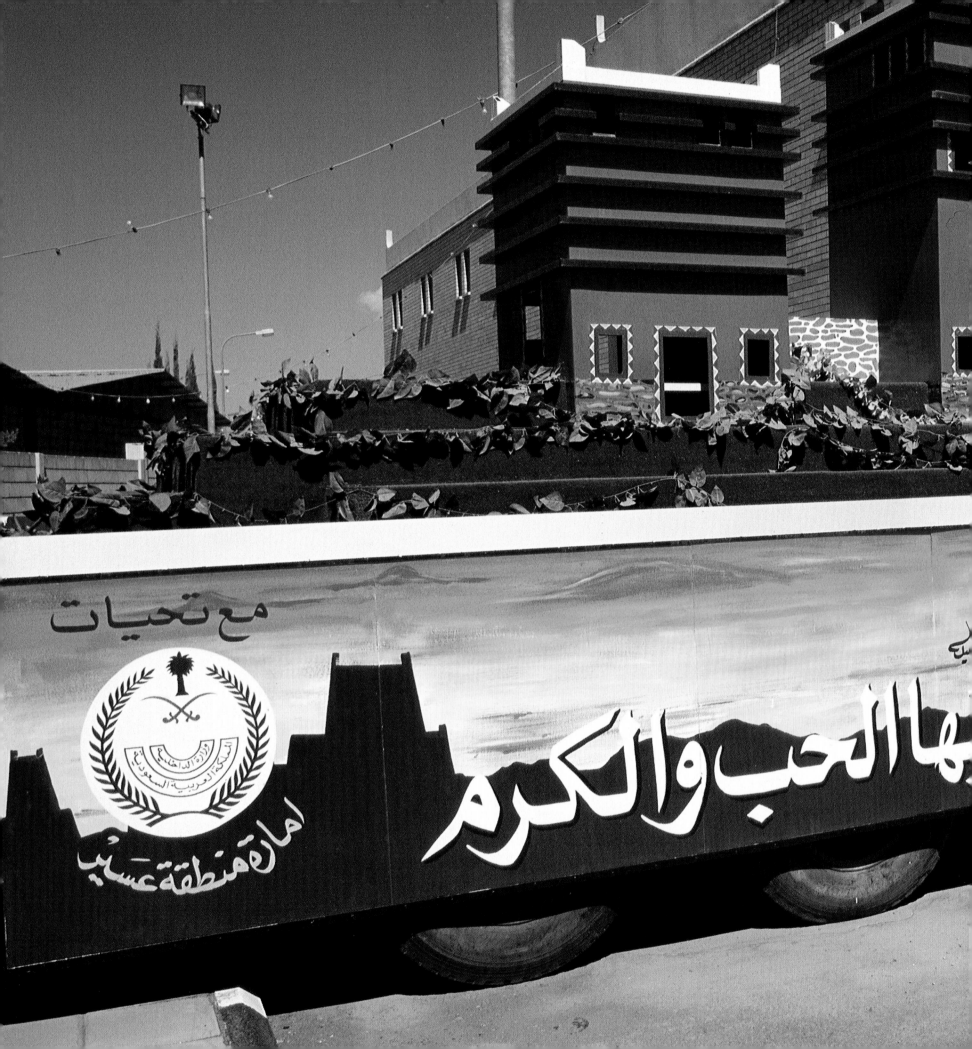

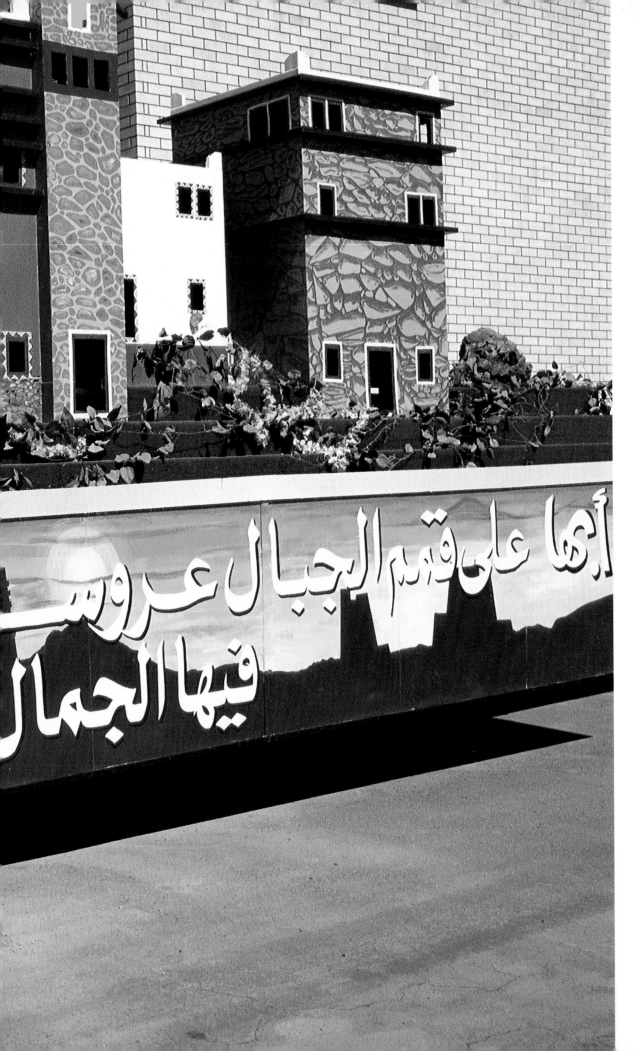

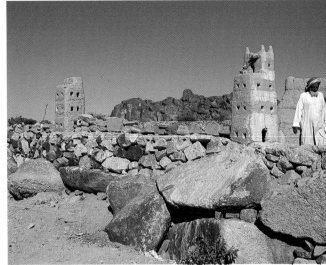

*The previous shot seems to echo these scale-models on an enclosing wall (Bilad Qahtan, Sinhan).*

*This trailer, used as a mobile support for scale-models of traditional houses, is part of the cultural promotion operation of Asir: "Abha is a young bride on the mountain tops, with all her beauty, love and generosity. With the compliments of the Emirate of the Asir region."*

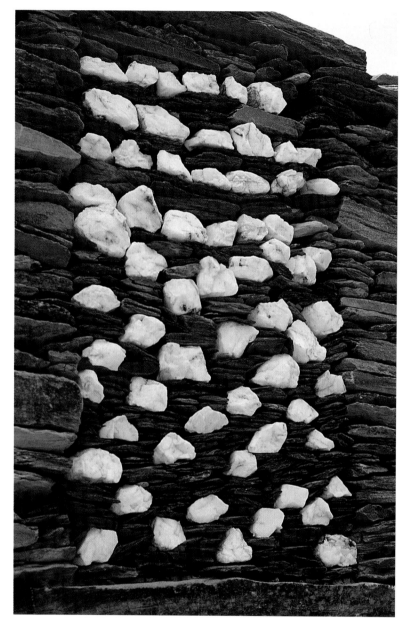

*The decors checkered with quartz find their exact equivalent in composition and color on the façades of the new houses, but in the form of diamond-shaped metalwork trellises (Rijal Alma).*

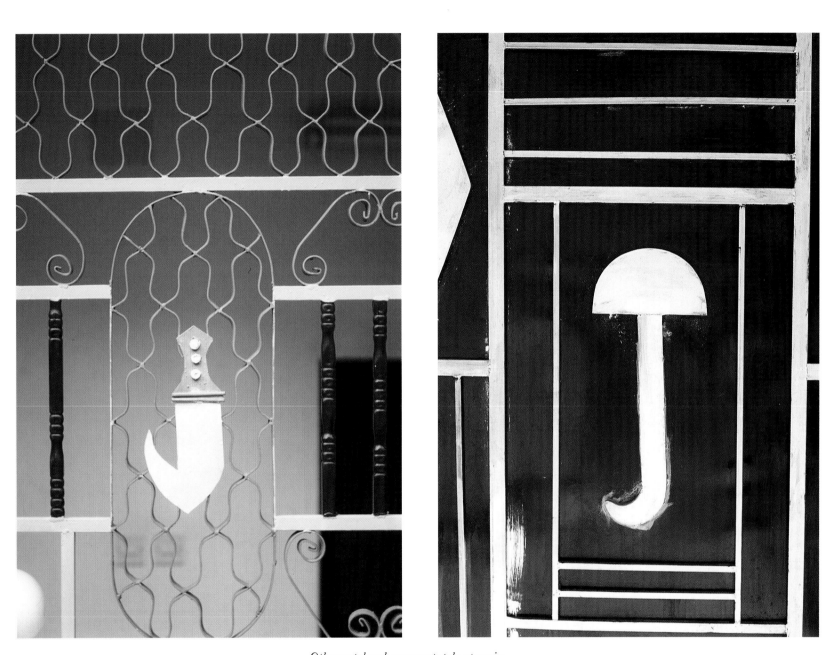

*Other metalwork ornaments take up again
the symbols traditionally represented by quartz
shards, such as daggers—either realistic
(Rijal Alma, Rijal), or stylized (Bilad
Qahtan, Sinhan).*

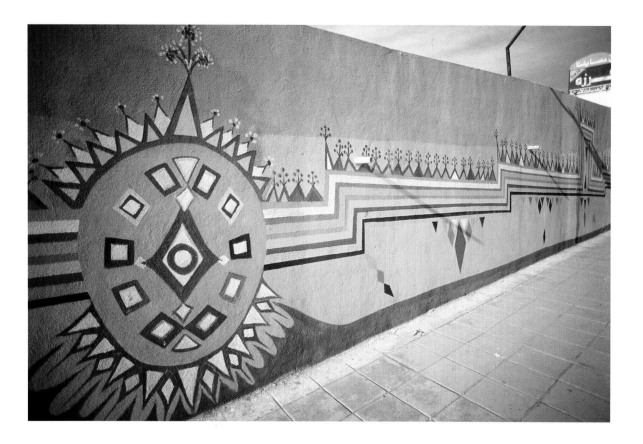

*The growth of tourism in this region
has given a new lease of life to the
mural art of painted houses, in all
its richness, right into the very streets
of the capital (Abha).*

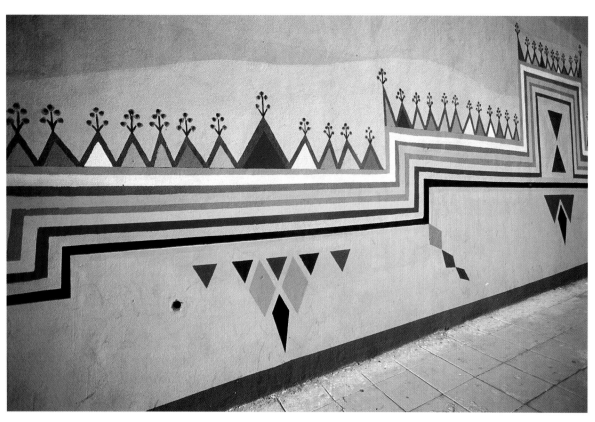

194

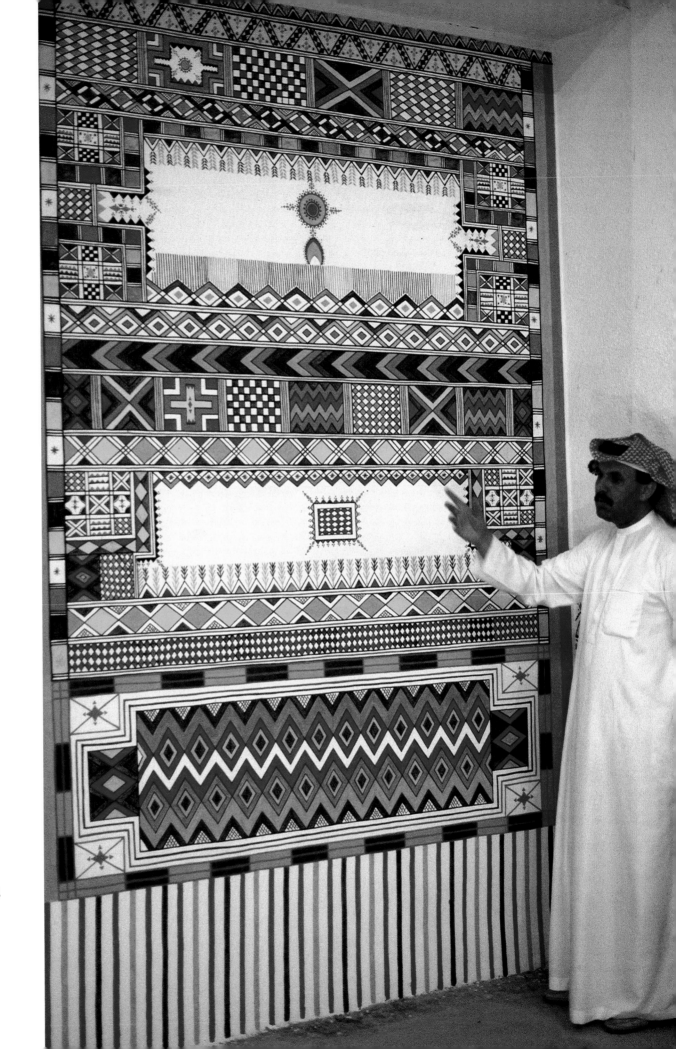

*Momentarily turning his back on his easel, the painter Dhafir Al-Hamsan has reproduced, in his tourist village, a pillar from Rijal (batrah). The designs appear dilated by the width of the support (Asir, Khamis Mushayt).*

# NOTES

1 The word *Tihama* appears in Sabaean texts in the form of the consonants *THM* meaning "flat lowland at the foot of the escarpment."

2 *Sarat* means "high."

3 *Wadi* designates the stream flowing after a flood and the bed which it has hollowed out of the land, and also, in a broader sense, the valley itself.

4 Their use ceased in the 1930s with the Saudi conquest of the region. Some of them serve today as stockpiles.

5 The method used is to mix soil and straw. The mason applies a coat of mud on top of the previous coat, all around the house. He repeats this operation as often as necessary to reach the desired height, reducing the thickness as he advances to give the building the silhouette of a truncated pyramid. It is necessitated by the presence, at ground level, of large and partly buried stone blocks, which guarantee the solidity of the structure on the soft marly foundations.

6 Literally "Shahran country," territory occupied by the Shahran tribe.

7 If the map of annual rainfall is superimposed on the map of the distribution of this type of architecture, they are found to match exactly, with rainfall in the range from 160 to 200 inches.

8 While the noun has a rather general meaning, the verb *hassana*, constructed on the same root as *husn*, means "to fortify."

9 An inhabitant claimed that his drystone house was three hundred years old, while the upper story made of mud was only thirty-five years old. While these figures are not completely reliable, the difference confirms the use of mud for additional stories.

10 Limewash acts as protection against the elements.

11 The morphological features of this model are repeated in the Mediterranean countries: an empty central space surrounded by living quarters which opens on to the central space. The model derives from a conception of the "Arab/Muslim" way of life.

12 As opposed to "South Arabian," the expression "southarabian" has a dual meaning, both geographic and linguistic, designating a specific region as well as a different language from Arabic.

13 The newborn baby is wrapped in bands which hold its arms along the body, its legs straight and its head aligned with the trunk. Thus swaddled, its little body is shaped to adopt a suitable posture worthy of a man.

14 This theme is repeated in the reception hall (*majlis*) where the domestic arsenal is displayed on the wall. On the green flag of Saudi Arabia is inscribed the Muslim profession of faith, next to a saber. Two sabers in a diptych on either side of a palm tree are the emblem of the kingdom. They are also found on the brightly decorated trucks.

15 According to a thesis taken up by Caussin de Perceval in his *Essai sur l'Histoire des Arabes avant l'Islamisme*, the Arabian authors identified three races in Arabia: primitive, secondary and tertiary. The primitive Arabs were thought to have come from Babylon during the exodus caused by the confusion of languages after the abortive attempt to build the Tower of Babel. They settled in Central and Southern Arabia.

16 Georges Conteneau, in *Le Déluge Babylonien*, gives us a precise description of brick-making in Mesopotamia.

17 Lucien Golvin writes: "As long as serious relationships relying on something more solid than mere fanciful impressions have not been established, we believe that the widespread idea of an architecture inspired by Babylonian antiquity must be discarded, particularly since we do not yet have an accurate picture of the Babylonian house, of which only the foundations and the ground layout are known."

18 While Westerners have called Shibam the "Manhattan of the desert," it is worth noting that the skyscraper became a necessity in New York because of the narrowness of the island of Manhattan.

19 Rijal can be linked to pre-Islamic history by the emigration, after the destruction of the Mareb Dam, of a group called Alma. The town was founded in the fifth century of the Hegira.

20 The façade of a house and the face of a man have the same root. The latter wears the former as the sign of his tribal membership, as Jacques Berque comments: "The *wasim*, the well-bred man, wears his genealogy on his face: an expressive beauty of which the ancient Arabs were very aware."

21 Small windows allow only a thin ray of light to pervade the interior. This explains the widespread use of neon since rural electrification.

22 The same concern has resulted in a reduction in the size of the doors to the watchtowers and fortified granaries, designed to keep out intruders.

23 The epigraphist, Jacques Ryckmans, claims that the Sabaeans sometimes represented the god Sin (moon) in the form of ibex horns, due to their resemblance to the first crescent.

24 Cattle horns, a clumsy imitation of an overly admired model, are sometimes substituted for the ibex horns which have become rare.

25 Branches curved into a semi-circle provide the frame, and the rest is covered with palm fronds.

26 Correspondence with Amirah Noura Bint Muhammad in 1989.

27 The vocabulary of trade is unconcerned with botanical or mineral accuracy.

28 Abbreviation of *arak* (*salvadora persica*).

29 When I returned in 1996 I was saddened to hear of the death of this young Saudi in an automobile accident. However he had been as good as his word and the house had been newly repainted.

30 See illustration above.

31 The goatherds' resistance to change goes hand in hand with a strong identity and an isolation which ensures that they are scarcely touched by the processes of westernization.

32 It is easy to agree with André Leroi-Gourhan that invasions typically introduce changes to traditional styles of behavior, including styles of dress, and this sometimes imposes styles that are less comfortable.

33 The national costume consists of a robe (*thawb*) and a three-part headdress (*kuffiyah, ghutra,* and *iqal*). The farmer working in the fields has to fold back the *thawb* and "turbanize" the headscarf.

34 According to Paul Bonnenfant, architects are inspired by Western cultural models, introduced into Arabia by the Americans in the eastern provinces, by Saudis going west for study, tourism and business, and by numerous Egyptian architects who have offices in Riyadh.

35 The concern not to go beyond the norm inevitably influences decision-making. Paul Bonnenfant observes that the architectural development of Bilad Ghamid between 1975 and 1979 shows a desire for uniformity. He also remarks that to look good to their superiors, the provincial officials are changing their traditional social behavior, as they have their clothing, to conform to national patterns. The standard house is now the cement villa type seen throughout Saudi Arabia. As with costume, architectural conformity prevails. This standardization eliminates any regional differences.

36 Layers of slate (or any other easily split schist) inserted into and jutting from the façades to protect them from rain-water.

37 This innovation is much more effective than the lime mortar or vegetable tar formerly used to waterproof the terrace.

38 This expression was coined by Bernard Rudofsky in his book *Architecture Without Architects*, published in 1964 by the New York Museum of Modern Art.

39 The land development fund aids villagers wishing to settle in the towns.

40 To repeat the metaphor of the face, the wall hides the lower half of the house, like a half-mask.

41 The town is an extreme case; each villa is surrounded by high walls and the women wear veils when they go out.

42 The effect obtained by the natural variety of colors of the stones used in alternating order is part of a very ancient southarabian tradition.

43 Built by Aid Bin Mari when he ruled as emir from 1834 to 1857. His son presided over the building of a fortified enclosure. In 1919 and 1920, the Turks added a citadel named Tash Qislhah. With the arrival of the Wahhabis, the palace became their military headquarters. It was occupied by a succession of emirs until 1935, and was demolished in 1979.

44 Some edifices are national monuments. The nation assembled around the fortress of Musmak in Riyadh, whose conquest by the young Abdul Aziz was the first decisive act in the restoration of the Saudi dynasty.

45 The excessive verticality of some official buildings does not connect them to the southarabian tradition already mentioned, but to modernity on the American model.

46 While this policy applies to the whole kingdom, Asir, because of its cultural and geographical singularity, and its historical antecedents, occupies an exceptional position.

47 Their decorative equivalent in the Najd is the triangular cut-outs on the façades.

48 Reported in *Le Monde* of Friday, 23 September 1994.

49 The folk costume displays a dual morphology: it is inspired by regional clothing, but only exists in one model. Thus it has been filtered by the influence of uniformity.

50 On the other hand, the Bedouin ornamental motifs are used in home furnishing fabrics.

51 This is an ancient practice. Mud models have been found in different archaeological sites in the Middle East. Some incense burners discovered in Yemen are in the form of a reduced-scale tower-house.

52 The artefact recalls that the walls of a house are raised somewhat like pottery.

53 When I returned in 1996 I was told that Sherifa had died in an automobile accident. Fatma is thus the only survivor.

# BIBLIOGRAPHY

ABDULFATTAH, Kamal, *Mountain Farmer and Fellah in Asir Southwest Saudi Arabia*, vol. 12, Erlangen: *Fränkische Geographische Gesellschaft*, 1981.

AMIRAH NOURA BINT MUHAMMAD et al., *Abha Bilad*, Asir, Riyadh, 1989.

AZIZA, Mohamed, *L'Image et l'Islam, L'Image dans la Société Arabe Contemporaine/Moha*, Paris: Albin Michel, 1978.

BACHELARD, Gaston, *The Poetics of Space*, trans. Maria Jolas, Boston: Beacon Press, 1969.

BERQUE, Jacques, *Les Arabes d'Hier à Demain*, Paris: Seuil, 1969.

BONNENFANT, Paul, *Les Hautes Terres d'Arabie Saoudite*, SEDES Report, 1979.

—, "La capitale saoudienne, Riyadh," in P. Bonnenfant, *La Péninsule Arabique d'Aujourd'hui*, vol. II, pp.655–704, Paris: Editions du CNRS, 1982.

CLÉVENOT, Dominique, *Une esthétique du voile*, Paris: L'Harmattan, 1994.

CONTENEAU, Georges, *Le Déluge Babylonien*, Paris: Payot, 1941.

CORNWALLIS, Kinahan, *Asir Before War I*, Cambridge: Oleander Press, 1976.

GOLVIN, Lucien, "Contribution à l'étude de l'architecture de montagne en République Arabe du Yémen," in J. Chelhod, *L'Arabie du Sud*, vol. 3, pp.303–328, Paris: Maisonneuve et Larose, 1985.

HALL, Edward T., *The Hidden Dimension*, New York: Doubleday & Co., 1966.

IBN KHALDUN , *Discours sur l'Histoire Universelle*, Paris: Sindbad, 1967–68.

LE CORBUSIER, *Sur les Routes*, Paris: Gallimard, 1941.

LEROI-GOURHAN, André, *Milieu et Technique*, Paris: Albin Michel, 1973.

LÉVI-STRAUSS, Claude, *Anthropologie Structurale*, Paris: Plon, 1958.

—, *Le Regard Eloigné*, Paris: Plon, 1983.

MAUGER, Thierry, *Flowered Men and Green Slopes of Arabia*, Paris: Souffles, 1988.

—, *Undiscovered Asir*, London: Stacey International, 1993.

—, *Essai d'Interprétation de l'Architecture Vernaculaire du Asir*, Doctoral diss., Paris: Ecole des Hautes Etudes en Sciences Sociales, 1995.

PAPADOPOULO, Alexandre, "Le mihrab dans l'architecture et la religion musulmanes," Proceedings of an international symposium, Paris, May 1980, Leiden: E.J. Brill, 1988.

PHILBY, H. St. John, *Arabian Highlands*, New York: Ithaca, 1952.

PROCHAZKA, Theodore, *Saudi Arabian Dialects*, London: Kegan Paul, 1988.

RUDOFSKY, Bernard, *Architecture Without Architects*, New York: Doubleday/Museum of Modern Art, 1965.

SEIGNE, Jacques, "Le château royal de Shabwa, Architectures, techniques de construction et restitutions," in *Fouilles de Sabwa*, vol. I, pp.111–164, Paris: Geuthner, 1992.

SOURDEL-THOMINE, Janine, *De l'Art de l'Islam*, Paris: Geuthner, 1984.

THESIGER, Wilfred, "A Journey through the Tihama, the Asir, and the Hijaz Mountains," in *Geographical Journal*, no.110, pp.188–200, 1947.

Origination: EVOLUTIF A.G., Montrouge

Typesetting: Octavo Editions, Paris

FA3624-03-V

Dépôt légal: 10-1996

Printed by Bookprint, S.L., Barcelona, Spain

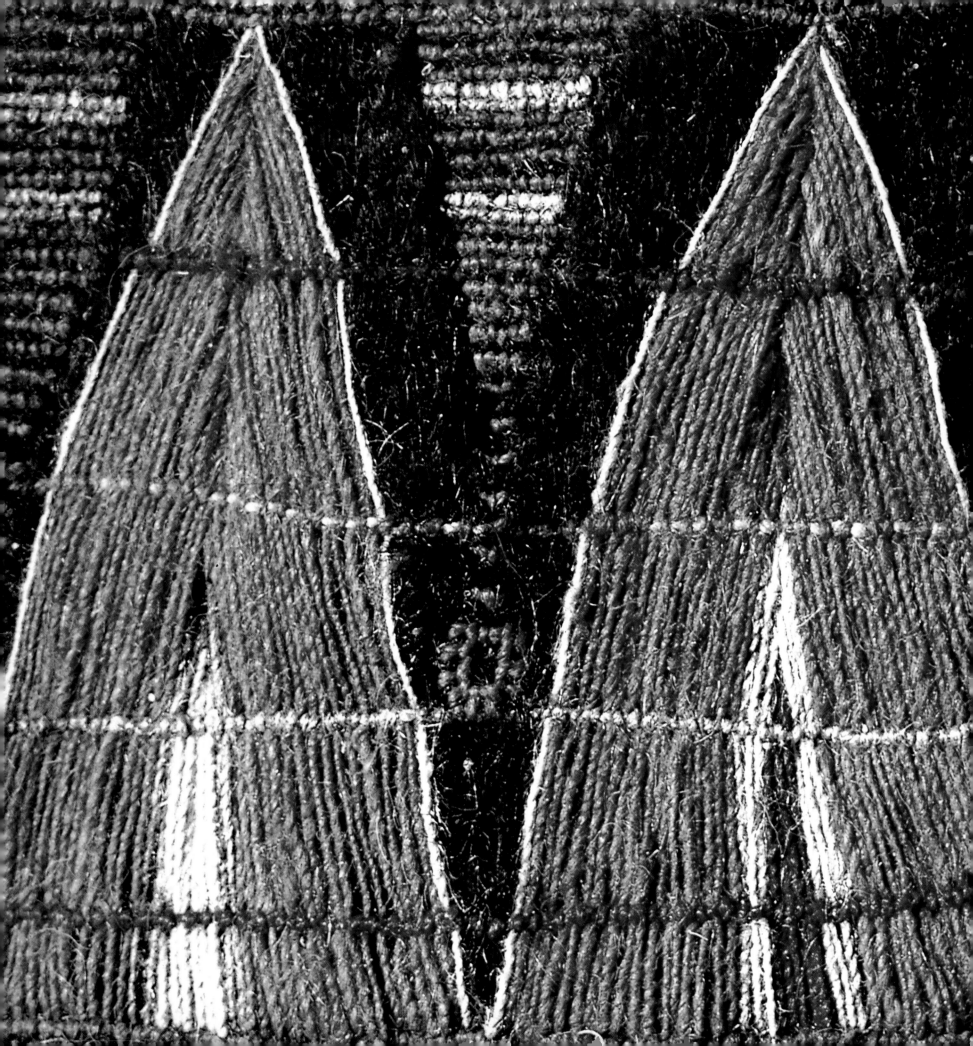